1

The Re-enchanted Landscape
Earth mysteries, paganism and art in Cornwall 1950-2000

Rupert White

Front cover: 'Hare Magic' by Andy Norfolk. (Used as cover art for Meyn Mamvro no.63 2007)

Back cover: 'Penglaz' by Gemma Gary.

Additional artwork (untitled): Hyman Segal p2, Gemma Gary p5, p44, p282 & Lucy Stein p290.

ISBN 978-0-9932164-3-5

ANTENNA PUBLICATIONS

And did those feet, in ancient times, walk upon England's mountains green? (Milton: A poem (1808) William Blake)

Cornwall has an attraction for the seeker, bearing as it does traces of those sunken countries, Lyonesse and Atlantis, which are lost in the depths of every mind. This 'end of the land' exerts a magnetic pull on those who are dissatisfied with themselves or their environment: it promises something other than a mere humdrum existence. This explains why many people from 'up country' come to settle here after retirement; others cannot wait for that but, irresistibly drawn, will jettison their prospects and come down here to find not only a living, but a life worth living. (The Living Stones (1957) Ithell Colquhoun)

For Claire

Foreword

Perhaps it is time that the Cornish seaboard and its hinterland, from the Carrick Roads to St Agnes Head, was officially designated 'The Pagan Coast'. Such a step would probably be controversial, and with some reason, as the region concerned abounds with the names of saints, with holy wells which were long Christian, or Christianized, and with medieval parish churches, some of which, like St Buryan's, have functioned as beloved landmarks in their own right as well as places of worship. None the less, there are three strong arguments in favour of the name.

One is the character of the land itself, that focus and container of divinity for most forms of paganism, ancient and modern. Its fantastic geology, with granite, serpentine and other kinds of rock weathering into forms which evoke at times living beings and at others mighty and venerable constructions, calls to the heart and the imagination. So does the many-coloured, ever-changing sea which surrounds much of it, and both ocean and land are often vivified by that remarkable, pellucid, aqueous light which often suffuses the area and had drawn so many painters, even as the shapes of the terrain call to sculptors.

The other argument draws attention to the extraordinary assemblage of monuments, most of them ceremonial – temples and shrines – left from every period of prehistory since humans first began to alter the earth. Quoits, circles, cairns, barrows, enclosures and fogous sprinkle or crowd the whole region, and are the more emotively potent for lack of much imprint from later millennia. The Romans hardly touched the area, and so did the Normans, so that the remains of the remote past are not overlaid by those of later monumental builders. There are no cities or large towns to engulf the land, and industry is virtually gone, leaving the ruins of pit-head buildings looking now almost as archaic as the Neolithic quoits. Everywhere the bones of the ancient past lie around on the surface of the ground, instead of being buried deep as they are in most other parts of Britain.

The third argument is that, unsurprisingly, this region has attracted a remarkable number of intensely creative recent adherents to forms of alternative spirituality, linked to the land and its long past; who are the subject of this remarkable book.

Both the region and the book, of course, draw their emotive strength from a further characteristic of West Cornwall: that it has functioned in history as the greatest refuge and powerhouse of a distinctive Cornish cultural identity which has suffused the whole peninsula beyond the Tamar. Of all the Celtic regions of Europe, Cornwall is the one which has most clearly and vigorously resisted the identity of a conquered and subjugated land. For one thing it has fought back with a special potency: in 1497, 1549 and 1643, armed movements which began in West Cornwall came very close to overturning the policies of the regimes based at London and remaking the whole history of the English kingdom. For another, having received English rule, Cornwall has done more than any other Celtic land to beat the overlords at their own game. By the Tudor period it had amassed more parliamentary constituencies than any English or Welsh county, making it a major force in national politics. As the old electoral system on which its strength depended began to collapse, it found a new pre-eminence as the cockpit of British industrialization, seat of many of the inventions which were to produce the Industrial Revolution, and exporter of skill, knowledge and expertise to every hemisphere of the world. Cornwall is one of those countries, like India, which has seduced most of those who have come to exploit it.

When the political and industrial power-brokers departed, it was left with a much more nebulous commodity to ensure it a continuing identity and importance: legend. Even here, it had already cornered a huge share relative to its size. At the humbler level of folk tale it produced Jack the Giant-Killer, as one of the staple British popular stories of the modern age. At the grander level, of the Matter of Britain itself, it had long contained the only place ever specifically claimed for Arthur's birth, and the most plausible one for his last battle, and the only well-known subsidiary Arthurian legend – that of Tristan and Iseult – to be set firmly in actual places in the landscape. Now this numinous aura of mighty myth has remained a resource when more tangible assets have disappeared, and is far more enduring. The progressive collapse of Cornish industry, from the end of the nineteenth century, onward, was accompanied by the generation of three successive waves of cultural creation and renewal, which spanned the twentieth century between them.

First came the nationalist revival, with the collection of the folklore, the foundation of the Gorseth and the rescuing of the language and the seasonal customs. Then, in the middle part of the century, came the visual artists, putting Cornwall on the global map of painting and sculpture. As they declined in number, the earth mysteries researchers, spiritual feminists and Pagans took over for the last three decades.

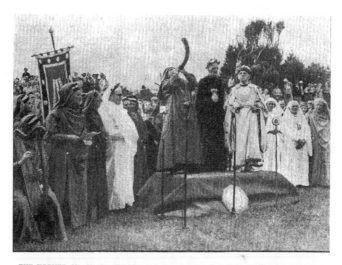

THE HORNER, Mr. Charles Murrish, of St. Ives, sounding Corn Gwlas, the Horn of the Nation, at Saturday's Cornish Gorsedd at Castle Dore. On the dais are also seen the Grand Bard of Cornwall (Mr. R. Morton Nance) and the Arch Druid of Wales (Rev. John Owen). White-robed Druids of Wales are also in the picture.

The Cornish Gorseth in 1954. Grand Bard and instigator of the Gorseth, Robert Morton Nance, is in the black robes next to the 'horner'.

Each has now found a place in history. The nationalist revival has by now been the subject of many scholarly books and articles. Historians of art have devoted excellent studies to the schools and studios of those who worked at St Ives and Newlyn, and their satellite colonies. The third great wave of modern Cornish creativity, that of what I once dubbed (in admiration and not satire) the Second Romantic Movement, of counter-cultural radicalism, now finds a worthy narrator in Rupert White.

His work achieves that worth in a number of different ways. First, it is meticulous, never asserting anything that it cannot ground in records or personal testimony. Second, it is inclusive, covering the whole range of activity and ideology with which that movement has been locally associated. Third, it is contextual, showing how the people and ideas

9

with whom it deals were rooted securely in the older movements described above, and how they relate to these and to each other. Fourth, it is modest, the author generally reserving his own opinions, loyalties and enthusiasms, and preferring as much as possible to allow his subjects to speak for themselves. Fifth, it is generous, portraying each of the personalities who feature in its pages to the best advantage, and this in turn enables its sixth virtue, that it is impartial, describing but never taking sides in the personal and ideological differences which feature from time to time in its pages.

Magical things often come in sevens, and it is easy to accord that number with a final lovely aspect of the book, that it is an easy and enjoyable read, clearly written, fast paced and beautifully illustrated. My hope is that by providing the history of the Cornish spiritual counter-culture of the past fifty years, it will help to establish the true nature and value of that culture, in all its richness and complexity, and so prepare the way for this great land to generate another burst of creative ferment, to carry its story forward into the new millennium.

Ronald Hutton
Professor of History, University of Bristol

THE LAND'S END.

From JT Blight's 'A Week at the Lands End'

Introduction

EARTH MYSTERIES (EM) is the holistic or "general systems" approach to ancient sites and their landscapes. It involves study of the curiously interwoven areas of archaeology, folklore, geomancy (sacred geography such as leys), ancient astronomy, geophysics, primary sensing, unusual phenomena, consciousness studies, etc. EM researches ancient peoples and their nearly-lost knowledge in order to uncover principles, insights and data from the remote past that might lay foundations for a wiser, more whole future. (The Ley Hunter (1990) ed Paul Devereux)

For well over 100 years artists and writers have been drawn to Cornwall, inspired by its remoteness, its light and its landscape. In the early 20th century it was perceived as a uniquely Celtic realm, unspoilt by urbanisation or industrialisation, and celebrated for its 'otherness'. In a letter to Bertrand Russell, D.H. Lawrence, who in 1916 was living in North Cornwall, puts it thus:

> Cornwall isn't England. It isn't really England, nor Christendom. It has another quality: of King Arthur's days, that flicker of Celtic consciousness before it was swamped under Norman and Teutonic waves (Sagar, 2003).

Already linked in legend to Arthur, and to Jesus and Joseph of Arithmathea, its mystical qualities were greatly embellished by the myth-making antiquarians and folklorists active in Cornwall in the 18th and 19th centuries.

Reverend William Borlase was the first of them to concentrate on the Duchy's ancient sites, and to speculate as to their purpose. He proposed, in fact, that the megaliths were used by druids for human sacrifice (Borlase 1754):

> ...Like the people of Canaan and Moab (the Druids) dyed their altars with human gore...That Altar which was for offering human victims must have been very different from what they used on less solemn occasions: there are many flat large rocks on Karnbre-hill which probably might have been appropriated to this horrid rite...of such holocaust Altars we have some I think remaining still in the higher parts of the parish of Gullval...

The folklorists, who were writing about 100 years later, included William Bottrell and Robert Hunt. In the introduction to his book 'Popular Romances of the West of England' (1865), the latter explains

why, prior to Brunel's railway, pre-modern beliefs seemed to live on in Cornwall:

It must not be forgotten that Cornwall has, until a recent period, maintained a somewhat singular isolation. England with many persons appeared to terminate on the shores of the River Tamar... The difficulty of transit explains the seclusion of the people...and to it we certainly owe the preservation of their primitive character...[1]

Bottrell meantime, working in West Cornwall (Bottrell, 1870), was able to describe a huge number of 'primitive' superstitions - enough stories to fill three volumes - including surviving beliefs in fairies and in witchcraft:

'According to ancient usage, the folks from many parts of the west country make their annual pilgrimage to some white witch of repute, for the sake of having what they call 'their protection renewed....Then the inhabitants of the Scilly Isles came over in crowds for the purpose of consulting the white witches of Cornwall, and that they might obtain their protection, charms, spells, and counter-spells...'

Illustration to Bottrell's 'Traditions and Hearthside Stories' by JT Blight

Coming out of the First World War, a generation led by Robert Morton Nance in St Ives, also explored Cornwall's 'otherness'. Nance, an Arts and Crafts artist, led the Cornish revival in the 20s and 30s and is best known for helping to reinstate the Cornish language, and for instigating both the Old Cornwall Societies and, in 1928, the extraordinary spectacle of the Cornish Gorseth. He was also a close neighbour and friend to the man who almost single-handedly revived British studio pottery: ceramicist Bernard Leach. [2]

In the middle of the 20th Century West Cornwall, having already seen the establishment of an art colony in Newlyn, became host to another,

when Leach was joined in St Ives by some of the world's most famous modern artists. These included the sculptor Barbara Hepworth, whose work echoes the grandeur of the naturally weathered rocks of her home (cf Figures in a Landscape, BFI (1953)). In 1968 Hepworth, like a number of the other St Ives artists, was made a bard of the Gorseth, but her death in a studio fire in 1975 marked the beginning of the end of the colonies.

By this time, however, a younger generation inspired by modern witchcraft and by writers like John Michell, had found new ways of responding to the landscape and its folklore. Products of the Sixties' spiritual revolution, they were drawn to Cornwall largely because of its wealth of prehistoric monuments. Exemplified by John Michell's book 'The Old Stones of Lands End' (1974), theirs was a mythopoeic creative response that defies easy categorisation, but together it formed what has become known as the 'Earth Mysteries' movement.

Unconcerned with academic respectability and unsupported by the mainstream, Earth Mysteries relished its outsider status. It was defiantly anti-rational: a quasi-science of poetic truths, that used forgotten and forbidden knowledge in a grass-roots attempt to re-enchant the lands-cape. Its activities came to overlap with the emerging concerns of Neo-paganism, as well as Feminism and Deep Ecology.

As we shall see, Earth Mysteries and Neo-Paganism in Cornwall specifically can be traced back to a period before John Michell's emergence, to two figures in particular: Surrealist artist and writer, Ithell Colquhoun, and founder of the Museum of Witchcraft, Cecil Williamson, both of whom settled in the region at roughly the same time (late 50's).

Colquhoun and Williamson are known to have met and corresponded with each other, but actually they rather talked at cross-purposes. Not only did they have different approaches to the occult and esotericism, but they also had different motives. Both ended up feeling isolated and misunderstood, and a letter Colquhoun wrote to Williamson asking him if he knew of any other Occult groups in Cornwall is particularly poignant in this regard.

'Figures in a Landscape' (BFI, 1953). Attempting to make abstract art more understandable to the public, this BFI documentary compares Barbara Hepworth's sculptures to the ancient landscape of Cornwall. Ironically, the sculpture depicted here at the Men an Tol ('Forms in Echelon') was made in 1938 - before Hepworth came to Cornwall - indicating that any resemblance may be coincidental.

It seems the spiritual revolution of the 60's came a shade late for them both. Interest in the Occult has never been mainstream, but by the 70's it was much more widespread and accessible, and a common vocabulary and set of values and beliefs - that is to say a paradigm - became widely adopted, such that it was easier for communities to emerge that had shared values, even in a relatively remote location like Cornwall.

Put simply, the paradigm involved a belief that modern civilisation is spiritually bankrupt: it has lost its connection to the Earth and become too urban, patriarchal and materialistic. Both Earth Mysteries and Neo-pagan writers tended to argue that the pre-Christian period, in contrast, was a Golden Age, in which Goddesses were held in equal or greater esteem than Gods, and that prehistoric man and woman, through techniques of ecstasy and use of other special abilities, were better able to connect with each other, the landscape and the Earth.

As the strapline of a report in The New Scientist (1982) implies, Paul Devereux's 'Dragon Project' came close to demonstrating this in the late 70s:
> Some say that stone circles are foci of 'Earth energy'; energy that our ancient ancestors were able to detect, and even to control. Modern research suggests that this outlandish theory may contain some truth.

In the eighties James Lovelock's fashionable theory of Gaia, was appended to the paradigm. John Michell, in 1989, was able to write:
> Our minds and senses are receiving messages from nature – from Gaia…together they amount to a statement, given directly by nature…that our present way of understanding and treating the earth is wrong, that we inhabit a living planet and must give it the respect due to any living creature. From that follows a quite different perception of our relationship to nature, leading to the rediscovery of the ancient spiritual sciences. (In Miller & Broadhurst (1989))

There was, in general, a belief that the wisdom of the ancients could be rediscovered, and remade for the modern era. As Ronald Hutton has said:
> The essence of 'earth mysteries' lies in the belief that by gaining access to the wisdom of an older world, one can redeem the shortcomings of the present. Indeed some think that the past may contain the means to save our planet from military and ecological destruction' (Hutton, 1991)

Cheryl Straffon and John Michell leading a tour of the old stones of Land's End.
Probably in 1990, at the Ley Hunter Moot.

This same paradigm, or variations on it, was transmitted more widely via other writers like Colin Wilson and Peter Redgrove, all with strong connections to Cornwall. And as we shall see, it was also reflected in the work of artists like Doc Shiels, Monica Sjöö and Jill Smith, and by pagans like Jo O'Cleirigh and Cheryl Straffon who met with others to perform rituals of various kinds at the ancient sites.[3]

By the 80's, Neo-pagans were less isolated. Thanks to a network of exchange magazines, and various national organisations linked to them, it had become much easier for like-minded people to connect and communicate with each other.

In Cornwall specifically, the launch of Cheryl Straffon's 'Meyn Mamvro' in 1986, marked a watershed. It also provided a platform for the expression of a uniquely Cornish blend of Paganism and Earth Mysteries, which was very much embedded in a specific landscape and place.

The next 10 years (86-96) would be a productive period for Earth Mysteries and Paganism in Cornwall, with more publications and new organizations appearing, but as it became more widespread, mainstream and accessible, it also lost some of its radical edge. However arguably, by then perhaps it didn't matter, because many of its arguments had been settled, and its goals achieved.

Notes: 1) A notion of Cornwall as a God-forsaken, lawless backwater has persisted into recent times, and was mercilessly exploited in Sam Peckinpah's film 'Straw Dogs' of 1971.

2) The Cornish revivalists had an uneasy relationship with Cornwall's pre-Christian past. The Gorseth has always gone to some pains to disassociate itself from paganism, despite the obvious difficulties in its doing so. (The ceremony, of which Nance was the architect, is in fact derived from Welsh revival druidism of the 18th century). Despite antipathy towards him, TFG Dexter, who was one of Nance's peers attempted, in 'Cornwall Land of the Gods'(1932) and 'Christian Crosses' (1938), to address the revivalists' reluctance to write about pre-Christian Cornwall. Interestingly, an earlier book of his, the obscure 'Fire Worship in Britain' (1931) was cited by Doreen Valiente (1978) in connection with her discussion of the Celtic Fire Festivals.

3) Ritual was used creatively, as a form of improvised theatre in some cases, as an embodiment of these and other shared values. A clear division between pagans and artists in their approaches to it is not always possible to draw.

Acknowledgements

This book emerged from interviews and research originally carried out for the online journal artcornwall.org. I first spoke with Lucy Lippard in 2010, and various other people were interviewed subsequent to this. In 2013 I contacted Tony 'Doc' Shiels, and ended up writing his biography - which led me in turn to Paul Screeton, editor of The Ley Hunter 1969-1976. The research really grew from these initial contacts, and from conversations with Cheryl Straffon, who encouraged me to complete the project and, once I had finished it, kindly proof-read the manuscript.

Contributors - or people I was in touch with during the research period - therefore include: Lucy Lippard; Richard Shillitoe (biographer of Ithell Colquhoun); Jeremy Deller (curator of The Bruce Lacey Experience), John Neal; Tony 'Doc' Shiels; Janet Bord; Paul Francis; Paul Screeton; Neil Roberts (biographer of Peter Redgrove); Jill Smith; Alan Kent; Lucy Stein; Steve Patterson (biographer of Cecil Williamson); Cheryl Straffon; Bob Forrest; Marie Yates; Peter Hewitt & Simon Costin (MoWM); Jo O'Cleirigh; Gemma Gary & Jane Cox; Paul Devereux; Paul Broadhurst; Jeff Saward; Ken Rees; Alan Bleakley; Cassandra and Laetitia Latham-Jones; Ian Cooke; Andy Norfolk; Philip Heselton; Craig Weatherhill; Sarah Vivian; Alex Langstone; Tom Henderson & Gabrielle Hawkes; Geraldine Andrew, Maggie Parks, Kelvin Jones, Adam Stout and Ronald Hutton.

Thankyou to all, especially to Ronald Hutton for his foreword and Andy Norfolk and Gemma Gary for their cover art. Thanks also to MoWM for use of their library, particularly their holdings of pagan mags, and Paul Screeton for sending a complete run of Ley Hunter magazines to me.

Most references to other books are in the back of this one, and references to websites remain in the text itself. References to journals and organizations include acronyms as follows: MM=Meyn Mamvro, TLH=The Ley Hunter, W&W=Wood and Water, IT=International Times, FTF=From the Flames, PF=Pagan Federation. The witchcraft museum in Boscastle was originally called The Witches' House, and more recently has been renamed: The Museum of Witchcraft and Magic (MoWM). For convenience I have tended to refer to it as the Museum of Witchcraft or MoW, which was its name for about 20 years from 1996 on.

Listen to the words of the Great Mother, who of old was called
Artemis, Astarte, Dione, Melusine, Aphrodite, Ceridwen, Diana,
Arionrhod, Brigid, and many other names.

*Gazowo orth gerriow a Thaama Vear, neb vee henwes en termen
eze passies: Artemis, Astarte, Dione, Melusine, Aphrodite,
Ceridwen, Diana, Arionrhod, Brigid, ha mear a henwyn erol.*

Whenever you have need of anything, once in the month, and better
it be when the moon is full you shall assemble in some secret place
and adore the spirit of Me who is Queen of all the Wise.

*Pesqueth dre vo thewh oathom a nepeth, eneth en meez, ha gwell po
lean an loor, cuntelio en lea kithes ha gorzeho an speres Ve, leb ew
Maternas an Feer**

*Starhawk's 'Charge of the Goddess' with Cornish translation by Craig Weatherhill and
Neil Kennedy, as featured in Meyn Mamvro 46 Autumn 2001

1. Living Stones

In 1950 a guidebook to Rocky Valley near Tintagel was published, in which its author announced the discovery of two petroglyphs adjacent to a derelict mill (Madge, 1950):

'Two mysterious symbolic ring-marked carvings (seen by the writer in September 1948 and again in 1949) are on the rock at the back of the mill. As they were covered by vegetation they had escaped notice previously'[1]

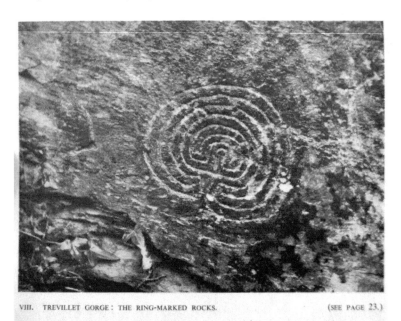

VIII. TREVILLET GORGE : THE RING-MARKED ROCKS. (SEE PAGE 23.)

The first published photograph of the Rocky Valley Mazes
(in Madge, 1950)

The labyrinth designs, carved into a sheer shale rockface, were subsequently brought to the attention of the world by a major 'exposé' in the Illustrated London News four years later. The article proposed that they were derived from Etruscan art, and had been created by Mediterranean traders during the Bronze Age. It was an assertion restated by a plaque later placed adjacent to them: 'ROCKY VALLEY

ROCK CARVINGS: LABYRINTH PATTERN CARVINGS PROBABLY OF
THE EARLY BRONZE AGE (1800-1400 BC)'.

The true origins of the labyrinths have been the subject of debate ever
since (eg Hutton 1991, Saward 2001), but one of the first to question
their alleged antiquity was writer and artist Ithell Colquhoun (b. 1906) in
her inspirational Cornish travelogue 'The Living Stones' (1957):

> I had heard of these as the 'Troy Stones'…They did not look ancient; or if
> they were must surely have been re-cut in recent times; who knows
> perhaps they are even yet used to instil the secrets of circle and
> cross?…Pre-Christian in origin, the design served as a map of the
> afterworld into which the soul entered at death; one version has seven
> revolutions, turning alternately to right and left, which recall the seven
> spheres of many systems…

At the time that her book came out, Colquhoun was best known as a
Surrealist artist, but her commitment to painting was, it seems, faltering
despite having a studio only a few miles from the then thriving
modernist art colony of St Ives.

This may be partly explained by the fact that Ben Nicholson (b 1894)
and Barbara Hepworth (b 1903) - regarded as the founders of the colony
- were actually rather hostile to Surrealism (Harrison, 1981). Living in
Hampstead, but in contact with many European Modernists, during the
30's they had purged their art of its literary and psychological content,
and stripped it back to an elegant and austere form of modernist
abstraction.

Theirs was a highly aesthetic style that has been referred to as
'International Modernism' partly because it emerged at the same time
amongst a group of artists from different countries, and partly because it
appears cut off from any locally-based tradition.

When they moved to live in St Ives in 1939, they passed on their artistic
credo to their disciples, particularly John Wells, Denis Mitchell and
Peter Lanyon who received their art education directly from their elders.
There were disagreements, and challenges to the 'tyranny of abstraction'
however, as Tony 'Doc' Shiels, who ran a gallery in St Ives recalls:
*Peter (Lanyon) fell out with Ben and Barbara though they'd been close
earlier: he thought they should allow anything in (to the Penwith
Society) as long as it seemed real* (White, 2015).

The hard-line on abstraction softened in time, however, and several of the St Ives modernists did reintroduce figurative elements into their work. In the case of aesthetes like Nicholson and Patrick Heron, these were tastefully composed views of St Ives or the landscapes of Penwith. In the case of the more romantically inclined artists eg Peter Lanyon, they were colours evocative of the landscape or symbolic elements, like the oily black crucifix hidden in the painting 'St Just'.

Ithell Colquhoun worked in Cornwall during exactly the same historical period as the first generation St Ives' modernists. Younger than Nicholson, but close in age to Barbara Hepworth, she shared none of their qualms about figuration. Instead, having been originally inspired by her visit to the London Surrealist exhibition of 1936 [2], her art was packed full-to-bursting with literary and psychological content. It engaged with everything that the abstractionists tended to avoid: dreams, madness, the irrational, sexuality, Celticism, religion and superstition, and it managed to do so with extraordinary prescience.

As we shall see, it is because of this richness of content that Colquhoun has become a crucial link between pre-war Modernism and post-war Feminism, Land Art, Paganism and Earth Mysteries. Yet despite, or because of this, she is not widely recognised. Colquhoun does n't fit into conventional narratives of either Cornish or Modernist art, and though she showed with the Penwith Society she is not even mentioned in the ground-breaking book 'Painting the Warmth of the Sun' by Tom Cross (1984) or the substantial publication that accompanied the first big St Ives show at the Tate (St Ives 1939-1964). However, more recently, she was one of the standout contributors to Tate St Ives' 'Dark Monarch', and as a result of this, and unstinting work by biographer Richard Shillitoe, her contribution is now becoming more widely acknowledged.

Born in India in 1906, of British parentage, Colquhoun came to the UK as an infant. She attended Cheltenham Ladies' College, and Cheltenham Art School before, in 1928, enrolling at The Slade School of Fine Art in Bloomsbury. As she recalled in 1976:

> At the Slade School one was taught to draw in the style of Michaelangelo but to paint in that of the French Impressionists. I could not see how to combine these disparate modes so I painted to match the drawing in monochrome with superimposed glazes of colour. The themes of my early works reflect those set for Slade compositions, which were usually taken from Classical or Biblical mythology.

Whilst at The Slade, Colquhoun won the prestigious Summer Composition prize in 1929 for the work 'Judith showing the Head of Holophernes'. She also attended meetings of The Quest Society in South Kensington and in 1930, at the age of 24, contributed the article 'The Prose of Alchemy' to their magazine 'The Quest'. Published for more than twenty years, and dedicated to the study of comparative religion, the magazine was edited by G.R.S. Mead, who as a leading Theosophist had been Madame Blavatsky's private secretary.

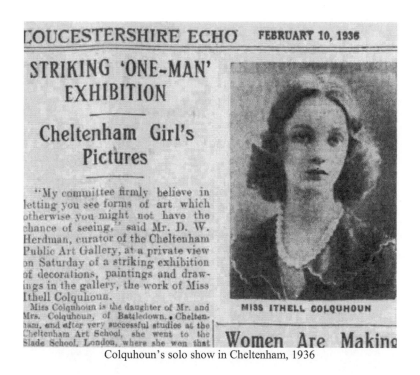

GOUCESTERSHIRE ECHO FEBRUARY 10, 1936

STRIKING 'ONE-MAN' EXHIBITION

Cheltenham Girl's Pictures

"My committee firmly believe in letting you see forms of art which otherwise you might not have the chance of seeing," said Mr. D. W. Herdman, curator of the Cheltenham Public Art Gallery, at a private view on Saturday of a striking exhibition of decorations, paintings and drawings in the gallery, the work of Miss Ithell Colquhoun.

Miss Colquhoun is the daughter of Mr. and Mrs. Colquhoun, of Battledown, Cheltenham, and after very successful studies at the Cheltenham Art School, she went to the Slade School, London, where she won that

MISS ITHELL COLQUHOUN

Women Are Making

Colquhoun's solo show in Cheltenham, 1936

Through The Quest Society, Colquhoun is also known to have been introduced to Edward J Langford Garstin, who was a member of the 'Alpha et Omega' a remnant temple of the 'Order of the Golden Dawn' (Colquhoun, 1975). Garstin, a much older man who turned out to be a distant cousin, acted as her mentor during this period: introducing her to texts such as Mather's *The Kabbalah Unveiled* and helping her apply to become a member of the Alpha et Omega. Though the application was unsuccessful, her interest in the Kabbalah, ritual magic and The Golden

Dawn was to stay with her for the rest of her life, and culminate much later in the book 'The Sword of Wisdom' (published in 1975).

After leaving the Slade, Ithell Colquhoun travelled through Europe and spent some time in Paris where she was photographed by Man Ray. In the mid-30s, at a time when she was feeling unsettled and 'under psychic attack', she visited Meredith Starr in Hertfordshire. She was very unimpressed by him (Colquhoun, 1975). [3]

Early in 1936, she had a solo exhibition in her home town of Chelten-ham (see clipping), which included paintings based on the Taro (Colquhoun's preferred spelling for Tarot). Designs for murals executed for a hospital in Gloucestershire also included Taro figures (cf Shillitoe).

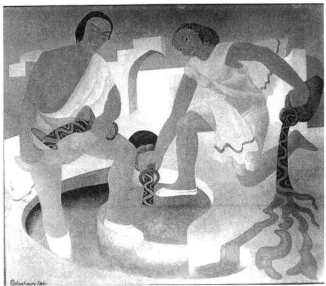

Completed in January 1936, a mural for Moreton in the Marsh District Hospital, Gloucestershire. The figures are based on AE Waite's Tarot pack.

Weeks later, in the summer of 1936, she witnessed the International Exhibition of Surrealism, and it was Salvador Dali who made the biggest impression on her:

Only in 1936 did the movement make its full impact on me; I had returned to London and was present on July 1st when Dali spoke at the first International Exhibition of Surrealism in Britain in the New Burlington Galleries. Dali, arrayed in a heavy diving-suit (skin diving gear was not yet

26

invented) entered with two wolf-hounds on a leash. He mounted the dais and tried to remove his helmet but it had stuck fast. He was beginning to suffocate when his wife, Gala...sprang up to release him...Andre Breton, robust and thickset with wavy hair of a length at that time conspicious, and others also spoke, but who could follow Dali? It seemed that he did actually evoke phantasmic presences which generated a tense atmosphere... Dali was minute, feverish, with bones brittle as a bird's, a mop of dark hair and greenish eyes (Colquhoun, 1976).

Colquhoun immediately allied herself with the nascent British Surrealist movement; a relationship cemented in 1939 when she shared a two-person exhibition with Roland Penrose at the Mayor Gallery, and had several articles printed in the London Bulletin.

Her enthusiasm for the group quickly faded however. She recalls her nemesis, artist ELT Mesens thus (Colquhoun, 1976):

Early in 1940 a Soho restaurant provided the scene for a meeting of those connected with the movement ...Attempting to form a closer organisation, Mesens announced about a dozen propositions to which members would be obliged to promise allegiance. The more important and controversial points were:-

1) Adherence to the proletarian revolution.

2) Boycott of any association, professional or other, including any secret society, except the Surrealist group.

3) Boycott of any exhibition or publication except those under surrealist auspices.

On Point 1) I explained that I had always objected to political commitments unsupported by action, and in any case, with war-time conditions no revolutionary action would be tolerated by the authorities...I further stated that effective revolutionary action was a full-time job and, therefore, irreconcilable with a creative life.

On Point 2) I said I wished to be free to continue my studies in occultism as I saw fit. (It was Mesens's quirk to oppose this aspect of surrealist activity, since Breton, Dominguez, Dr. Mabille, Masson, Seligmann and other continental surrealists pursued such researches without query).

To Point 3) I also objected because it meant not exhibiting or publishing at all, since there was then no surrealist gallery or publication in Britain, and those abroad were barred by war-time conditions.

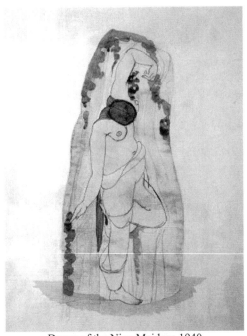

Dance of the Nine Maidens 1940

But as some doors closed, so others opened. As if precisely to assert her right to pursue her occult studies, in 1940 Colquhoun completed her first works inspired by Cornwall, specifically the Merry Maidens stone circle. It can be assumed that she visited the antiquities of Penwith at around this time, though it is known she had also visited Cornwall as a girl. Richard Shillitoe: *There is a naturalistic watercolour of the Men an Tol dated 1940, and one of Lanyon Cromlech, of the same year. So she must have been in Cornwall then. But the first trip where records survive was in 1941. In August 1941 she stayed at 1, Porthenys Villas, Mousehole and in September she was contactable c/o Mrs John, Fish Store, Mousehole. Later that month she was in West Cornwall Hospital, having broken her leg climbing on the cliffs. Her first recorded exhibition in Cornwall was in June-July 1949 at the Arra Gallery Mousehole "Exhibition of Paintings by Lamorna Artists".*

In 1942 she completed two significant paintings using Cornish subjects: 'Sunset Birth' and 'Dance of the Nine Opals'. The title of the former seems to refer to the subtle body, or higher self of the woman, who we can assume is Colquhoun herself, being delivered via the circular birth canal of the Men-an-Tol.

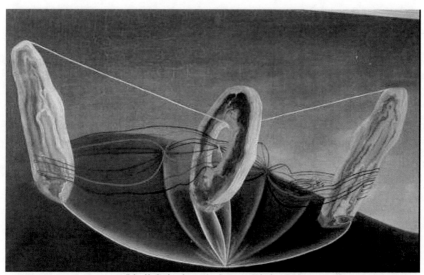

Ithell Colquhoun's Sunset Birth 1942

For 'Dance of the Nine Opals' we have the benefit of Colquhoun's own extraordinary written reflections on the work, which include reference to a 'hexentanz' (meaning witches' dance), and make it clear that its iconography was largely unpremeditated: (ithellcolquhoun.co.uk)

> When a picture comes directly from the unconscious, it is almost as difficult for the artist as it is for the spectator to say what it means. Imagine seeing a full-grown tree for the first time, without having any idea of its history or function!
>
> When unknown forms arise, they appear as any natural form might when seen for the first time; this is, in fact, what they are—forms from a super-nature which is only beginning to be explored. It is important to record these 'rocks and stones and trees' of the supersensual life.
>
> This painting, it seems to me, comes from some hinterland of the mind, some border-line region, since elements drawn from both actual and potential worlds are to be found in it. It is built from several impacted strata of material meaning:
>
> 1) Various druidic stone-circles known to Cornish folk-lore as 'Nine Maidens' (ni mén = 'holy stones'). Legend says that the circle is composed of girls turned to stone for dancing on (at) the Sabbat, and can be restored to natural shape if embraced at midnight when the moon is full. The monument is a petrified 'Hexentanz'; it is here seen as one of the 'psychic zones' of the country-side, one of its 'fountains out of Hecate.'

29

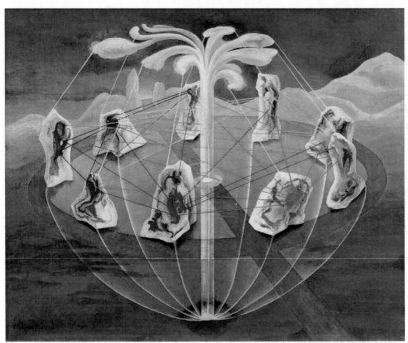

Dance of the Nine Opals 1942. Colquhoun refers to the central efflorescence as a 'fountain out of Hecate'.

2) A Celtic solar festival or fertility-rite; the Maypole's streamers are replaced by coloured 'lines-of-force' connecting the stones with the central fountain and with each other.

3) The nine planets of traditional astrology, including Pluto and Vulcan, revolving round the cohesive and dynamic force of the solar system.

4) Apollo, symbolised by the sun-burst in the centre of the ring, 'leading his choir, the Nine.'

5) The common chord, symbolised by the three tints—one of them basic- in each stone, carried through an octave, including the first two accidentals. The 'music of the spheres.'

6) Kether ('the crown') mitigating the nine lesser sephiroth—often represented in cabalistic tradition as a tree of life.

7) A supernatural flower with nine petals and fiery pistil.

8) The nine moons of pregnancy with perpetual solar impregnation.

9) The opal signifying by its combination of colours the animal, vegetable and mineral worlds. By its connection with the Zodiacal Libra, it links the whole morphological system with the idea of a balance between static and dynamic forces.

Colquhoun's comments, referring to 'psychic zones' of the countryside, and the mysterious 'fountains out of Hecate' (derived from Porphiry [4]) anticipate many of the concerns of later Earth Mysteries and Paganism.

In 1943 Colquhoun married Toni del Renzio, another renegade Surrealist, and back in London, together they antagonised those who had remained loyal to Mesens by claiming that it was they alone who had remained true to Breton's original vision.

Their marriage only lasted until 1947, however, a year in which more paintings inspired by Cornish folklore appeared, notably 'Linked Islands'. Linked Islands, too, has a commentary (published in The Glass No.1 (1948)).

In 1949, Colquhoun, acquired a property close to the stream, towards the top of the Lamorna Valley in West Cornwall. Already having been used as an artist's studio, it was clad in corrugated iron and initially had no electricity or sanitation. The process of buying and naming it is described in 'The Living Stones', published by Peter Owen in 1957:
> I called the hut Vow Cave Studio…the name is tautological, as the first word means cave as much as the second.

In a memorable first chapter she describes her feelings about Cornwall:
> 'Where am I, between east and west? A lost soul indeed. Daunted by the length and cost of the journey to the nearest of Gaeldom, I had to find somewhere more accessible that would pander to my latent thrall…
> I had stayed at Mousehole——whose name derives from the Cornish words Mo Sul, 'dear Sun'- once or twice during the war. From thence I had visited Lamorna and was overcome by its leafy water-loud charm.

> Then the Isles of Scilly supervened; once, on a brief escape from the scolding bombardment and the seamy side of the black-out curtain, I was riding in the Airport bus from Penzance to St. Just. I could see, far out beyond the landmark of St. Buryan tower, beyond the last of the land and the first of the swan, a pale crescent lying in the horizon's haze. That sandy stretch, white as coral, was the northern strand of St. Martin's isle, just visible from the mainland on a clear day. It seemed to me like a glimpse of the earthly paradise; and I remembered, ages ago, having a dream of arrival in a tiny boat on just such a shore.

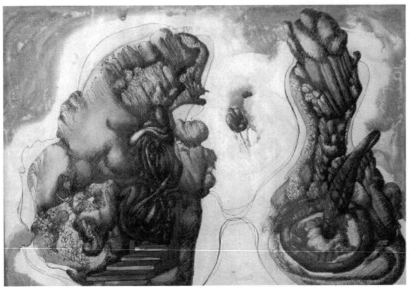

Linked Islands II (1947) presents an aerial view of St. Agnes, Isles of Scilly and interprets it as a sexualized landscape. [5)]

When the war was over and I could partially escape from my own entangled life, it was to this region, this 'end of the land' with its occasional sight of the unattained past, that I was drawn. There is some balsamic quality in the air which never fails to bring healing; after years of blitz I felt that here I could find some humble refuge from the claustro-phobic fright of cities. I determined that I would never be so trapped again.

The molecular dance of the particles composing an azure sky are best seen over Penwith's moors—as once the circulation of atoms became visible to me in the nursery-door like dazzling sap that streamed through wood long since dry. Many have remarked on the strange light which bathes this peninsula; they say it is reflected from the seas which almost surround it upon the low- sailing clouds above. The same appearance, but intensified, illuminates the Scillies; but Penwith has shade as well as light.

In Lamorna I first saw the falling of dew; and it was at Penberth that the shifting of the landscape-veil first presented itself to my clear-sight disclosing—what? Later I was told that it was in this tiny cove that the remnant of the Atlanteans, escaping from cataclysm, first landed, bringing with them primrose and convolvulus, poppy and furze.

The Living Stones is less of a travelogue than its predecessor 'The Crying of the Wind' (Colquhoun, 1955). Instead it details a number of sight-seeing excursions to other parts of Cornwall from Lamorna, such as seeing the 'Obba Oss' - *'the image of a demon'* - in Padstow, and FT Glasscock's King Arthur Halls in Tintagel.

Significantly – perversely, even, given the influence it had at the time – the book doesn't include mention of the art colony of St Ives. Cornwall-based John Tunnard, a fellow Surrealist who showed in Peggy Guggenheim's gallery in 1939, is the only contemporary artist to get so much as a name-check, but only because he *'has made a bird sanctuary on his property a little way down the lane'.*

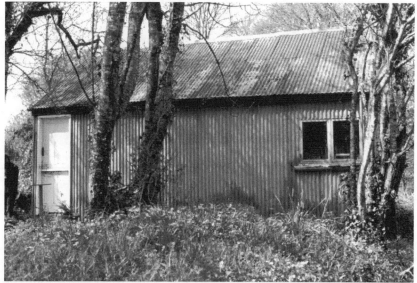

Vow Cave in Lamorna Valley in the 80s. Despite letters of protest written by Jo O'Cleirigh, it has more recently been replaced by a stone building of the same size and shape.

However, during the 50's Colquhoun's focus had moved away from painting, and she was more fully embracing Celticism, early Earth Mysteries, folklore and the occult (Amy Hale, 2012). This is reflected in the book, which indicates that, for Colquhoun, there is little separation between the physical world and the spirit world. In the chapter Lamorna Shades, for example, she suggests that Vow Cave may be haunted:

A grey-green presence from the boughs outside seeps through its frail ways; each evening the line, 'There falls thy shadow, Cynara, the night is thine', comes to my mind and I know that I am no longer mistress in my house, for another life will fill it until dawn...

At several points, whilst she doesn't mention leys, Colquhoun describes earth currents in the landscape. In the chapter featuring the Rocky Valley mazes, for example, she says:

The atmosphere (in Tintagel) resembles that of Cape Cornwall, for the same tingling magnetism reaches a terminal in each case. The current runs across England from Blythborough in Suffolk-another place of strong air and buffeting gusts, at its best in sunlight-to plunge into the sea, here and at the Cape. It reappears in the Scillies on the island of St. Helen's where a ruined chapel, but lately reclaimed from bracken, marks the spot; hence it dives again into the Atlantic, only emerging on the eastern coast of the United States. It crosses the continent to California, sinks again under water as it touches the Pacific, to regain land on the Eurasian continent, over which it passes to the Baltic and North Sea. Below these it vanishes till it surfaces again at Blythborough, having 'put a girdle round about the earth.'

This, at least, is its route according to the teaching of a hidden order whose existence and very name is known only to a few. Little can be said of it, since it is now withdrawn from human manifestation; it was however in the past the source of many mystico-military brotherhoods...

Colquhoun uses the term 'Michael-force' for these earth currents. In the chapter 'Dance to the Sun', on Helston's Furry Dance for example, she writes:

Much could be written about the Michael-force as it has been sensed in Cornwall - indeed, all over Europe, from Iceland to the toe of Italy and beyond. Some writers have suggested that this Archangel took over for Christianity some of the functions exercised in Pagan pantheons by the sun-god...The operation of this force may be traced through church-dedications, the sites of whose buildings are magnetically linked. Michael is associated with steep islands and high places, and many of his dedications are hilltop shrines.

Colquhoun's allusion to the 'teaching of a hidden order' is tantalising. The term 'Michael-force' would seem to relate back to Dion Fortune's books 'Avalon of the Heart' and 'The Goat Foot God' (published in 1934 & 1936 respectively), in which Fortune describes early Christians as having exorcised the old *'power centres'* by *'putting up chapels dedicated to St Michael'*.

34

Whilst Colquhoun would have been familiar with Fortune, and with Rudolf Steiner's even earlier writing on St Michael, in fact her own notion of the Michael-force is most likely to have been borrowed from her friend Margaret Thornley. Thornley, who was close to Glastonbury mystic Wellesley Tudor Pole, was made a bard of the Cornish Gorseth in 1953 and took the name 'Maghteth Myghal' or 'Servant of Michael'.

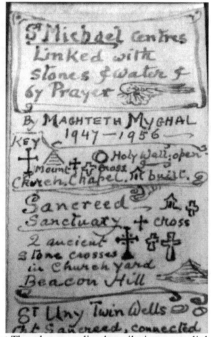

A scroll by Margaret Thornley recording her pilgrimages to link St Michael centres.

Not only was 'The Living Stones' dedicated to Maghteth Myghal, but she is thanked by Colquhoun *for lending me her unique diaries'*. These diaries are likely to have described the pilgrimages Thornley made to Michael sites all over Europe between 1947 and 1956, in order to *'link them with stones, and water and prayer.*[6]

Towards the end of 'The Living Stones' Ithell Colquhoun details a visit to witch-hunter Bill (William) Paynter in Liskeard who, like Thornley, was another bard of the Cornish Gorseth:

The traditions of folk-medicine are only just dying out, and there are still old people suffering from shingles or 'wildfire,' rheumatism or thrush who

prefer its ministrations to a 'bottle o' trade'- chemist's or doctor's medicine. An important branch of it is concerned with 'charming' and the man or woman gifted with this faculty is called a 'pellar.' In former times almost every village would have its pellar, but though charming is still practised it is becoming rare, and seems rarer than it is because both the pellar and his clients hesitate to admit their allegiance for fear of ridicule... Folk-medicine in Cornwall as elsewhere is indissolubly connected with witchcraft and constitutes a major part of the witch's stock-in-trade. The village 'wise woman' or 'cunning man' is the last repository of the traditional herb-lore handed down from Druidic times or even earlier... The witch's province extended beyond the alleviation of illness; next to the demand for healing that for love-philtres was probably the greatest.

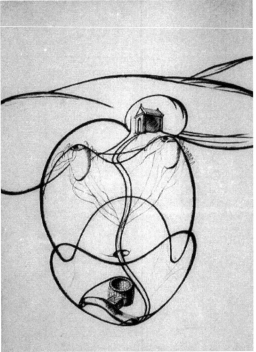

Interior Landscape 1947 Inspired by St Euny (photo Richard Shillitoe)

The cunning-folk active in the 19th and early 20th century were, almost invariably, Christians: they did not worship a pagan god or goddess, or think of themselves as belonging to a separate religion. As Colquhoun explains, however, nor either were they completely reliant on localised folk traditions:

36

The greater part of Cornish witchcraft was of that shamanistic, down-to-earth, empirical kind which is found all over the world, largely because it may be worked by those who can neither read nor write. But side by side with this, and used in conjunction with it, a more sophisticated tradition may be traced, one with a more localised appeal simply because it required literacy in the operator...

In the collection of Mr. Paynter is a Quabalistic anthology entitled 'The Sixth and Seventh Books of Moses' which contains excerpts from various grimoires like 'The Lesser Key'; and among some loose sheets of paper given him by witches I recognised a page copied from Barrett's 'Magus'. Talismans and spells in the grimoire tradition were often employed—I saw the famous formula of Abracadabra written, leaving out a letter at each line, to form an inverted triangle on a heart-shaped piece of parchment, this to be worn constantly by the recipient. Many such scraps of ceremonial magic, smelling of incense and the midnight oil of the adept's study, have drifted down haphazard to the rustic sage, to be mingled with a maternal lore redolent of the hay-field and cow-byre.

Ithell Colquhoun moved to 'Polgreen Cottage' in Paul near Penzance in 1959, later renaming it 'Stone Cross Cottage'. By then already in her 50s, she lived in Cornwall for the rest of her life.

Notes 1) Madge's fascinating guidebook is largely focussed on the magical waterfall of St Nectan's Kieve (or Glen), its depiction in literature, and the various romanticising name-changes it underwent at the hands of Robert Hawker, the poet, during the 19th century (from Nathan's Kieve, via Nighton's Kieve to Nectan's Kieve).

2) Surrealism had originally announced itself to the British public in 1936, with the International Surrealist Exhibition held at the New Burlington Galleries. It was organised by Roland Penrose (b 1900), who the following year would come to stay at Lambe Creek in Cornwall with Man Ray, Leonora Carrington, Max Ernst and other key members of the movement.

3) Starr, who had previously lived near DH Lawrence in Zennor, worked with Aleister Crowley, but is now best known for introducing Indian guru Meher Baba to the West.

4) A dream diary now owned by Richard Shillitoe and written in 1968 includes the following notes: *(I) realised that the Earth is a being, and that certain places on its surface and leading to its interior, are conducive to different kinds of esoteric perception. (Different esoteric schools?). Porphiry (was it?) called these places 'fountains out of Hecate' - this is I suppose the name of this being of Earth...They, the fountains, might be called the mundane chakras of the Earth itself using the phrase somewhat differently from Dion Fortune; marmas is the Hindu term. As the microcosmic chakras in the human body are each associated with a special perception of power so the location of each marma confers a special psychic 'world view'.*

5) Shillitoe writes on Linked Islands II: *Depending on the state of the tide, St. Agnes is two in one. At low tide it is one island, and at high tide it becomes separated into two smaller land masses, linked only by a slender sand bar. Each islet has its own gender identity. St. Agnes is the site of a holy well, shown on the left of the painting. Water, as always in Colquhoun's work, symbolizes the female force. The islet of Gugh on the right, with its prehistoric phallic menhir known locally as the Old Man, is the male counterpart. When, at low tide, the two are united in conjunctio, they become the 'hermaphrodite whole' of the alchemists.*

6) In 'Michael: Prince of Heaven (1951)' Tudor Pole, who is known now for his work in preserving Chalice Well in Glastonbury, advocated making pilgrimages to Michael sites, in order that the shrines *'become centres of great spiritual illumination once more'*. This was something Margaret Thornley, who was living in Carbis Bay, commenced from 1947 when her husband died. For about a decade she visited Michael sites all over Europe transferring waters from sacred site to sacred site in her devotion to the saint. 'Michael: Prince of Heaven' includes contributions by others from Cornwall including artist Hyman Segal and Cornish revivalist Robert Morton Nance.

2. WHYLER-PYSTRY

First, I paced and measured out my circle on the grass. Then did I mark my pentacle in the very midst, and at the intersection of the five angles I did set up and fix my crutch of raun (rowan). Lastly, I took my station south, at the true line of the meridian, and stood facing due north. I waited and watched for a long time. At last there was a kind of trouble in the air, a soft and rippling sound, and all at once the shape appeared, and came on towards me gradually... (Rev Hawker, 1870 describing an exorcism that is said to have taken place on January 12th 1665).

William Paynter (b. 1901), having languished in obscurity for many years, has recently been the subject of an in-depth study that adds much to Colquhoun's account in The Living Stones (Semmens, 2008).

A B R A C A D A B R A
- - - - - - - - - - - - -

or

THE CONFESSIONS OF A WESTCOUNTRY WITCH-FINDER
- - - - - -

BY

WILLIAM H. PAYNTER

(Whyler-Pystry-Searcher-out of Witchcraft).

Written in 1939, but only published by Jason Semmens in 2016, the original manuscript of WH Paynter's account of traditional witchcraft practices continuing well into the early 20th century.

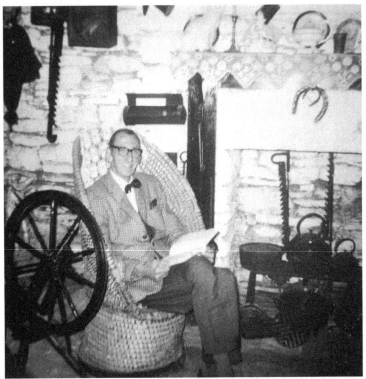

Bill Paynter sat inside the 'Cornish Museum' in Looe c1960. Cecil Williamson's Museum of Witchcraft (then called 'The House of Spells') may have occupied the same site for a short period before moving to Boscastle.

Born in Callington, in East Cornwall, Paynter started systematic folklore-collecting following encouragement by artist and Cornish revivalist Robert Morton Nance in the mid-twenties. Morton Nance had founded the first 'Old Cornwall Society' in St Ives in 1920. Paynter would follow his example by starting up a branch in his own home town and as a result of these activities, which included helping to revive mid-summer bonfires, he was made a bard in 1930. He took the bardic name 'Whyler Pystry' or 'Searcher-out of Witchcraft'.

During his lifetime Paynter published several guides and booklets aimed at the burgeoning tourist market. Most popular of these was a reprint of John Wesley's 'Primitive Physic', a collection of herbal cures and folk remedies originally compiled by the Methodist preacher in 1747.[1)]

Despite Colquhoun's attempts to broker a book deal for him with her publisher Peter Owen, the witchcraft research for which Paynter was best known was not published in one volume during his lifetime. Instead, it appeared in numerous separate articles in local and regional newspapers.

Some of the earliest pieces were, for example, short reports relating to the clairvoyant white witch Tamson Blight (or Tammy Blee) of Helston, who was famously able to use her psychic powers to repel, or reverse, the effects of ill-wishing (Western Morning News 4th June 1928).

From 1929 onwards Paynter gave lectures and even had a regular radio slot. He did not report on historical accounts of witchcraft, such as the 17th century witchcraft trials held at Launceston Assize courts, but focussed more on the present and recent past. (artcornwall.org)

For more than a decade, his work would enhance Cornwall's reputation as a haven for the on-going practice of witchcraft. However with the increasing spread of modernity in the post-war period (electricity, the NHS etc) his informants and source material started to dry up. Jason Semmens puts it thus:

> Belief in witchcraft, ill-wishing and the malignant power of the Evil Eye as an explanation for persistent illness and misfortune amongst humans and domesticated animals had held sway in Western Europe for several centuries....(But) by the 1950's notions of ill-wishing were increasingly rarely met with. Put simply, witchcraft withered away because it ceased to be a relevant or viable explanation for misfortune... Paynter's writings chart the eventual collapse of witch-beliefs in Cornwall...such that in 1969 (Cornish Review 13) Paynter could declare that 'witch-belief in its traditional form appears to have gone for ever...' (Semmens, 2008)

After he retired in 1959, Paynter opened the 'Cornish Museum' in a fish cellar in Lower Street, East Looe (see photo). At the time Ithell Colquhoun met him he had already amassed a large collection of objects that made for suitable exhibits. This included items like the mounted fragments of Tammy Blee's scent bottle.

The museum generated a lot of publicity, and Paynter made several TV appearances whilst sitting on a wicker chair inside it. In one of them, a BBC documentary 'The Power of the Witch' (1971) he is seen, with his distinctive bowtie and Roman nose, demonstrating some of the items in

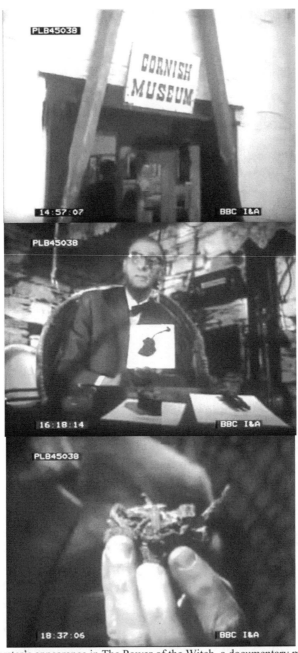

William Paynter's appearance in The Power of the Witch, a documentary made in 1971 by the BBC, that also included Doreen Valiente, Alex & Maxine Sanders, Cecil Williamson, Eleanor Bone & fellow folklorist Theo Brown.

the collection. One of them is a lumpy, black, shrivelled heart, which he holds up to the camera: *People often had their cattle ill-wished, bewitched or over-looked. They were told 'take the heart of the animal that had met with the mysterious end, pierce it with nails and pins and horse-shoe nails and put it in a chimney and all will be well'.*

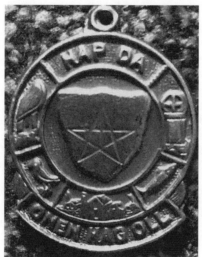

The brass Hap Da (or 'Good Luck') talisman, designed by Paynter, was sold at his museum in Looe. Photo Jane Cox.

Unfortunately, Paynter's museum has now been largely forgotten: upstaged by a more renowned and enduring attraction in Boscastle opened by film-maker and spy, Cecil Williamson in 1960.

Notes 1) Semmens (2008 – drawing from eg Davies, 1999) describes a synergistic relationship between Methodism, which was taken up enthusiastically in Cornwall, and witchcraft:

'In its early days, before it began to court mainstream respectability, Methodism was blamed by the Anglican Church for fanning superstitious beliefs in witchcraft, owing to its tenet of the active involvement of Satan in the affairs of men...However it would be more accurate to say that it was the continuation of popular beliefs in the supernatural during the eighteenth and nineteenth centuries that enabled Methodism to gain such a strong foothold in Cornwall'.

3. The Cloak of Delusions

William Paynter, who lived in Cornwall for his entire life, was an impartial observer of witchcraft, rather than a practitioner. This is not true of Cecil Williamson, however, whose relationship with the Occult was far from straight-forward.[1]

Williamson was born in Devon in 1909. Once, when staying with his uncle in North Bovey as a seven year old, he witnessed an elderly woman being assaulted by a gang of 4 or 5 farm-workers:

> ...to my surprise I saw a dear old soul who I knew as 'Aunty' on the ground and they were stripping her completely naked... And here was this poor old woman that I knew, who lived in a cottage just by the entrance to the Vicarage, with her clothes pulled up over her head. So I ran up to her as a kiddy might do, because she had always been kind to me, and I threw myself upon her... I found later that these agricultural workers...thought this little old dear had put a curse or something on their cattle. They were saying she was a witch and they were looking for the devil's teat.
> ('Conversation with Cecil Williamson' Talking Stick 1992)

It was a formative event in his life, and a story that Williamson often retold. Later, despite the age gap, Aunty and he became friends and she taught him *'a little about witches'* and how to *'tickle trout'*.

After boarding school at Malvern College, Williamson worked in a tobacco plantation in Rhodesia. Here he befriended another witch, this time a witch-doctor called Zandonda, who *'together with his brother craftsmen, unlocked and opened the door for me to step through, into their secret world of Never Never land'* (Patterson, 2014).

Williamson subsequently returned to Britain and worked for a while in the film industry. As a result of this he met his wife Gwen, who was a make-up artist, but as the war approached he was recruited by Dion Fortune's brother-in-law, a Colonel Maltby, to assist MI6 in their spying operations.

In 1938 Williamson set up a 'Witchcraft Research Centre', in what appears to have been a cover for this work for the foreign office. This work, which included broadcasting propaganda and disinformation, continued through the war.

Cecil Williamson inside his museum in Cornwall c1970

After being demobilised, in 1947 Williamson opened his first museum in Stratford-on-Avon using artefacts collected throughout his life, but it was a short lived affair and he was quickly run out of town.

In 1950 he and Gwen moved to Castletown on the Isle of Man and tried again. The Museum, which opened in the summer of 1951, was initially called 'The Folklore Centre of Superstition and Witchcraft', and it included a number of elaborate displays including the reconstruction of an entire Golden Dawn temple, made with the help of Steffi Grant, wife of occultist, Kenneth.

Shortly before the museum opening Williamson recalls going to greet an unexpected visitor, and *'being confronted by the pathetic sight of Dr G Gardner with a music case that had his pyjamas and a toothbrush in it'.*[2]

Gerald Gardner's first book, a novel with witchcraft as its theme called 'High Magic's Aid', had been published in 1949. It was put on sale in the museum, and Gardner was taken in and installed as the 'resident witch': a visitor attraction in his own right.

It was during this period that Gardner wrote the hugely influential book 'Witchcraft Today', regarded by many as the founding text of modern Paganism. As Williamson recalled many years later: *I was there – I, as it were, held the scissors and thread, ready to pass it to the great man as he stitched together his cloak of delusions'* (Patterson, 2014)

Williamson and Gardner became formal business partners in 1952, but after two years, as a result of financial pressures, they fell out and, famously, Gardner attacked Williamson with his athame or ritual knife. Williamson ended up selling his share of the business to his rival who remained in charge of the museum on Man until he died in 1964.

In a letter dated June 16th 1954, Ithell Colquhoun wrote to Williamson in order to organise a visit to the museum. He replied:

> I am sorry to report: for your sake, that my collection is not on exhibition this year, by reason of the fact that Dr G Gardner has taken over the establishment... As we are on anything but good terms I shall make no comment ...But don't let that stop you seeing and hearing what he has to say, it is an experience to be taken with a pinch of salt, a rather large one – then it can be quite a lot of fun.
> Yours Sincerely
> Cecil H Williamson. (letter in MoWM)

Colquhoun did manage to see Gardner's museum, and her account of it appeared in 'The London Broadsheet' in 1954. In the article she gives a comprehensive account of Gardnerian witchcraft - which at the time was still a novelty:

> Witchcraft is a Dionysiac cult of nature-mysticism, and what remains of it today is a genuine folk-survival from the Stone Age. It has no connection with the 'Black Mass' which is obviously a post-Christian phenomenon; and little with Ritual Magic which evokes spirits to obey the operator's will. Rather, it is shamanistic, developing little-known powers of the human body and mind to achieve its effects.

CALLING ALL COVENS

Castletown, I.O.M.

ANY practising witch who can rev up her broomstick in time should take off immediately for Sunday lunch in a weird old mill in this town. All witches are welcome.

They will be greeted by the resident witch, who is not a woman but a man—he says a wizard is a different cauldron of fish.

The master of magic is white-haired Dr. Gerald B. Gardner, 67, who will declare open the Folklore Centre of Superstition and Witchcraft. Then, under the same roof as a scarifying collection of bones, charms and evil eyes, lunch will be brewed.

The witch-doctor—a doctor of philosophy from Singapore and a doctor of literature from Toulouse—is a member of the Southern Coven of British Witches.

"Of course I'm a witch," he told me. "And I get great fun out of it."

13 WITCHES

A COVEN of witches normally consists of thirteen officers with a chief. They work at weekly meetings called Esbats but come together with all the other covens in the great quarterly meetings called Sabbats — the Witches' Sabbaths.

by
Allen Andrews

"Great fun," says Dr. Gardner, his eyes twinkling.

If the witches are feeling particularly festive they do not wait until "quarter day." There is generally some ritual anniversary that can be celebrated. "Suppose you feel like a bit of a binge," said Dr. Gardner. "You just call up the others and have some fun."

They do not call each other by telepathy, or supernatural means.

"It might come off," said the doctor, "but it's much less trouble to send a telegram."

CAPERS

THE resident witch of Castletown once attended the ritual of the Winter Solstice, when the witches caper with torches round a fire on the year's shortest day, lamenting the loss of the sun. Gradually they break into a dance which grows more and more exciting as they implore the sun to return.

"A very pretty ceremony," he said. "Luckily, we found a place to do it. Because, of course, if you did it in a back garden in Tooting you'd have the police and the fire brigade on you in no time."

One of Dr. Gardner's regrets is that the tunes of the witches' dances have

not survived. "With the advance of modern science," he said ruefully, "I'm afraid we just tend to turn on a gramophone. Any music will do — Debussy's L'Apres Midi d'un Faune is good."

In the Folklore Centre is a floodlit memorial to the nine million witches who were tortured and killed in Europe through the centuries, some of the torture instruments are in a case.

OOH! ER!

OTHER exhibits are the skeleton hand of a murderer, a collection of lucky charms, and a magic sign written on human skin.

A complete witches' temple has been reconstructed, with highly coloured sorcerers' designs around a magic circle—in the middle is an altar.

"We had trouble with that altar," said Mr. Cecil H. Williamson, the forty-six-year-old former film producer, who is running the Folklore Centre.

"It had to be the exact height of a witch's navel. I worked out that the average man's navel is 40in. off the ground."

The ground floor of the museum is a "Witch's Kitchen," where meals are served.

Here Mrs. Williamson will serve a special "Witch's Brew" at 3s. 6d. per potion.

"I THINK IT WILL HAVE A RUM BASIS," SHE SAID.

Sunday Pictorial 29/7/51. A light-hearted feature announces the opening of the 'Folklore Centre of Superstition and Witchcraft'. Gerald Gardner is described as the 'Master of Magic'.

Like Ritual Magic, Witchcraft uses the Circle; but whereas for the Magician this is a defence against hostile forces, for the Witch it is a psychic accumulator for conserving and directing the power raised by the coven. While the Magician often works alone or with a single assistant, the Witch, who may be of either sex, is gregarious, for the ritual demands a group of participants. The magician in operation is appropriately and sometimes gorgeously robed, but in the coven nudity is insisted upon because clothes inhibit the forces latent in the vitality-aura from which 'the power is raised'.

48

Two chief deities are worshipped - the Moon in her Hecate-aspect, the 'Triple Goddess' or 'White Goddess' of Robert Graves' study; and a Horned God who is night, 'Death-o-what lies beyond', almost the 'Baron Samedi' of Voudoun. Although each is allotted two yearly festivals, the Goddess is the favourite, as one might expect in a cult deriving from a matriarchal epoch; and all the monthly Sabbats take place at full moon.

This account is true to Gardner's own description of Wicca, or Wica as he called it in 'Witchcraft Today', which was published the same year as Colquhoun's visit.

In his book Gardner speaks as if with the voice of the Castletown museum guide. He describes himself as an anthropologist who has befriended a coven of witches and won their goodwill and confidence. In the process of revealing their beliefs, he again reasserts that witchcraft is a folk-survival from the Stone Age.

The provenance of modern witchcraft is a point of controversy, and its claims to being of great antiquity, have been important to its success and popularity. Whilst aspects of witchcraft are undoubtedly of ancient origin, key features of Gardnerian Wicca, like the liturgy and the blindfolded initiation ceremony (incorporating a five fold kiss), are of modern origin and borrow directly from Freemasonry and ritual magic (Valiente, 1989).

Gardner's pairing of god and goddess appears to have been particularly influenced by three writers, who in turn would have drawn from Sir James Frazer's 'Golden Bough'. They were Robert Graves - as mentioned by Colquhoun - together with Dion Fortune and Egyptologist Margaret Murray (Hutton, 1999).

It was Murray who also did most to promote the concept of witchcraft as a survival of an old religion, rather than the assortment of folk medicine and superstition described eg by William Paynter.[2] In 'Witch Cult in Western Europe' (1921) - academic in tone if not in method - she emphasised that victims of the early modern witch trials had been practitioners of a fertility cult focused on a horned god, that represented the generative powers of nature, who held sabbats on the old quarter days (of Candlemas, May Day, Lammas and All Hallows).
It was therefore Murray's ideas that formed the main fabric of Gardner's 'delusional cloak'. Certainly her thesis has been discredited in recent years, but as Hutton explains, at the time:

'It appealed to so many of the emotional impulses of the age; to the notion of the English countryside as a timeless place full of ancient secrets, to the literary cult of Pan as its deity, to the belief that until comparatively recently Christianity had represented only a veneer of elite religion covering a persistence of paganism among the masses, and to the characterisation of modern folk customs as survivals from that paganism'(Hutton, 1999).

1e Wishing Well

Gerald Gardner on the site of his Museum of Magic and Witchcraft, Isle of Man (from a postcard).

Cecil Williamson, after his bust up with Gardner, left Castletown, and moved his version of the museum to Windsor, and then to Bourton-on-the-water in the Cotswolds. He had more correspondence with Colquhoun in 1955 (Sept 18th) at around the time of the second move:

…I should welcome any assistance or contributions of knowledge which you may care to make. In fact when I am settled in Bourton I am seriously considering the formation of a study group. This I feel may well appeal to you.

50

Unfortunately in Bourton, as well as in Windsor, he was made unwelcome and he eventually relocated to Cornwall, opening the 'House of Spells' in Looe in 1958, as well as other attractions including the Museum of Smuggling, House of Cats, House of Shells, and the Museum of Sorcery in Tintagel (Hale, 2004)[3]. His witchcraft museum in Boscastle - the only of his museums to survive - was opened in 1960 as 'The Witches House'.

Colquhoun corresponded with Margaret Murray herself in 1960. Then, in 1963, when she was more settled in Cornwall (having moved to Paul near Newlyn in 1959), she once again wrote to Williamson. This letter from her to him, dated 1963, suggests that she was finding it hard to adjust to aspects of life in Cornwall:

> So far I have not been able to contact any occult group in the neigh-
> bourhood; it would surprise me if none exists, as the countryside seems full
> of power which I feel sure could be used if one knows how to do it. Can
> you suggest any contacts? Are there for instance any Tanats in the region?
> I would of course be very discreet about information.

Precisely because of the geography of Cornwall and its scattered population, it is unlikely that there were any established occult groups, comparable to The Quest or Golden Dawn, in Cornwall in the early 60's. There would have been several active Freemason and Comason lodges, and in fact, in 1963, Colquhoun joined one based in Tintagel, called The Lodge of the Holy Grail No.5 (Hale, 2004, ithellcolquhoun.co.uk).[4]

Colquhoun appears to have narrowly missed artist Pamela Coleman Smith. In 1909, Smith designed the well-known Waite-Smith tarot pack, having been an influential member of The Golden Dawn. She moved to Parc Garland on the Lizard in 1918, then to Bude in 1942, where she died in 1951.

At some point, probably later in the Sixties, we know that Colquhoun managed to befriend occultist Aleister Crowley's family in Cornwall, however. Crowley's favourite son Gair MacAlpine, nick-named by his father 'Aleister Ataturk', had been born in 1937, and lived in Newlyn with mother Pat Doherty (Newman, 2007).[5]

Other witches passed through Cornwall during the immediate post-war period. Gavin Frost, a controversial Wiccan who later started the 'Church and School of Wicca' in the US, claimed to have been intiated

51

into witch-craft in 1948 by a coven at Boskednan stone circle whilst a student at King's College, London University. Wiccan Brownie Pate, who lived in Hayle and was a close friend of both Williamson and Colquhoun was, by coincidence, self-initiated after correspondence with Frost's organisation.[6]

In addition Ray Howard of the obscure 'Coven of Atho', had a house in Crantock near Newquay in the early to mid-sixties (Bourne, 1998).

The Tanats, to whom Colquhoun's letter refers, may never have existed, however. Certainly it has been hard to prove or disprove their existence. From the time that Williamson's museum was in Bourton, it contained an elaborate tableau featuring a scantily clad figure spread-eagled on an altar that was described as a priestess of the Coven of Tanat. According to the museum display-label:

> The Tanats are still to be found in South and West of England. This cult believes in and practices ancient fertility magic…In all Tanat ceremonies a woman's body is used as an altar or table on which the offerings are made and magic worked…

Aleister Crowley on holiday in Cornwall visiting his son Ataturk (1938). From Colquhoun's Sword of Wisdom. Crowley died in 1947.

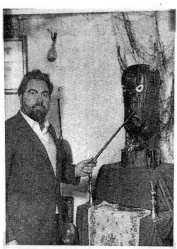

Ray Howard with the head of 'Atho'. The head was designed to house a candle, so that its red eyes would glow in the darkness.

Tanat (or Tanith) was a Phoenician Moon Goddess, and there has been speculation that, many centuries ago, Phoenician traders may have introduced her worship to the Cornish. However whilst questioning why Williamson should want to go to such ends to invent the practice, researchers like Steve Patterson, have struggled to verify it continuing into the 20th century: *He's taken the secret about the Tanat to his grave. Ithell asked to be introduced to the Tanats, and Cecil wasn't best pleased. That was the last correspondence, and after that I think they fell out.*

Williamson's museum in Boscastle did not receive any public funding, and so, like his other ventures, its viability was dependent on ticket sales. The displays were not for the *'benefit or pleasure of living witches'* and they did not need to be historically accurate. Rather, like Hammer Horror or Dennis Wheatley, they tended to pander to 60's popular taste: many of them exploiting the salacious and titillating aspects of witchcraft, and using shock-tactics to attract tourist-visitors.

Setting aside Williamson's motives as a business man, aspects of his involvement with witchcraft and the occult were sincere, however. As a magician, Williamson was a solitary practitioner, and was known to openly converse with his 'familiar spirit', or shadow. It was this spirit-world of the wayside witch, which he felt Gardnerian Wicca had overlooked to its detriment (Patterson, 2014).

53

Another of the tableaux in Williamson's museum alluded to this. It was an angular metal bed suspended from the ceiling, used as a way of contacting spirits by inducing mystical out-of-body experiences. Williamson's museum label explained it thus:

'In all their works of witchcraft the witches rely upon and seek the powers and the cooperation of the underworld. To make and develop these contacts the witch has to surrender, and offer herself to the powers of darkness. The most effective means of doing this is by the method shown here of the Witches Cradle'

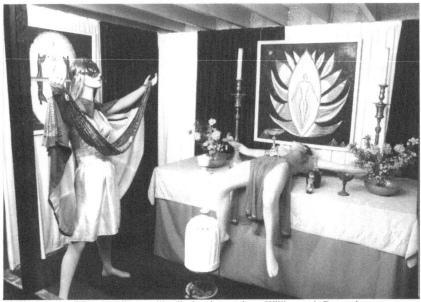

The Temple of Tanat: A diorama-like display downstairs at Williamson's Boscastle museum

Williamson's own spiritual views remain difficult to pin down. Writing later, in the 80's and 90's, he appears to focus more on the landscape and on the way earth energies manifest in particular locations, which he refers to as 'pulse spots'. Describing ways of contacting the spirit world in such places, he says:

when a West Country witch wishes to draw to her spirit forces when working in the open countryside, she makes use of a Wind Roarer, being a flat section of shaped hard wood secured to a length of stout pliable string which is then rotated at arms length at spend around the head. The sound emitted varies in its pitch depending on the blade size…By this means

54

strange wailing sounds can be created. Little wonder that the spirits come flocking in to see what the ghastly noise is about.

He increasingly emphasises the numinous power of the ancient landscape:
The man-made message of the standing stones (was) written on the landscape thousands of years ago. The West Country witch understands the message of the stones and those who by sweat and strength set them up to stand for so many centuries.

Some may take issue with these confident assertions about the West Country witch. None of Paynter's informants a few decades earlier reported using a wind-roarer, for example, nor would they have necessarily had a significant relationship with prehistoric sacred sites.

However, if Williamson's emphasis shifted during his life, this should not be surprising. Neo-paganism grew exponentially during this period, and it too, changed with the times. Its growth, and its spread to other countries, was fuelled by the publicity Wicca received in the media, particularly in the tabloids, during the 60's and 70's. Ronald Hutton later said Wicca *'is the only religion England has given to the world'*.

Ironically, given his eventual antipathy to Gardner, it was a process very much set in motion by Cecil Williamson himself. As early as 1952, whilst still on the Isle of Man, more than ten photographs oozing with shadowy atmosphere appeared in the magazine 'Illustrated'. These all feature Williamson - who is described as a 'witchcraft consultant' - wearing ceremonial garb (a long dark cloak) and making a poppet. In one of them, for example, he *'has appealed to the spirits for power'* and *'breathes through a straw into the mouth of the poppet. This symbolic rite gives it life'*.

Doreen Valiente describes that it was through seeing this particular article that she was first made aware of modern witchcraft, and she contacted Gerald Gardner after writing to Williamson at the museum (Valiente, 1989). She would go on to become initiated into Wicca by Gardner the following year, and to help write the seminal Gardnerian 'Book of Shadows'. She ended up becoming Wicca's most important female advocate.

Gardner himself later appeared on the BBC TV show, 'Panorama' (1958) as well in numerous newspaper articles. The pattern of new initiates being recruited through the media, continued even after Gardner died in

1964 (Howard, 2009). Arnold and Patricia Crowther, initiated by Gardner in 1961, were approached for initiation by Alex Sanders, who in turn initiated Stuart and Janet Farrar [7]. All made TV appearances, wrote books and, in general, worked hard to find publicity for themselves and their beliefs.

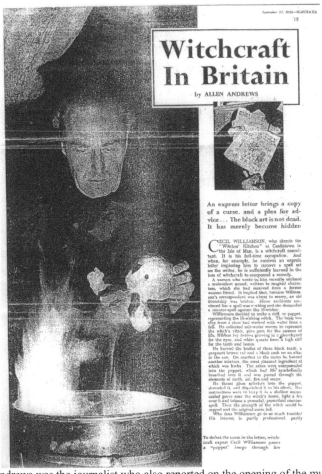

Allen Andrews was the journalist who also reported on the opening of the museum in 1951. This illustrated 5- page article describes active covens all over the country, but, interestingly, there is no mention of Gerald Gardner.

In fact Alex Sanders, to the dismay of parts of the emerging pagan community, took this to new extremes, controversially announcing himself to be 'King of the Witches' in the mid-sixties, and becoming

involved in exploitation films like 'Eye of the Devil' (1966) with ill-fated beauty Sharon Tate, 'Legend of the Witches' (1970) which includes a section on the museum in Boscastle, and Secret Rites (1971) an X-certificate quasi-documentary.

Jo O'Cleirigh is a pagan who lived in West Cornwall for many years. He expresses a typically ambivalent view of Alex and Maxine Sanders who moved from Manchester to London in 1967: *In the 60's I lived in Ladbroke Square so was very near them. He was a big self-publicist, which put me off. I remember seeing a poster in Atlantis bookshop. He was going to hold a meeting and it said 'Dare you meet Europe's Most Powerful Witch?'. I thought it was a bit embarrassing. But he did make an important contribution. We have strange bedfellows in Paganism! A lot more people got into the craft because of him.*

Doreen Valiente has her own recollection of the London 'scene' in the late 60's: *There were many people in London who were sympathetic to witchcraft and looking for initiation. In 1967 the hippy era was in full swing. It was a time of spiritual revolution, especially among the young. The sixties search for peace and love may have been naïve but it was eminently worthwhile, and some of the things achieved in that magical time have endured. The world has never been the quite the same again.* (Valiente, 1989)

Notes 1) William Paynter's more 'straight-forward' approach to his material was no doubt reflected in the contents of his museum. As Jason Semmens explains (pers comm): *Williamson and Paynter corresponded and I presume met in the early 1960's. I think Paynter did try to be helpful to Williamson but understood Williamson's approach to the subject, which was not his own: with Paynter it's clear he interpreted his sources according to his understanding of folklore rather than producing a completely dispassionate record, but he did aim to be accurate with the materials he gathered.*

2) Interestingly towards the end of his life, Paynter expressed sympathy with Murray's description of witchcraft as a 'Dianic' cult.

3) In a letter in Tate Britain archive, from Cecil Williamson to Ithell Colquhoun, dated 6/10/63 Williamson uses headed paper: "Cecil H Williamson. The Smugglers Rest, Polperro, Cornwall. Proprietor of the Museum of Witchcraft, the Museum of Smuggling, The House of Cats, the House of Shells, the Hangman's House, The Witches' House"

4) As pointed out by Hale (2004) this is not to be confused with the better known chivalrous order based at Frederick Glasscock's King Arthur's Halls in Tintagel, 'Fellowship of the Round Table' which ceased in 1936.

5) Pat Doherty had been introduced to Crowley whilst still a teenager by Robin Thynne, Crowley's publisher then living in Trevithal outside Mousehole. Colquhoun would write about them both - an account based mainly on quite intimate discussions with Pat - in an article that was published a few years ago (Colquhoun, 2011 & Newman, 2007).

6) A memoir written by 'Sylvanus' in the MoWM indicates that he met Pate in Lancashire around 1980, when she already held a diploma from 'the American School of Wicca'. Pate, born on 3/4/22, served as a nurse during WW2 then, after an unhappy first marriage, married Norman Pate and came to live in Cornwall (1960s?). She worked as a ballet-teacher in Hayle (whilst living in Black Rock near Praze?) but this ended when the papers exposed her as a witch. Pate moved to Bodmin (to a house in which Jo O'Cleirigh recalls staying) then, after Norman died, to Lancashire, but she returned to live near Williamson in Devon towards the end of her life. She died on 4/5/06.

7) Sanders approached Patricia Crowther in 1961 after seeing her on TV. She then introduced him to other Gardnerians that she knew. As Ronald Hutton highlighted to me (pers comm.): *Crowther did not initiate Alex Sanders: had she done so, the history of Wicca would have been different. She turned him down, and he was (according to his high priestess at that time, Pat Kopinski or Kopanski) initiated by a Derbyshire Gardnerian high priestess who took the name of Medea.*

4. Conceptual cauldron

'In the Sixties there was a general rebirth of interest in occultism along with leys, UFOs, and a multitude of other formerly ignored or 'taboo' topics, and the fledgling area of Earth Mysteries began to cook in the seething conceptual cauldron of the psychedelic decade' Paul Devereux (Shamanism and Mystery Lines, 1992)

Although now settled in her cottage in Cornwall, in 1961 Ithell Colquhoun managed to visit the Brittany Gorseth with druid Ross Nichols[1] and had a short but haunting Surrealist novel published ('The Goose of Hermogenes').

The novel, which details a visit of the female narrator to a magic island, had been written several years earlier and extracts were published in 'The London Bulletin' as early as 1939. Richard Shillitoe: *It is an allegory of the alchemists' quest, whether that be regarded as the elixir of life or spiritual purification...Some passages are clearly derived from dreams, but as no working drafts survive, her method of composition is not recorded* (artcornwall.org).

Then in 1967, the year Alex and Maxine Sanders moved to London, Colquhoun received an unexpected delivery. The most famous painting of the Victorian Occult revival, Moina Mathers' portrait of her husband McGregor Mathers, had inexplicably been donated to her by a *'relation of Mrs Weir'* who had offered to send it to her *'rather than put it on the bonfire'* (Colquhoun, 1975).[2]

1967 was the year 'Ritual', a novel set in Cornwall by playwright David Pinner, was written. It was later made into the film 'The Wicker Man' (1973). 1967 also saw The Beatles and Donovan travel to an ashram in India to learn transcendental meditation. Significantly they'd been introduced to LSD the year before, and as evidenced by the films 'Magical Mystery Tour' (1966) and 'Wear your Love like Heaven' (1967) - both shot in acid-drenched colour in Cornwall - their work was becoming more surreal and more psychedelic.

Occultist MacGregor Mathers painted by his wife Moina. From 1967 this oil-painting
was in the collection of Ithell Colquoun.

The doctor and social reformer Havelock Ellis was the first person
outside America to report taking mescaline, the naturally occurring
hallucinogen often compared with LSD. As with all his books, he wrote
up his experiences in his little studio in Carbis Bay, near St Ives, and the
results were published in the Lancet in 1897:

> It is clear from the foregoing descriptions that mescal intoxication may be
> described as chiefly a saturnalia of the specific senses, and, above all, an
> orgy of vision. It reveals an optical fairyland, where all the senses now and
> again join the play, but the mind itself remains a self-possessed spectator
>It may at least be claimed that for a healthy person to be once or twice
> admitted to the rites of mescal is not only an unforgettable delight, but an
> educational influence of no mean value.

Mescaline was later taken up by Aldous Huxley who, inspired
particularly by William Blake and Henry Bergson (coincidentally Moina

Mathers' brother), took the view that the brain's function is, in the main, eliminative and not productive: ie it is a 'reducing valve' that tends to restrict consciousness. Huxley considered that mescaline works by allowing the mind to access a greater degree of awareness, by enabling 'Mind at Large' (Huxley, 1954):

> According to such a theory, each one of us is potentially Mind at Large. But in so far as we are animals, our business is at all costs to survive. To make biological survival possible, Mind at Large has to be funnelled through the reducing valve of the brain and nervous system. What comes out at the other end is a measly trickle of the kind of consciousness which will help us to stay alive on the surface of this particular planet.

Huxley's experimentation in the fifties inspired other writers, like psychologist Timothy Leary, and inquisitive beatniks and bohemians like Cornish artists Bryan Wynter and Roger Hilton. (Wynter, for example, was introduced to mescaline as early as 1954 (Michael Bird, artcornwall)).

By 1967 LSD, a hallucinogenic drug more potent than mescaline, was being actively promoted in the US by the likes of writer and 'Merry Prankster' Ken Kesey, who drove from West to East coast in his brightly painted school bus called 'Further'.

It was also made more available in the UK, thanks to the 'World Psychedelic Centre', which was set up in Chelsea by Timothy Leary's collaborator, Englishman Michael Hollingshead. Both men encouraged the use of mantras, mandalas and a spiritual guide or guru whilst tripping out on the drug. They also adopted Leary's radical injunction to 'Turn On, Tune in and Drop out'.[3]

The spiritual revolution to which Doreen Valiente refers was therefore, of course, partly chemically-induced. Though many who used LSD now play down its significance, Paul Devereux, a key earth-mysteries writer who moved to live in Penzance in the late 80's, considers his experience with the drug as having changed the course of his life. He was at Ravensbourne College of Art at the time: *I was in on 'Swinging London' before it became a fad. I had a profound experience under LSD. I'd written to Aldous Huxley asking 'where could I get hold of that mescaline that you talk about in 'Doors of Perception'?', and he did actually write back.*

I ended up having some Sandoz LSD dribbled on three sugar cubes, but I didn't know anything about dosage. One cube would have given a heavy trip, but I tossed all three back. I went on a serious trip, that yielded both deeply mystical and occult experiences. In the occult phase, I could see auras around people, and for a period in the trip I had X-ray vision. The more profound part of the experience, though, was the mystical – I went beyond, outside, time and space; I died to my ego, I went somewhere without myself, so to speak, and encountered an almighty power, a force that underlies all existence. This was March 1966. I had some experimentation afterwards as well, but nothing was as massive as that first one.

Devereux recalls another life-changing experience that led him, like many of his peers at the time, to voraciously explore all the available literature on UFO's: *In May of 1967 I had an extraordinary, non-drug experience that triggered a mild mental breakdown. I was working late for the Diploma show in the top floor studio of the college, about four storeys up. There were a few of us working away. I moved to the north-facing window to mix some paints in daylight (it was about 6PM) when something caught my eye. I looked up, and from the north heading south towards the College was an orange glow in the sky. As it got closer it was clear that it was a perfect - I mean perfect - rectangle of orange-coloured light, and it was pulsing. It came to a halt over Bromley Common. It was a glowing upright rectangle, like a flaming door in the sky.*

People came onto the car-park below, pointing up at it. I hoarsely called out to the others in the studio: 'Come and look at this!'. Nobody bothered at first, but I shouted out again and they caught the urgency in my voice, so moved over to the windows. As we all looked in awe, I glanced sideways at my companions. I found it was true - when people are amazed their jaws do drop open! It didn't fly away, it went through some remarkable shape changes, and finally faded to a rosy smudge in the sky. The next day word about the phenomenon had got around, and someone who hadn't seen the thing asked if I'd seen a UFO. I don't know if it was a UFO, but it was something pretty weird, more like something out of a visionary bible. It was incredible, and it affected me to a point that I couldn't take the standard message about the nature of reality we are fed in mainstream society any more. For a few months I had what might be called ontological shock. I've followed my own star ever since, as an independent writer, researcher and speaker.

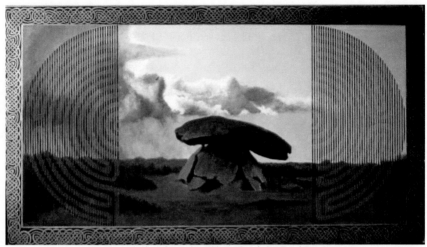

An early painting featuring Chun Quoit by Paul Devereux

When I look back and talk about it like this, it seems like something from a biblical age. It was extraordinary. And whether it was because millions of people were penetrating the mists of consciousness with psychedelia I just don't know. It was a moment of high idealism when the music and art world came in close contact with direct forces of inspiration, and there was a tremendous florescence of creativity.

Notes 1) Nichols, a Cambridge graduate who was friendly with Gerald Gardner, would, in 1964, become the founder of O.B.O.D. (Order of Bards Ovates and Druids). Robert MacGregor Reid, another leading druid, also accompanied them to Brittany.

2) Mrs Weir's true identity is not revealed in Sword of Wisdom (1975), but as an associate of Colquhoun's cousin Edward Garstin, she was the person who accepted her application to join the A: O: Lodge of the Golden Dawn in the Outer.

3) Discovered in 1943, LSD started to be used more widely in the early 60s. Englishman Michael Hollingshead was an important early evangelist. Able to order large quantities from the Sandoz labs, he distributed it amongst influential friends and associates like Timothy Leary in the US, and Alexander Trocchi and Christopher Gibbs in the UK. Having worked closely with Leary in the US, in 1965 he returned to London, and having set up the World Psychedelic Centre, like Leary, promoted a quasi-religious reverence for the drug. When the WPC was busted in 1966, several tabloid newspapers published lurid stories about LSD. Just as they had with witchcraft, the tabloids, in condemning the use of LSD, created a moral panic that merely encouraged further use.

5. The Age of Aquarius

'A man who gives his books titles like 'The View over Atlantis' or 'Flying Saucer Vision'
is deliberately not bidding for the attention of academics' Ron Hutton, Pagan Religions
(1991).

Very much synchronous with Devereux's life-changing experiences, in
January 1967, in underground paper 'International Times', (IT) the
following prophetic statement appeared:

'The end of the Age of Pisces, which coincided with the reign of
Christianity, is now at hand and the spring-point is entering Aquarius. At
such a time significant changes must be expected, involving a shift in the
archetypes and leading to chaos and bewilderment for those not prepared to
receive them. Already the symptoms and portents are becoming apparent.'

John Michell in International Times. January 1967.

The words are those of John Michell (b 1933, d 2009), a 34 year old ex-
Etonian who would go on to become a key player in the emerging Earth
Mysteries movement. Based in Notting Hill, Michell, whose father was
Cornish, is described by Hutton as 'the reincarnation of the free-thinking
gentleman-scholar of the 18th century' (Hutton, 1991).

Referring to his own experience with LSD, Michell himself puts it bluntly:

> Most of my contemporaries had made it, and were successful by that time, so they don't know what its like for a failure aged 30 to become an acid freak. It was marvellous. A head full of liberal academic nonsense was spun around, and new patterns of thought appeared, far more natural and interesting than any which had been offered by the education process. (Michell, 2010)

'Flying Saucer Vision', Michell's first book, was published in November '67, and was inspired by the psychoanalyst Carl Jung who envisaged the UFO sightings as portents of a New Age. In it Michell expresses the view that modern man needs to start thinking differently:

> The arbitrary framework which limits our way of thinking, our western liberal-humanist system, based on the Hebrew-Christian tradition…has evolved to its limits and is now approaching a state of decadence.

He explains that reports of flying saucers or UFO's are not new, and refers to the disc of Vishnu and the Egyptian eye of Re, as examples of gods especially associated with flying discs. He goes on to explore the mythology of dragons, and the notion that they were considered to be the gods' 'sky vehicle'.

He then emphasises myths that associate serpents with knowledge, including eg the Mexican god Quetzalcoatl. Chapters on flying machines, alien sightings, abductions and disappearances follow, before Michell turns his attention to British history, and Stukeley's description of the serpent cult of Wessex.

In a book full of breathtaking imaginative leaps, he leaves the biggest one for Stonehenge:

> The remarkable thing about Stonehenge is the way in which its form exactly reflects the conventional image of the flying saucer…As a reproduction of the flying saucer, Stonehenge is evidently a sort of cargo cult monument, a pattern of the sacred disc, built to attract this object for which men felt such a yearning'

Towards the end of the book John Michell also mentions leys and dragon-lines or 'lung mei', and does so again in another article for IT early in 1968.

IT, or International Times, in which these early stirrings of post-war Earth Mysteries appear, was the first and most influential of the

underground magazines. It was launched on April Fool's Day 1966, and it provided a lively and outspoken focus for the youthful counter-culture of the metropolis.

Despite the paper's emphasis on this emerging London 'freak-scene', it was read by many in the provinces. This included Tony 'Doc' Shiels and his friend Paul Francis, who were members of the St Ives art colony in the early 60's, and who contributed several pieces of artwork and photography. Doc Shiels in particular drew cartoons that filled 7 or 8 half pages in consecutive issues.

St Ives had received beatnik visitors from Soho and further afield since the late 50's. The Guardian newspaper had described it as the UK's 'centre for beatnik life' (White, 2013), and because of this reputation, the town was also often mentioned on the pages of IT. In an article describing *'fuzz (police) repression'* for example, St Ives was compared to London's Piccadilly: *'The dilly is one pole of the beat circuit with Ives as its Antipodes'* (IT August 1969).

'Witchcraft is spreading its weird tentacles throughout Britain': Tony Shiels' own idiosyncratic take on 'the craft' as featured in International Times.

During 1968 the focus of IT's content moved towards music, with reviews of albums and regular features by John Peel. Although Monica Sjöö, who we will return to later, wrote a piece on New York (referring

to Valerie Solanas' SCUM manifesto as 'magnificent'[1]), there was less content relating to landscape mysteries or Paganism.

Other publications were starting up, however, that were able to fill the gap. 'Gandalf's Garden', launched in 1968 by Muz Murray, was published from a headshop in World's End, Chelsea. It ran to six glossy issues, advertised meetings for the Theosophical Society, Aetherius Society, Swedenborg Society, Druid Order and College of Psychic Studies, and included articles of a highly esoteric nature by Colin Bord.[2]

More enduring, and probably more important for galvanising Paganism as a movement, however, were the more modest magazines which together made up a new, ever-evolving network of 'exchange mags'.

Building on the growth of Gardnerian Witchcraft, 'The Wiccan' edited by John Score, was launched in autumn 1968. Described as *'A Newsletter of the Old Religion (run by the craft for the craft, and for those interested)'*, in 1970 it became the newsletter of the Pagan Front which, in 1981, was renamed the Pagan Federation.[3]

From Samhain 1970, 'The Waxing Moon' was published in the UK for several years. Its editor Joe Wilson, an American airman, had moved to live in Oxfordshire after being posted to the UK. A first generation Neopagan, he had originally started the newsletter in Kansas in 1964, and as a result had had extensive correspondence in the mid-sixties with a number of influential witches in the UK, including Ruth Wynn Owen and Robert Cochrane. The latter, who committed suicide in 1966, offered a more spontaneous and intuitive approach to witchcraft: a third strand that was an important corrective to the more narrowly prescriptive approach of the Wiccans.

Once settled in the UK, Wilson joined forces with Tony Kelly of the Selene Community in Wales, and together they formed 'The Pagan Movement' with the clearly stated objective: *'to create a pagan society wherein everyone shall be free to worship the Goddesses and Gods of Nature'.* [4]

Marian Green's quarterly Quest magazine was also started up in 1970, following two Esoteric Conferences that, still in her twenties, she organised in London in 1968 and 1969. Green's inaugural editorial contains the following sisterly advice regarding the 'spiritual revolution':

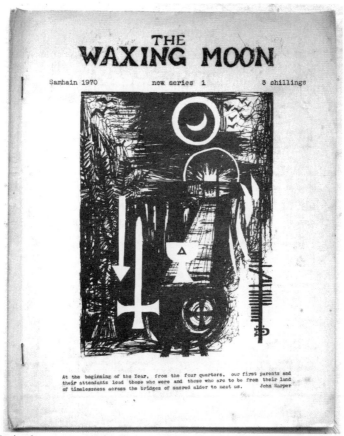

THE
WAXING MOON

Samhain 1970 new series 1 3 shillings

At the beginning of the Year, from the four quarters, our first parents and their attendants lead those who were and those who are to be from their land of timelessness across the bridges of sacred alder to meet us. John Harper

Having been an energetic advocate of the commune movement and editor of 'Communes', Tony Kelly later worked with Joe Wilson to produce 'The Waxing Moon'. Kelly and Wilson were an influence on Cornish pagan, Jo O'Cleirigh.

Many young people, no longer bounded by the conventions of thought or action are turning towards a new, and in some cases, mystical horizon. With the increasing availability of soft drugs used in large doses to 'turn on' (and 'tune in' to the Infinite, they are having experiences once only reserved for the priesthood.

The expansion of consciousness, the super-awareness that these people are experiencing, the visions unclouded by reason or logic, are the same that seekers have witnessed throughout history. The difference is that in the past it was the trained minds of the priests or the initiates of the ancient mysteries who sought answers beyond the normal perception of the mind…

TUNE IN to the rhythm of life.
TURN ON to the inner reality.
TAKE OFF on the magic carpet of clear undrugged inspirational vision.

Ithell Colquhoun, who we can assume attended one or both of Marian Green's conferences, contributed a short article 'The Interlace', on Celtic knot-work to the first edition of 'Quest'.

When key Earth Mysteries magazine 'The Ley Hunter' (TLH) re-appeared under Paul Screeton in 1969, it found an unlikely kinship with this network of pagan magazines. That it should have done so is actually not surprising: early issues of TLH included articles by Doreen Valiente and Ross Nichols, which very much demonstrate a shared enthusiasm for the mysteries of the British landscape.

The Ley Hunter magazine 1969 -1976 (issues 1 to 71), all with Paul Screeton as editor, as donated to the author in 2017. An earlier version of the magazine appeared for six issues from April 1965, under Philip Heselton.

However, Paul Screeton has never thought of himself as a pagan. Screeton, working as a twenty-three year old rookie journalist at the time he revived the magazine, was originally alerted to ley-theory by a tantalising mention in one of Michell's 1967 IT articles: *It extolled the virtues of ley hunting and Alfred Watkins' visionary rediscovery of a*

70

landscape criss-crossed by straight ancient trackways. Wow! Next day, during a break from sub-editing at the Hull Daily Mail I visited the city's central library and borrowed a dog-eared Methuen copy of Watkins' 'The Old Straight Track'. I read it, was hooked and little did I suspect how my life would change irrevocably. John Michell told me later that many such as myself found the revelation came as if forgotten but familiar, akin to remeeting an old friend.

I had already devoured Pauwels and Bergier's cornucopia of weirdness 'The Dawn of Magic', later retitled as 'Morning of the Magicians'. Science fiction by Ray Bradbury and the more speculative J. G. Ballard was also feeding my brain. I had always read left-field strange fiction. In many spheres, too, Colin Wilson had been an inspiration.

On a practical level, I began pencilling straight lines across Ordnance Survey maps with gay abandon and imagined myself quite the expert. How deluded I was. In those days my youthful enthusiasm excused the woolly thinking. I was on a mission, evangelising, possessed, so as we journalists say, 'don't let the facts get in the way of a good theory'.

Using a friend's business duplicating machine I launched the new series of The Ley Hunter in November 1969 with an introduction to ley hunting by Jimmy (Goddard), a piece on John Michell and another on tumuli allegedly laid out in star patterns. (artcornwall.org)

Notes 1) This was shortly after Solanas was convicted of shooting Andy Warhol. An earlier edition of IT (issue 14, 1967) includes a short excerpt of an interview with Sjöö.

2) In Gandalf's Garden, No.4 (1969), for example, Colin Bord reports on his involvement with the Aetherius Society. The founder George King had claimed that, in 1958, Jesus appeared before him on top of Holdstone Down in North Devon, having travelled there from Venus in a spaceship (cf Leger-Gordon, 1965). Every year since, the Aetherius Society have met at the same spot, as part of 'Operation Prayer Power'.

3) Famously, in 1970, it was on the pages of The Wiccan that the Gardnerians' grievances against Alex Sanders were most publically aired. Score was concerned that Sanders' self-promotion and involvement with the tabloids was bringing witchcraft into disrepute:
> *We really must apologise for the whiff of sewer in this issue, but if you will bear with us a little longer we think that the air may clear by the end of this item...........*
> *Yes. You guessed! A. Sanders, Esq., (salaam), Enter His Highness, King of the witches (none other).....the nit. Who does he think he is fooling? Certainly not US! Indeed we question whether in fact he was ever initiated by ANYONE.*

4) Tony Kelly had been the moving force behind the Selene Community, a commune in Wales described in more than one article in Gandalf's Garden. He had also edited 'Communes', a magazine published in the mid-sixties.

6. Atlantis

'The View over Atlantis', John Michell's second book, was published in November '69, the same month as Screeton's first Ley Hunter magazine, and it made Michell a star of the counter-culture. It also gave unprecedented publicity to leys, which, having first been described by Alfred Watkins in the 1920's, were resuscitated and given a make-over befitting the New Age.

John Michell in Notting Hill in the 80s. Photo by Paul Broadhurst.

Michell's second book, in dropping the central theme of his first, replaced flying saucers with a poetic meditation on the ancient British landscape. It was a decisive shift, and an account in which Cornwall, and particularly St Michael's Mount and the other Michael sites, looms large.

Michell initially invokes early archaeologists - known then as antiquarians - John Aubrey and Dr Stukeley, the former who discovered the stone circle at Avebury, the latter who described its ground plan as representing a giant serpent. He goes on to recall the discovery of leys by Alfred Watkins:

One hot summer afternoon in the early 1920s Alfred Watkins was riding across the Bredwardine hills about 12 miles west of Hereford ...Suddenly in a flash he saw something which no one in England had seen for perhaps thousands of years...The barrier of time melted and, spread across the country he saw a web of lines linking the holy places and sites of antiquity...

Watkins established that place-names containing Cold, Cole, Dod, Merry and Ley seemed particularly common on these alignments, hence why he chose the last as the name to give them. His working hypothesis was that these long straight lines linking various sacred sites, marked paths and trade-routes across the landscape. Michell, however, points to other, more mystical explanations, in particular expanding on the idea of 'lung mei':

In China they are known as lung-mei, the paths of the dragon... Geomancers, exponents of fung-shui were consulted over the erection and siting of any building or tomb anywhere in China...It was recognised that certain powerful currents, lines of magnetism run invisible over the surface of the earth. The task of the geomancer was to detect these currents and interpret their influence on the land over which they passed.

In a second chapter exploring the iconography of the dragon in both China and Britain, Michell mentions the Padstow Obby Oss and Helston Furry Dance and references various other dragon-killing legends. Indicating that the dragon symbolises hidden earth energies, he says:

It may be inferred that the Chinese lung-mei and the leys of Britain have an identical function...Many centres of the English dragon legend stand at the junction of well-marked leys, and in one case the straight line between them is of the highest precision and of obvious astronomical significance. This is the St Michael's line that runs from Avebury circle to the extreme west of Cornwall...[1]

The third chapter expands on the second, explaining that Stone Age man had geomantic powers that enabled him to sense earth energies, perhaps using divination. It was this consideration that determined his choice of sacred sites, later taken over by the church:

Through its policy of occupying and reconsecrating the old places of inherent sanctity the Christian Church quickly assumed the spiritual control of the country. With the help of those native priests and magicians who understood the secret of the old alignments, the first missionaries founded their churches at those places where the celestial forces asserted their strongest and most beneficial influence...

In the middle section of the book, Michell examines examples of alignments, specifically mentioning leys in West Cornwall - a geographical area he already knew well - before delving into the arcane sciences of gematria and metrology. There are in-depth analyses of the dimensions of the Great Pyramid, Stonehenge and Glastonbury all of which seem to demonstrate the sophisticated arithmetical systems of the ancients.

The last section of the book is the most speculative. Entitled 'Sacred Engineering', it guesses as to the rites performed at the sacred sites of Britain. Referencing Lewis Spence, Michell discusses the process of Druid initiation using a *'dark, sealed cavern or chamber'*, compares Neolithic caverns to orgone accumulators, and - over two particuarly mind-bending pages - attributes the Druid's ability to levitate and float long distances to the energy accumulating properties of such underground earthworks. Lastly he speaks of dowsers, like Guy Underwood, and other 'sensitives':

> the sensitive person feels the magnetic surge within the stone ring. For such places still bear the invisible marks of some feat of natural magic, performed by the adepts of the former world, space and time travellers, masters of revelation, to whom the earth was but another living creature, responding like a man to certain shapes, sounds and poetic correspond-ences, the keys to universal enlightenment.

The View over Atlantis, sold well and gave a timely boost to The Ley Hunter magazine. Paul Screeton: *Subscriptions rolled in and also written contributions by Tony Wedd and Frank Lockwood (as 'Circumlibra) Subsequent issues developed a lively letters column and my father began operating a primitive Gestetner machine to produce issues. The schedule slipped from being monthly, as quality trumped regularity. There was cross-fertilisation with other small magazines, such as Fortean Times, Arcana, Pendragon, Undercurrents and Torc. I was also distributing through a few London shops such as Compendium in Camden and Atlantis in Bloomsbury.*

From then on the fate of Michell and The Ley Hunter magazine would be inextricably linked.

Notes 1) Michell first visited Glastonbury in 1966, and once there discovered the booklet 'Michael: Prince of Heaven' compiled by Wellesley Tudor Pole. It is likely to be this that alerted him to the idea of the Michael line.

7. God giving Birth

When we first arrived, you can understand why they were so suspicious of us beatniks: Cornwall was a very naive and uncorrupted place... It was like another country.
Ralph McTell (White, 2013)

Monica Sjöö - another who wrote for IT magazine - was a pioneering feminist artist born in Sweden in 1938 to a mother who was an impoverished painter and single parent. After leaving school, Sjöö came to the UK via Paris in 1958, attracted by the reputation that Cornwall had as a centre for modern art: *'We lived a winter in St. Ives where we were able to hire a large studio/home above the Penwith gallery. I was starting to paint then and we were drawn there because of the artist colony centred around Barbara Hepworth and others. I discovered, though, that there was a tyranny of abstraction, and figurative art was unacceptable'* (autobiography on monicosjoo.com).

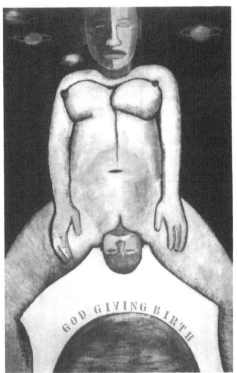

'God Giving Birth': considered by Parker and Pollock (1987) to be the painting that marked the start of second-wave feminist art in the UK.

76

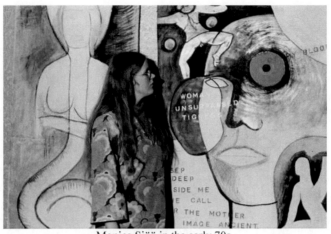
Monica Sjöö in the early 70s.

In the 60's she moved back to Sweden and then to Bristol, where she became politically active, and in 1968 under the surname Sjöö-Trickey, reported indignantly on the trip to New York which she undertook during a three month stay in the U.S. (IT October, 1968 – already mentioned).

Sjöö's painting 'God Giving Birth', is widely considered to have initiated second-wave feminist art in the UK (Parker and Pollock, 1987). Extraordinarily primitive and powerful, it was started prior to leaving for the States, finished in 1969 and shown for the first time in 1970 in St Ives Guildhall: one of six large canvasses exhibited as part of a 'Festival/ Gathering' organised by poet Nicki Tester. Others involved at the time included poets Peter Redgrove and Bob Devereux.[1]

The Mayor of St Ives famously objected to Sjöös paintings, and ordered they be removed on the grounds that they were blasphemous: *'God giving birth' and some other of my paintings were censured and not allowed to be shown anywhere in the town. It caused a scandal and I was traumatised as I was breastfeeding at the time and felt vulnerable. I was shocked also that the artists, like Barbara Hepworth, in St Ives made no protest nor did they give me any support at all.*

Sjöö's canvasses were, in fact, taken down and turned to face the wall. It was an act of censorship that appears, in part, to have been another episode in the long-running feud between beatniks and townsfolk which had been rumbling on since the early 60s, and which came to a head in

77

1969, when around fifty hippies claiming squatter's rights barricaded themselves into a building in the town (IT August 1969).

In 1970, second-wave feminism was still embryonic and had not yet coalesced into a coherent movement - The Female Eunuch and Spare Rib magazine, for example, didn't appear until 1972 - and so, artistically and politically, Monica Sjöö, was a true pioneer.

She formed the UK's first Women's Liberation Group in Bristol, and, starting in 1971, organised a series of ground-breaking exhibitions in London which marked the beginning of the feminist art movement in the UK. 'Womanpower' (1973 – Swiss Cottage Library) in particular received a lot of press coverage, and again, it was the work 'God Giving Birth' as it had in St Ives, that generated the most discussion and controversy (Parker & Pollock, 1987).

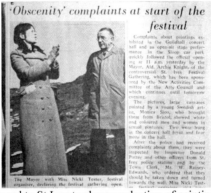

Monica Sjoo returned to St Ives to show a selection of paintings in the 'Festival/ Gathering' of 1970. Organised by poet Nicki Tester (pictured above in the St Ives Times and Echo), the event was a victim of long-standing mistrust towards 'hippies' or 'beatniks' in the town.

Still smarting from her experience of St Ives, Monica Sjöö at the time was clear that simple, direct, figurative painting was her preferred way of working. At the time of Womanpower she wrote on behalf of all the participating artists:

We regret the abstract researches, playful gimmicks characteristic of contented and successful male artists. Although aware that these are not entirely without purpose and interest, we feel that it is not possible as members of an oppressed group – half of the human race – and with a

78

powerful means of communication in our hands to sit around playing games with surface reality.

Unlike Ithell Colquhoun, it is fair to say that Sjöö was an art-world outsider who viewed art as a political weapon and propaganda tool, rather than something more private or esoteric.

The incident in St Ives marked the beginning of Sjöö's career as a feminist artist, and though based in Bristol and then Wales, she went on to have a long relationship with Cornwall and its landscapes.

Notes 1) The Guildhall in St Ives has been an important venue for the arts for many years. In summer 1971 it would host an early gig by COB. Founded by Clive Palmer (ex-Incredible String Band) most of the songs on their two albums were written whilst they were living in a caravan in the countryside near Truro. COB's otherworldy folk music - relevant to this book because it seems both ancient and magical - marked the highwater-mark of acid folk (White, 2013).

8. Colin Wilson's Occult

In 1971 Colin Wilson's book 'The Occult' weighed into populist debates on the nature of consciousness. His unusual angle on the subject, partly borrowed from Alfred Adler and transpersonal psychology, provided another significant contribution to the 'spiritual revolution' of the times.

Bracketed with the work of the 'Angry Young Men' of the 50's, Wilson's earlier book 'The Outsider' (1956) was widely discussed in the media, and considered required reading for beatniks and wannabe existentialists alike (cf Nelson, 1989). An article describing Soho in late 1956, speaks volumes about this particular context:

> The skiffle group is built round the guitarist, to add rhythm and harmony to his melodic line...Its present revival in London coffee-bars derives from the current craze for guitar music there...Until recently the clientele took Lucky Jim to be their prototype; now they identify themselves with Colin Wilson's Outsider. ('Coffee Bar Skiffles' The Observer October 21st)

The 'skiffle' generation, included the likes of David Bowie, who named The Outsider as one of his 100 'must reads', and Donovan - another with connections to St Ives - who said it was the reason he became a beatnik in the first place (White, 2013).

In 1957 Colin Wilson moved to Gorran Haven near St Austell. Author Paul Broadhurst was one of many younger writers who were later supported by him: *The only reason Colin moved to Cornwall was to escape Joy's father who had threatened to whip him to within an inch of his life! I'd met Colin because I'd been down taking photos of him for a newspaper, and as soon as we started talking we got on like a house on fire because I was into the same things that he was. It was a great privilege to know him.*

After his move to Cornwall, Colin Wilson developed a reputation, perhaps not unlike Ithell Colquhoun, for being a reclusive visionary. During the sixties he published around twenty books, both fiction (eg 'Adrift in Soho' and 'The Mind Parasites') and non-fiction (eg 'Beyond

the Outsider' and 'Introduction to the New Existentialism'). None however, sold as well as The Outsider, and Wilson had to wait until 1971, when The Occult was published, to achieve anything like as much commercial success. Paul Broadhurst: *He was a lovely man: completely honest about everything. He told me about 'The Occult', and said 'The publisher commissioned me to write a book debunking the Occult, but about 20 pages in I suddenly realised it was all true!' So there is a man who completely reversed his opinion when he'd done some research, and not a lot of academics are that open-minded. I very much admired Colin for that.*

'The Occult' is a rambling beast of a book (my paperback copy runs to 800 pages). Although it shows some overlap with the grand themes of John Michell's work - prehistory, consciousness and evolution particularly come to mind - Wilson's writing is more self-absorbed and self-referential. However, his enthusiasm is infectious, and the book's breadth impressive.

Indifferent to academic respectability, in 'The Occult' Wilson starts with the basic assumption that telepathy, telekinesis, poltergeists, second sight, sixth sense, thaumaturgy, ESP, prophecy, clairvoyance, astrology and divining are all real, and all eminently possible.

> Magic powers...powers of second sight, pre-vision, telepathy, divination...these are not necessarily important to our evolution; most animals possess them and we would not have allowed them to sink into disuse if they were essential.

The idea that our prehistoric ancestors had special psychic powers that were lost as part of a process of evolution, is in fact, repeatedly reinforced. It is a notion that is taken as self-evident and, significantly, it would become a corner-stone of Earth Mysteries and Goddess culture later in the decade. (Wilson's ideas in this regard are cited by Margot Adler in 'Drawing Down the Moon' (1979), for example).

Wilson argues that these powers have once again become essential if man is to evolve. He introduces a new concept by way of explanation:

> FWH Myers suggested that consciousness could be regarded as a kind of spectrum. In the middle of the spectrum are the powers we know about - sight, hearing, touch and so on. Below the red end of the spectrum are the organic processes...but beyond the violet end of the spectrum lie other powers of which we are almost totally ignorant...

He advocates using and developing 'Faculty X' in order to extend consciousness and the powers of human mind into the violet end of the spectrum. In a section on telepathy:

> ...we must recognise that the powers we have been discussing are commonplace....what prevents us from summoning them? The answer is: the blinkers, the narrowness, the fact that my consciousness is occupied with trivial issues'.

Colin Wilson on a cliff-top near Gorran Haven. Photo taken by Paul Broadhurst in the early 1980s.

The nature of consciousness is further explored by reference to a large number of other writers. The second chapter, in particular, is dedicated to Robert Graves, who Wilson visited at his home in Majorca in 1969. Here 'The White Goddess' is taken as Graves' key text:

> According to Graves there are two forms of poetry: 'muse poetry' and Apollonian poetry'. The first is created by 'inspiration, checked by commonsense'; the second with the intellect. He associates muse poetry

with the White Goddess of primitive lunar cults. Science, like Apollonian poetry, is an attempt 'to banish all lunar superstitions and bask in the light of pure solar reason'…. magical systems should not be regarded as primitive attempts at science but as attempts to express these depths of lunar knowledge in their own terms…

Going on to discuss WB Yeat's 'A Vision' he says:
'The White Goddess' and 'A Vision' are closely allied to the I Ching and the Kabbalah: they are attempts to organise 'lunar knowledge', our intuitive sense of meanings behind reality, into some kind of system…

Wilson's description of the magic and mysticism of the classical world is brief and perfunctory, but the middle section of the book provides lively biographical accounts of Paracelsus, Agrippa, Dee, Swedenborg, Mesmer, Caglistro, Eliphaz Levi, Madame Blavatsky, MacGregor Mathers, Crowley, Rasputin and Gurdjieff, the last of whom he rates particularly highly.

Wilson mentions Cornwall a few times, and in doing so restates a thesis first presented at the end of the 19th century. Writers like Yeats, Evans Wentz and Arnold, had suggested that that the Celt was somehow less rational but more intuitive than his Anglo-Saxon cousins - in Wilson's terms, perhaps, *more* evolved. In the third chapter 'The Poet As Occultist' Wilson, in describing his near neighbour Cornish poet AL Rowse's experiences of presentiment and the paranormal, highlights the fact that both he and Graves are Celts.

Although he mentions Gerald Gardner's museum on the Isle of Man, it seems surprising that Wilson does not mention Cecil Williamson, and the museum in Boscastle. Perhaps it was not well advertised in Cornwall at the time.

Nor does Wilson appear to have met Ithell Colquhoun in Cornwall. Colquhoun herself, in reviewing her near neighbour's book the following year, however, damns it with faint praise (Prediction, 1972):
In broadcast interviews to launch this book, Colin Wilson candidly stated that he wrote it at the request of his publishers - i.e. to turn an honest penny. Fair enough; but don't expect a labour of love or a masterpiece of scholarship: it is neither…His basic theme is that 'man's biological destiny is to evolve Faculty X'. Still largely dormant, this faculty lies at the upper or violet end of the spectrum of consciousness, in contradistinction to the 'jungle sensitivity' or shamanistic psychism which is shared with primitives and animals and found at the lower or red end…

Colquhoun points out some mistakes of scholarship, relating particularly to her own pet subjects of the Cabalah and The Golden Dawn, before concluding:

> I have not met Colin Wilson since the epoch when he appeared in the gossip-columns of evening papers with his sleeping-bag on Hampstead Heath. His output since then is proof of immense vitality and industry but I feel that he has still not 'found himself'. If I might make a suggestion, it would be to forget his fluent talking and voluminous reading, and concentrate on *one* system of attainment - no matter which, so long as he studied its own texts (or good translations where necessary), rather than the comments and summaries of other writers. He would find such a praxis rewarding.

Colquhoun, however, also had more than one 'system of attainment', but her mastery of a range of artistic genres enabled her to adapt her 'mode of address' to suit different subjects. As she continued writing into the 1970s, the result was a disparate collection of works, even more diverse than Wilson's.

In 1973 'Grimoire of the Entangled Thicket', a small collection of her poetry was published. This was followed in 1975 by 'Sword Of Wisdom', a biography of occultist MacGregor Mathers, whose portrait would have looked down on her as she worked.

Colquhoun's books were all niche publications. Unlike Colin Wilson, she never attempted, and was never able, to reach a mass audience.[1] Two earth mysteries writers that did, however, were husband and wife, Janet and Colin Bord with their first joint project together: 'Mysterious Britain' (1972).

The Bords met at the very end of the sixties because of their shared interest in UFOs, and BUFORA (British UFO Research Association). Janet was the editor of UFO magazine 'Spacelink' at the time she started to be drawn into Earth Mysteries, and she did so following John Michell's example: *In the late '60s I was mostly reading UFO books and magazines, and also some books on ghosts and other paranormal matters. A major influence at that time was John Michell's 'The Flying Saucer Vision', which I read in 1968. In 1970 I began reading books relating to earth mysteries topics, such as Guy Underwood's 'The Pattern of the Past', T.C. Lethbridge's books, and branching out into so many other fields by reading Colin Wilson, Charles Fort, Ivan Sanderson – anything I came across* (interview artcornwall.org).

84

Colin and Janet Bord on Trencrom Hill outside St Ives during the period they were researching 'Mysterious Britain'. Janet published several articles in TLH as 'Janet Gregory', eg 'The Days When Giants Threw Rocks About' (TLH 19, May 1971) which includes discussion of Trecrobben, and Cornwall's other giant legends.

Garnstone Press published several important books in the 1970s. *I was approached by Michael Balfour, owner of Garnstone Press, who was looking for someone to do the picture research for a book he envisaged, but for which he only had a title – Mysterious Britain. He asked me because he knew that one of the editorial skills I was offering to publishers was picture research, and he also knew that I was part of the 'mysteries' community. I agreed to take on the job, thinking that I would be able to use plenty of our own pictures. Colin was a freelance professional photographer and had already taken numerous 'atmospheric' photographs, and together we were already travelling around visiting and photographing ancient sites.*

We didn't have the luxury of spending a year or two visiting sites and collecting material. So far as I recall, we only had a few months, and so the work was very intensive. We were able to use photographs we had already taken since getting together, I also obtained photographs from other photographers and agencies, and we went out on short excursions to take some photographs especially for the book.

Note 1) This is in contrast to best-selling Cornish author Daphne Du Maurier whose 1966 book 'Vanishing Cornwall' is comparable to Colquhoun's 'The Living Stones'. Du Maurier's book displays the same evocative prose and love of the Cornish landscape, but none of Colquhoun's profound esoteric knowledge.

9. THE ROLLING STONES AND THE OLD STONES

'The Old Stones was the finest piece of surveying work hitherto undertaken by an 'alternative' archaeologist and made a case worth answering by others' Ronald Hutton (1991)

A photo from the late sixties shows John Michell alongside other counter-cultural luminaries, like U.F.O. club DJ Jeff Dexter, attending a New Age conference at Sir George Trevelyan's Attingham Park in Shropshire (Michell, 2010). In 1972 Trevelyan, who is now acknowledged as one of the architects of the New Age, dedicated a plaque on a rock on the summit of Chapel Carn Brea to the memory of Margaret Thornley who died in 1961. Overlooking the Atlantic, it had been one of her favourite beauty spots.[1]

The previous year (1971) John Michell had attended a gathering referred to in The Times as a 'Mystic's Picnic' organised by Paul Screeton, in Herefordshire. A precursor of the Ley Hunter 'moots', attendees included Philip Heselton, Jimmy Goddard (thanks to whom Michell originally became acquainted with leys), and Andrew Kerr. Kerr, in common with a number of the others, had travelled to Herefordshire from Glastonbury, fresh from organising the first Glastonbury Festival (or Fayre as it was then). He was a fan of 'The View over Atlantis', and had chosen both the Glastonbury site, and the design of the famous pyramid stage, having been inspired by Michell's book (Screeton, 2010).

Whilst Colin Wilson did not write specifically on Earth Mysteries until later in the 70's, John Michell was committed to exploring the field more fully. Indeed both before and after 'The View Over Atlantis', he was an active ley-hunter, and some of his field-trips have become the stuff of legend. One celebrity outing included Brian Jones (Rolling Stones), Christopher Gibbs (LSD socialite) and Kenneth Anger (film-maker – his 'Lucifer Rising' includes Michellesque UFO imagery), who were taken to Herefordshire to re-examine leys originally identified by Alfred Watkins (Fortean Times 249). Another trip involved The Incredible String Band and their manager Joe Boyd, exploring Michael line sites whilst en-route to Wales (Screeton, 2010).

Mystics' Picnic (1971): L to R: Philip Heselton, Paul Screeton, Jimmy Godard and John Michell (photo Paul Screeton)

It was West Cornwall that provided the raw material for Michell's most systematic ley-hunting, however, and he visited and revisited the area many times.

He sketched out some initial findings as early as 1970, when he described a series of alignments radiating out from the stone circles of Boscawen-Un and Tregeseal East:

> Since you kindly asked me to contribute to The Ley Hunter, I should like to describe the result of some researches in West Cornwall which appear to demonstrate the fact of leys beyond any reasonable doubt....The area chosen for a survey was the Penwith peninsular...there are several reasons why this area was an obvious choice quite apart from the luxuries of the Penzance bed and breakfasts. It contains more ancient stones than any other area of corresponding size, and several stones circles which were analysed for their astronomical properties by Sir Norman Lockyer earlier this century... TLH 10 Aug1970

Goaded on by Michell, in the autumn of 1970 Paul Screeton made contact with archaeologist Glyn Daniel, eminent editor of 'Antiquity' journal, imploring him to look at Michell's data from Cornwall. Michell even offered to give £50 to a charity of Daniel's choosing if his findings

88

could be refuted. Daniel responded dismissively, however, and in a subsequent editorial referred to the ley hunters as a 'lunatic fringe'.[2] Undeterred, Michell continued his Cornish field work. A photo from 1971 provides an insight into the relaxed, sociable nature of ley-hunting at the time. It was taken by one of Michell's friends, Gabi Nasemann, who backstage at Glastonbury Fayre that year, took exclusive photos of David Bowie.[3]

Also in the photo, and wearing glasses and a bandana is John Neal who recalls climbing on top of the megaliths to check the horizon for alignments: *At the time of the photograph we were in Cornwall helping John's research for his book, 'The Old Stones of Land's End', in order to substantiate the theory of megalithic alignments. We stayed in a lovely old hotel, The Queen's Hotel on the seafront in Penzance, and ventured off on our sorties from there. We'd travelled down in a VW van, and that particular visit was about two weeks. John picked up the tab.*

The book 'The Old Stones of Lands End' came out in 1974 published, again, by Garnstone Press. A collation of all of Michell's Cornish research, it is also a distillation of many of the most mystical ideas of the Sixties. His fondness for Cornwall is also very apparent in the text, which, in parts, reads like a love-poem:

Sacred territory, as well as the individual shrines within it, belongs to the country rather than to its inhabitants; for while these come and go, the native gods remain constant as at the beginning. Thus the western end of Cornwall was a place of ritual magic and invocation long before it became a sanctuary of the Celts, Druid and Christian....

After mentioning the Cornish antiquarians Dr Borlase, Robert Hunt, JT Blight[4] and others, in the central section of the book Michell provides a photographic catalogue of the old stones and crosses of West Cornwall, recording both their history and their alignments.

In a long polemical essay at the end Michell takes modern archaeology to task, and indicates that the reason why so little is known of the civilisation of the megalith builders is because it has been wrongly assumed that they were savages:

The most ugly consequence of Darwinism, sociologically applied, was the establishment of the modern European with his materialistic philosophy and science as the highest product of an evolutionary process, in the course of which the human race has supposedly been led through stages of bestiality, unreason and superstitions to modern enlightenment...

Gabi Nasemann (photographer), John Michell, Christopher Rudman, Jake Hemming, Linda Wroth (of Sago press: Michell's girlfriend and secretary at the time), John Neal and Lizzie Benzimra at an over-grown Boscawen-Un, Cornwall 1971.

He also opines that the methodologies of modern archaeology are not fit for purpose:

> Since the emanations from underground waters can only be detected by those who have developed the dowser's gifts, their presence at all megalithic sites is not proved in the sense prescribed by materialistic science. However the stones we are investigating were the instruments of an older science not necessarily bound by the same conventions that obtain today...

> Guy Underwood supposed that ancient men in Europe were in touch with a natural (telluric or magnetic) source of therapeutic energy, which might be discovered to the benefit of the present...(cf Underwood, 1969)

> Whatever else they may have been, menhirs were certainly instruments of fertility, not merely symbols of the phallus...but actual operative phalli the media of intercourse between the rays of cosmic energy, and the receptive field of the earth's magnetism...

Though not a practising magician or Occultist himself, in the last few pages he indicates the importance of ritual and magical thinking:

The modern approach to cosmology is physical and analytical and our science is directed accordingly; but the science of the megalith builders was required to deal with a world populated by gods, spirits and the shades of the dead. In these circumstances the best advantage is to be gained by magic...

Drawing an analogy with pilgrimages made by the Australian aborigines, he describes Watkins' straight paths as ritual paths linking sacred sites, and concludes:

The megalithic sites of Cornwall are relics of a former system of institutionalised magic, once universal, the object of which was to maintain contact with the spirit world...Its locations were the shrines of the archaic deities, places where the forces of heaven and earth were united in such as way as to be of use to men and of benefit to the living earth...The various operations of traditional magic, invocation, divination, communion with the dead or necromancy, levitation were performed (there). Of their rituals not much is known...the Church purged its domains of surviving magical practice even more thoroughly than it destroyed its monuments.

Notes 1) The Trevelyan family, Cornish over many generations, is descended from an ancestor who was supposed to have escaped the deluge that engulfed Lyonesse. Sir George Trevelyan (b1906), after teaching at Gordonstoun became principal of Attingham Park Adult Education College in Shropshire in 1947. As committed anthroposophist, he organised teaching seminars on 'New Age' topics from the 50's onwards. The Wrekin Trust was founded by Trevelyan on his retirement from Attingham Park in 1971.

2) This was the start of two decades of intemperate skirmishing between The Ley Hunter and the archaeological establishment. As described by Stout (2006) it was social evolutionism versus the paradigm of the Golden Age, which was largely at the root of their disagreement.

3) Nasemann, who, like Michell, was acquainted with The Rolling Stones, is also noted for having taken several backstage photos of Brian Jones, including the last ones before he died.

4) In 1977 Michell published a biography of Cornish artist and antiquarian JT Blight. (Michell, 1977)

10. Monstermind

Early in the 1970's a group of artists with a common connection to the Royal College of Art, made a conscious decision to move to the countryside in order to revive a particular mode of painting inspired by the Victorian Pre-Raphaelite movement.

Nominally led by Peter Blake - best known for his Sgt. Pepper album cover - they called themselves 'The Brotherhood of Ruralists', and two of them, Annie and Graham Ovenden settled on Bodmin Moor. Here they built Barley Splatt, a theatrical neo-Gothic house set in 20 acres, inspired by Augustus Pugin. From 1975 onwards, the 'Ruralists' would all meet for annual working holidays in Coombe, in North Cornwall, where some of their most memorable paintings were completed.

Whilst they were not unlike others who moved to the rural South West at the time - leading environmentalists like James Lovelock, Satish Kumar, Teddy Goldsmith and the entire editorial board of The Ecologist magazine also come to mind [1] - the Ruralist's paintings themselves now seem awkwardly anachronistic.

Certainly with the rise of minimalist and conceptual art in the late sixties, for at least a decade, painting became unfashionable: most cutting-edge artists considered it too traditional, too elitist and too easily recouped as a consumer commodity. Instead there was a move towards making art works that couldn't be bought and sold so easily: art that was transient, or that only existed in the mind.

One interesting, if oblique, manifestation of this new art was Cornelius Cardew's Scratch Orchestra, which performed on Bodmin Moor in the early 70's. Another was Land Art, pioneered in the UK by Richard Long. Quiet and understated, Land Art was another sub-genre of conceptual art, and an approach to art-making that was more perform-ative than painting. Rather than depicting the landscape, in this case it required Long to physically interact with it, thus, arguably, moving from an 'onlooker mode' to a 'participating mode' of consciousness (to use Peter Redgrove's dichotomy - see later chapter).

Born in 1945, Long grew up in Bristol, and spent long periods as a child on holiday in Devon and Cornwall. He knew Dartmoor particularly well, and many of his earliest works were made there. Richard Long: *I've probably made more works just walking around the West Country roads and lanes than I have anywhere else. It's my home territory as an artist and it is still a good one for me...Dartmoor is a sort of prototype landscape for me. It's just always there for me to work in...What I've always liked about Dartmoor is that it is this big empty place which nevertheless has traces of all these layers of human history, like the tinners, or the farmers, or whatever. And I suppose after so many years I can also say that it also has traces of my own walks and history on it....* (Gooding, 2002)

Interestingly Richard Long has tended to deny any connection of his art to ley-lines, or to the theories of John Michell or others. This may be part of a deliberate strategy of obfuscation, as it's impossible not to see some parallels. As if manifestations of invisible energy lines, Long has arranged sticks and stones in the landscape to create straight lines and circles; sometimes using other materials like seaweed. He has also elevated walking to the level of an art-form, and carried out journeys that followed pre-planned straight lines miles across the landscape, or that have connected different sacred sites.

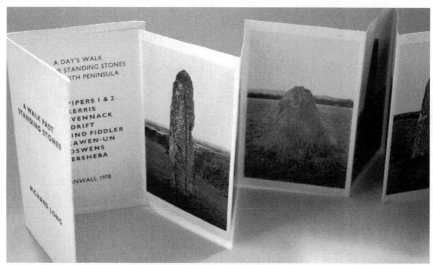

Richard Long's 'A Walk Past Standing Stones' (1978): the record of a walk in Penwith, published by Coracle in 1980 as a tiny limited edition booklet.

Another land artist, Long's friend and contemporary at St Martin's School of Art, Hamish Fulton, has been more explicit about his debt to Alfred Watkins' theory of leys, and recalled paying a visit to the library in Hereford in about 1969, to visit Watkins' archive there. (Daniels, 'Lines of Sight' Tate Papers 2006).

Cornishman David Tremlett, who was born near St Austell, knew Colin Wilson as a near neighbour, and was another who made his name as part of the same small group of conceptual artists during the late 60's, but he, like Long and Fulton, largely did so in London, having completely bypassed what was left of the St Ives colony (interviews artcornwall.org).

Marie Yates: Field Working #9 (detail - Harford Moor, Dartmoor).

At the time art made in Cornwall did manifest some aspects of these new trends, however. Ithell Colquhoun moved more towards Neo-Dada, using found objects in her work, for example, whilst many in St Ives eg Roy Conn, John Charles Clark, Bob Law and a younger artist called Marie Yates adopted a simpler, pared down form of geometric abstraction.

In the early 70's Marie Yates (b 1940) went on to adopt a transient style of sculpture made with 'poor' materials (inspired by Italian Arte Povera), siting simple, poetic works in the landscape and photographing them as part of the 'Field Working' series (interview on artcornwall.org).

Whilst later in the 70's Marie Yates became involved with mainstream feminism, one man already mentioned, rejected a conventional route to artistic recognition and went on a very different path. In the process he became a cult figure in the Fortean and pagan communities, and thus, like Colquhoun, extended his influence far afield.

In spring 1976, Falmouth and the Helford River featured in local and international headlines (including eg News of the World, Daily Telegraph, Radio One and Radio Four), after several sightings of a sea monster in the area. The monster became known as Morgawr, and a series of reports including startling eye-witness accounts and a few grainy black and white photographs, appeared.

Many of the reports seemed, bizarrely, to link back to Tony 'Doc' Shiels - by then a self-proclaimed-wizard - who, assisted by a coven of nude witches, claimed that he could use psychic powers to locate and even raise sea monsters.

Shiels at the time was living with his wife and five children near Falmouth. Previously, in the late 50s and early 60s, when he had lived in St Ives as a painter, he had been a member of the Penwith Society Committee (replacing Barbara Hepworth after she resigned) and friendly with Peter Lanyon and Terry Frost, as well as younger artists like Bob Law.

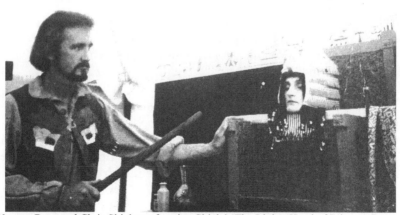

Vernon Rose and Chris Shiels performing Shiels' 'The Living Head of Princess Ramon Ra' in an agricultural show, 1970.

After running a surrealist gallery in St Ives, and whilst still working as an artist in the late sixties, he published a number of books that are now regarded as classics in the genre of 'bizarre magic'. He went on to present weird magical illusions, like the Living Head of Princess Ramon Ra, and the gory 'buzz-saw' illusion, in the unlikely setting of Cornwall's agricultural shows.

In the early 70's Shiels was involved with the folk scene in Cornwall, at a time when there were several active folk clubs in the area, and local perfomers like banjo-player and acid-folk legend Clive Palmer (of The Incredible String Band and COB) were popular.

Through music, he became friendly with Tony Shaw who, with Tony Deane, had written an important and reputable book 'The Folklore of Cornwall' in 1974 and, as Shiels' monster-raising exploits reached a climax, Shaw was wheeled out for the press as a local expert on sea-serpent legends.

Later in the 1970's, Doc Shiels, writing for Fortean Times, reported on the first sighting of the 'Owlman of Mawnan'. He also, famously, obtained exceptional colour photographs of the Loch Ness Monster which have been reproduced countless times since.

During this period, Shiels became involved with Footsbarn Theatre, whilst also directing his theatre company, 'Tom Fool's Theatre of Tom Foolery', and writing and performing his own surreal plays.

Shiels, with his coven of co-conspirators, was the first person to overtly publicise magic, and magical rituals in Cornwall. His motives were, simply, to astound the public, and with the co-operation of the media, he was successful in doing so.

As she was a fellow occultist-surrealist, his relationship with Ithell Colquhoun is worth mentioning. They were both members of the Newlyn Society of Artists, and would have met several times. In fact in about 1980 Colquhoun gave Shiels a copy of the script of her play 'The Pilgrimage' in the hope that he might perform it with Tom Fool's Theatre. As Shiels explained to me in 2014: *I am less of a shut-eye than Ithell was. The term shut-eye is a term used by fake psychics. People who believe too much. I am sceptical about myself shall we say. Ithell was more suggestible.*

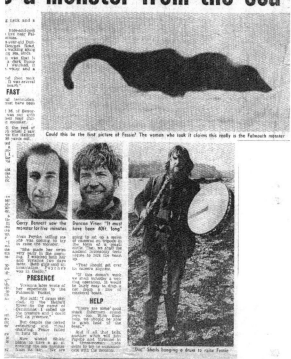

Article in Reveille (1976) reporting on 'Fessie': the name 'Morgawr' came later. Doc Shiels is pictured with a drum.

She lived at Paul at this time. She was rather seriously involved in Occultism, whereas I was playing tricks. Let's be fair about this. She told me that I could do the real thing, but she also recognised the fact - as I always admitted - that I was a charlatan. I told her that I was (a charlatan) and she denied it: 'Oh no' she said 'you have real power'. I said 'no more than anyone else my dear'. She was a bit too involved in the Occult. She was a practicing occultist. She was quite theatrical but I was more authentically theatrical because I am a cheat you see – or I pretend that I am.

Shiels understood the magical power of the image, and was able to tap into real unconscious forces to disrupt reality, in the sense always

intended by the Surrealists. This is probably what Colquhoun recognised.

Like his monsters, Shiels is now also something of a legend amongst those few who know about him. The extent of his involvement in the occult is still shrouded in mystery, as much as his career as an artist defies categorization. However, as part of a 1970's alternative 'counter-culture', and friend to Peter Redgrove, Colin Wilson, Craig Weatherhill and others in this book, Shiels provides a crucial missing link between modernist St Ives art, Paganism, Earth Mysteries and contemporary 'Post-modern' art from Cornwall.

One of the witches in Shiels' coven c1976 photographed (by Shiels) on Mawnan beach. The 'sigil' on her abdomen, also known as the Nnidnidogram, was used as the sign of the coven.

A drawing of Gwennap Pit by Tony 'Doc' Shiels, used as cover art for The Cornish Review.

Writer and artist Gemma Gary has said recently: *Outside of books, the first glimpses I had of witchcraft as a contemporary practice were catching brief clips of Tony "Doc" Shiels performing cliff-top rituals with a coven of nude women on local television... The bizarre creatures that their publicised rituals seemed designed to conjure; the Cornish sea monster "Morgawr", and the mysterious "Owl Man" of Mawnan, may have been pre-existing entities, or they may have been the creation of the Shiels themselves. In either case, these creatures did indeed have life, existed, and were seen and experienced by others. I was immed-iately intrigued by the glimpses of these mysterious people, doing strange things in remote Cornish places; they seemed to be defiantly re-enchanting an increasingly mundane world* (interview with Wiccan Pagan Times).

In 2016 Vernon Rose, musician and poet, and one of Shiels' closest friends and collaborators, contacted me by letter to describe a previously unrecorded event involving them both: *It was, I think, 29th April, the beginning of the pagan year: Walpurgis Eve. I think we had been*

99

discussing conjuring and magic, not separating the two, and we decided it would be a good time to sally forth and attempt to raise a dragon. It was an exercise we had often considered. We selected for our attempt to go out onto Trefusis Point, a long level area of meadow grass overlooking the Carrick Roads (river). We got together various items which we decided were possessed of certain magical properties, and we took 13 candles which were to provide a circle of light...In short we created a ritual and spells of our own devising such as would call up a dragon or at least make one aware of our presence and friendly intent.

We arrived on the site...and set out the candles in a circle of some 3ft, lit them and then began to incant such as we had deemed suitable spells and a declaration of intent. The candles burned steadily; the air was perfectly still. After some time when the candles were half down and no dragon had appeared, nor any change in the sky, it began to rain around us but not in the circle. Steady, straight rain, yet not a drop on us or the candles, so that we were in a circular cage of silver and glittery rain bars. This delighted and surprised us. It wasn't a dragon but it was a magical acknowledgement that we were there and on magical business. We sat down on the dry grass and drank from Doc's potion bottle, had a ciggie and returned to my house in Flushing. (It is) an occasion which has stayed with me over the years...

Notes 1) 'The Ecologist', under editor Teddy Goldsmith, moved to Wadebridge in North Cornwall in 1972. Its editorial board all lived on farms in and around Bodmin. The magazine remained in Cornwall for more than ten years and played a role in the founding of both the Ecology Party and Green Party. (Peter Bunyard artcornwall.org interviews)

11. Wilson's Mysteries

Colin Wilson, still living with his wife Joy in Gorran Haven, was only peripherally connected to the Earth Mysteries and Pagan communities as they came together in the 70's. Nonetheless he was a supportive influence and, as we shall see, friends to several of the younger writers, including Doc Shiels.

'Mysteries', published in 1978, was the second of three books by Wilson now referred to as his 'Occult Trilogy'. Its later sections are given over to his ruminations on the nature of consciousness and his concept of the 'ladder of selves', both of which build on ideas from the earlier work of 1971. The first section, which is probably more relevant to this book, however, is dedicated to renegade archaeologist Tom, or T.C., Lethbridge who Wilson helped rescue from obscurity.

T.C. Lethbridge spent most of his career working in the Museum of Archaeology at Cambridge University, before in 1957 getting caught up in a controversy over 'Gogmagog', a book describing his work excavating some chalk figures on a hill outside the town. Lethbridge ended up retiring later that year to Branscombe in Devon where he dedicated himself to dowsing, witchcraft, UFOs, ghosts and para-psychology.

Lethbridge was friends with Margaret Murray who supported him during the Gogmagog dispute, and within a few years he had written a book called 'Witches: investigating an ancient religion' (1962), dedicated to expanding on some of her ideas. He also referred to Neolithic stone circles:

> Magic was the great object to be obtained through the witch ritual and their way to obtain it was by the simple expedient of working up mass excitement. The stone rings on our hills and the wild dances of the witches were all designed for this purpose…The magic power was generated by these dances and it was kept in and directed to its object by the stone circles, which were put there so that the power should not drift away and be lost in the countryside.

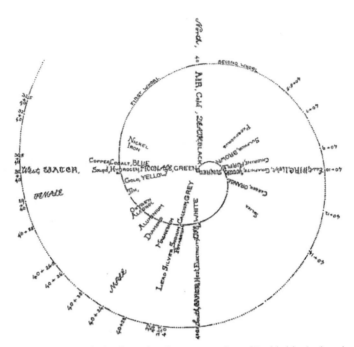

The first and second whorls: a visual representation of Lethbridge's dowsing
experiments from 'A Step in the Dark'

During the research for the book, Lethbridge explored the sacred sites of
West Cornwall. According to Wilson:

> The notion that megaliths could be giant accumulators had come to him
> when he and (wife) Mina visited the prehistoric stone circle known as the
> Merry Maidens… Lethbridge took his pendulum, set it at thirty inches (the
> length for age), and allowed it to swing. He stood with the other hand
> resting on one of the stones. After a few moments the hand on the stone
> began to tingle, as if a mild electric current were flowing through it, and the
> pendulum began to swing so strongly that it became almost parallel with
> the ground. The stone felt as if it was moving.

Wilson describes his own cack-handed experiments with dowsing at the
Merry Maidens, on one occasion in the company of David Cornwell
(John Le Carre) who lives nearby. He then relates Lethbridge's
experience to the track lines, aquastats and energy-dowsing theories of
Guy Underwood (explained in 'Patterns of the Past' (1969)) and the
early works of John Michell, including 'The View over Atlantis',
already discussed.

For Wilson, Lethbridge's main interest lay in the other extraordinary claims he made for pendulum-dowsing, which are explained in a series of books, especially 'ESP Beyond time and distance' (1965) and 'A Step in the Dark' (1967).

Lethbridge found that different substances, particularly metals, induce rotational movements in a pendulum, at pendulum-lengths specific to that substance. This finding had a high level of test-retest reliability, and could be applied in a straightforward way to lengths up to 40 inches. However Lethbridge judged that 40 inches corresponded to death itself, so then, as Wilson puts it:

> When you lengthen it beyond forty, the pendulum registers another dimension beyond death -presumably the 'spirit world'. Lethbridge's experiments led him to the conclusion that various worlds - including the state of life-after-death - exist parallel with this one, and will even respond to a pendulum.

Colin Wilson dowsing at the Merry Maidens. Published originally in the Fortean Times.

In 'Legend of the Sons of God' Lethbridge expressed the belief that access to this parallel world, which he referred to as 'the second whorl', may one day be possible, by use of some kind of futuristic dynamo:

> Having altered your personal bio-electronic field of force from that of your earth body to the vibrations of the next whorl, you would be in the timeless zone and could go backwards and forwards in time...

Colin Wilson never did meet Tom Lethbridge as he had died in 1971, a few months before Wilson attempted to make contact. With his panoply of extraordinary theories and his willingness to think the unthinkable, however, Wilson clearly saw in Lethbridge a kindred spirit.

12. Elemental Coordinators

Alongside the growing literature on Paganism and Earth Mysteries in the 1970's, were other examples of artists who developed non-verbal responses to the ancient sites. Jill Smith, with her husband Bruce Lacey, created a body of work in the late 70's and early 80's that is particularly notable in this regard.

Bruce Lacey and Jill Smith at their wedding in 1967, with robot R.O.S.A. B.O.S.O.M. as the 'best man'.

Smith, who performed as Jill Bruce, trained as an actress at RADA and met Lacey in 1959. They married in 1967, after collaborating in performances or 'happenings' at the counter-cultural hub 'Better Books' in London. Lacey by then had become known as a maker of strange contraptions; automata and robots that also featured in elaborate performances with surreal, futuristic themes at theatres and art centres across the country (Mellor, 2012)).[1]

Towards the late 60's, Smith became more interested in the ancient history of the landscape. Speaking to me in 2015, she recounted an incident in 1968: *Once we went on holiday with the children to discover the sacred sites. When we climbed Windmill Hill above Avebury, I had this experience as though I was somebody from the Neolithic Era. It was as if we were a tribe of people who had travelled on The Ridgeway path, and had an annual gathering on Windmill Hill...I felt the West Kennett Long Barrow belonged to us.*

Another time travelling on a train going to Wiltshire, I got this feeling that there were all these prehistoric ancestors rising up from the ground...They were really talking to me, saying 'it's your duty to go out into the world and tell people what we were - that we weren't stupid savages'. (artcornwall.org)

In coming to an understanding of these experiences, Smith was helped by two publications in particular: *There was a series of magazines called 'Man, Myth and Magic' and we started to get those. When I started to read them, it was like I had this knowledge already deep inside me. That was the only real reading I did then.*

(Later) my son bought me 'The View over Atlantis' by John Michell, and all the time my brain was going click-click-click, and there was this sense of things joining up. And then on the telly there was this programme with Mary Caine talking about the Glastonbury Zodiac. Massive things were happening inside me at the time.

In 1976 the couple's performance-style changed, and it became less technological and more primitivistic when Smith and Lacey were asked to perform outdoors at the last Barsham Fayre in Norfolk: *Up to that point, everything we'd done needed electricity! When it came to doing something non-electric we thought: well what shall we do? And so we decided to call ourselves Elemental Coordinators.We decided to work in a circle, but it was me who worked out the ritual, and I started making the costumes. It was a way of expressing my creativity and spirituality, through these elemental costumes. I was working out the rituals initially, and telling Bruce what to do. I devised the ritual language, with all the objects.*

Bruce Lacey and Jill Bruce at The Rainbow Fayre.

At the time Jill Smith had no background in ritual magic or witchcraft, however: *I didn't know about pagan rituals, though I suppose I was learning little bits about solstices and equinoxes, learning about the cycles of nature and evolving what felt right. Bruce had a vast collection of props and they were the things we performed with.*[2]

There was a place in London called Theatre Scene Armoury where you could get coloured fire that you could light with a match. So you could light something from the sun, and if you sprinkled the powder on some straw, you knew you could get it to ignite. We used to do a lot of fire performance, and I had a headdress that I lit, and I'd walk about with fire on my head.

I'd go around all the markets and find fantastic fabrics. When we were still in Hackney I had a shop window dummy that I made the costumes on, and I had a sewing machine on the floor. I think all my life I'd been trying to create identities for myself. During the ritual performances at the fayres I didn't realise what was happening to me. It was like a self-initiation into my woman-power.[3]

Smith and Lacey went on to develop a series of private rituals or actions that were carried out for their own sake, without the necessity of an audience. In the process they visited countless sacred sites, and for Jill Smith the process was profoundly spiritual: *For the Glastonbury Zodiac performance, we went down to Somerset for 4 days, and went round doing performances, doing 3 signs of the zodiac a day, so we did the whole thing in 4 days.*

At the time we kept on going out to lots of ancient sites, and this is when I began the concept of the 'journey': of journeying between them…It was as though ancient sites had been connected by paths of energy. Or paths of 'British dreaming' like the 'Australian dreaming'. And so I'd take sacred water, maybe from Chalice Well in Glastonbury, and I'd anoint the stones, or I'd take one thing from one site and carry it to another, as a way of linking them; feeling that they'd once been part of a whole web or network that in the modern world had been lost.

The journeying and the rituals became art works, exhibited, for example at the ACME Gallery in Covent Garden: *There were two shows at the ACME (1978 & 1981). I did all the wall panels. This was a way of presenting to the public the documentation of the things we'd do in private.*

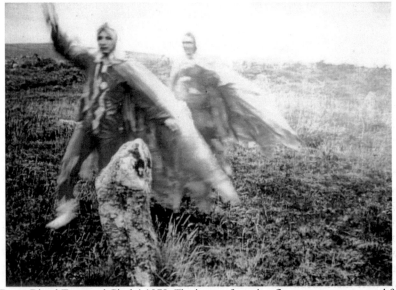

'Dawn Ritual Tregeseal Circle' 1978. The image, featuring fire costumes, was used for their poster for 'Ancient Forces' ACME Gallery 1978.

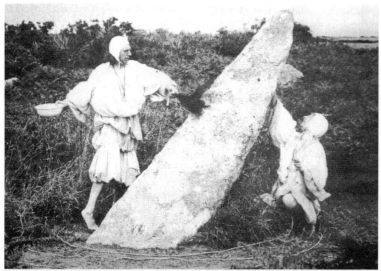

Bruce Lacey and Jill Bruce's ritual at Boscawen Un, wearing 'air costumes' and featured later on the front cover of Artscribe Magazine.

Cornwall provided some of their most important ritual sites during this period: *We did a ritual at Boskednan. There was another one high up on the moor (Tregeseal). There's a famous photograph of us going round a circle in Cornwall with our fire costumes on, and some fire torches (used as the poster for 'Ancient Forces'). At Boscawen-Un we did something with the air costumes.*

We would have driven down especially, and slept in the van. It was a 3 ton yellow ex-GPO truck. We'd take our van of stuff, all our props, and we wouldn't pre-plan it, but think 'right, what does this place want us to do?' Then we'd evolve something we wanted to do. We'd do it for real, then we'd re-enact it with a camera, taking photos.

Fire, as well as sacred water, became an important part of their rituals, as Smith wrote some years later:

We always carried a flame which had been lit from the sun (as with the recent Olympic flames) and often at a site at sunrise I would carry this flame in a flask round the stones of a circle, weaving patterns of energy by my walking. It was to honour the rising sun and the life it gives to all on earth and also to acknowledge the relationship between sun and circle. Sometimes we were more theatrical, lighting torches of hay or straw from the fire source and walking great flaring patterns around the stones. We were always extremely careful to damage nothing nor to leave anything at a site. On our

Cornish journeys I particularly remember working in this way at Boscawen-ûn, Tregeseal and the Nine Maidens circle at Boskednan.

On one visit to the Cheesewring on Bodmin Moor we took a small stone back to an East Anglian fair to become part of a 'Mercurial Harp'. I can assure people it was returned afterwards!
(MM 2012)

The Laceys: Homage to Alfred Watkins (1978). In the centre of the photo, taken in Herefordshire, is a portrait of Watkins mounted on a twig.

In 1978 the couple also visited Herefordshire to investigate some of Watkins' leys for themselves, and documented the visit with a simple photographic homage. Always sympathetic to The Ley Hunter's concerns, Lacey and Bruce attended, and spoke at, a Ley Hunter moot towards the end of the 70s: *We always wanted to get involved in (Paul Devereux's) Dragon Project, but they didn't want us! Bruce was interested in the experiments they were doing, and he made lots of machines that could measure and record things. We spent a weekend at the Rollright Stones trying to measure things. And strange things happened, like his razor suddenly got sharp.*

One of their largest exhibitions, 'Cycles of the Serpent', was held at the prestigious Serpentine Gallery in 1981. However, early in the summer of 1982, Lacy and Smith separated and Smith reverted to using her maiden name: *It was becoming quite overwhelming. It was like this ancient knowledge was rising up inside me, like I'd always known it. I left the house and went to sleep in the little goat shelter, because I didn't want*

to be indoors. I would cook the supper and go outside. I was like that for a number of years. I started to reject houses. I needed to be physically on the land. There was a big upheaval in my life, and I wanted to go to the ancient sites on my own…

Notes 1) Some of this work was more recently shown as part of 'The Bruce Lacey Experience' at Camden Arts Centre and Penzance Exchange.

2) Whilst several books on modern witchcraft were published in the 60s and 70s, it wasn't until 1978 that its rituals were laid out in a way detailed enough for others to copy. As well as providing a 'Book of Shadows' (or 'Liber Umbrarum') Doreen Valiente, in 'Witchcraft for Tomorrow', makes multiple references to leys, Paul Screeton and John Michell, and even cites TFG Dexter's work on Fire Festivals. She explains *'it is the circulation of bowdlerized versions of wtichcraft rituals that has been one of the motives inspiring me to write this book. For one thing it irks me to see misquoted versions of material I wrote for Gerald Gardner being offered for sale, no matter under what pretext.* The following year Starhawk's 'Spiral Dance' offered her own hugely influential US West Coast version of the rituals.

3) One of the fayres visited by The Laceys was the Festival of Fools in Penzance, organised by FootsbarnTheatre (1979).

111

13. The Wise Wound

Their great god, a dragon decorated like a church ('At the Witch Museum' Peter Redgrove 1979)

As it was, Jill Smith became dramatically drawn into the Goddess movement as it emerged in the 80's. The movement, as the spiritual branch of second-wave feminism, is generally accepted to have started in the US, with publications like Mary Daly's 'Beyond God the Father' (1972), and Merlin Stone's 'When God was a Woman' (1976).

'The Ancient Religion of the Great Cosmic Mother of All' (1981) is a potent reworking of an original pamphlet by Monica Sjöö from 1975. The cover depicts Sjöö's large painting entitled 'Avebury'. Co-author Barbara Mor was poetry editor of 'Womanspirit', an influential US magazine (based in Oregon) that distributed Sjöö's book in America.

Feminist painter Monica Sjöö started painting landscapes in 1978 after a psilocybin-induced revelation on Silbury Hill. Sjöö it was who, arguably, did most to spearhead the Goddess movement in the UK, partly by acting as conduit for many of the American writers.

Still based in Bristol, late in 1975 she had published an uncompromising polemical pamphlet 'The Ancient Religion of the Great Cosmic Mother of All' which proposed that the earliest human communities were matriarchal and worshipped a Great Goddess. That same year Sjöö became one of the founding members of the Matriarchy Study Group (MSG), along with Pauline (later Asphodel) Long. The group published three booklets, the first of which stated:

> We do not wish merely to contemplate the past. Our aim of understanding the past is to influence the present. We see the part that male-based religion has played in demeaning and exploiting women. In exposing this, we want to share our regained confidence in ourselves with other women... (Matriarchy Study Group 1977 'Goddess Shrew')

The second publication, entitled 'Menstrual Taboos' (1978), was a collection of short essays and poems. Long's contribution included the following:

> Menstruation began as the very holiest of all mysteries - the origin of the word means deity, and the idea of the sacred, it is the link of women with the moon in her aspect of goddess throughout her 28 day cycle of waxing and waning, in fact the essence of the female vitality, spirit and major contribution to total understanding of, and unity with the universe. How did the changeover happen; what made this sacred subject into a curse - and still the major reason for the ban on women priests since they may be 'unclean' when handling the Host and kindred objects?

The three MSG booklets reached a limited audience; however 1978 saw the publication of 'The Wise Wound', a book covering much of the same ground as 'Menstrual Taboos', and drawing upon many of the same sources. Emerging completely independent of the US Goddess movement, it echoed many of its main themes and became a best-seller in its own right.

The chief author was Peter Redgrove (b. 1932). Already an established poet, he had moved to Falmouth in 1966 to take up a post as a lecturer in Complementary Studies at the art school (Neil Roberts artcornwall.org).[1]

He met co-author, Penelope Shuttle (b 1947) in 1970: the same year that he took part in the Festival/Gathering in St Ives (see Chapter 7).

As they explain, 'The Wise Wound' emerged out of Jungian therapy sessions:

Penelope Shuttle was suffering from premenstrual depressions... Peter Redgrove spent 1968-1969 as the pupil of the famous analyst Dr John Layard and with the use of his methods Peter Redgrove enabled Penelope Shuttle to draw pictures of her depressions...in a few months it was clear the analysis was having a good effect...

First edition of The Wise Wound, by Shuttle and Redgrove 1978.

Described by one reviewer as a 'fascinating, challenging, breathless excursion through menstrual dreamland' (NWSA 1989), the book approaches menstruation from every possible angle, and draws on a heady mix of mythology, anthropology and Jungian psychology (especially Erich Neumann and Esther Harding).

Central to Shuttle and Redgrove's argument is the idea that women should be at their most creative and inspired when they are menstruating:

Menstruation...is regarded by some as a sickness. This is not necessarily so. It is the time when the healthy woman may draw on abilities and capacities that are not related to the values of ovulation and childbearing, but that are instead related to that other side of her nature of independence of thought and action....

114

Instead of it being an unmentionable taboo experienced by the woman as pain or discomfort, they therefore call for menstruation to be reframed in a way that focuses on the positive:

...instead of a 'menstrual epidemic' we would have the 'Quadruply Sensuous Woman' capable of enjoying without fear not only her orgasm, her childbirth and her breast-feeding as deep erotic experiences, but her menstruation also for what it can give...

Shuttle and Redgrove seek out multiple references to menstruation and moon worship, explaining that knowledge relating to the moon's phases was widespread in the ancient world, but has since been lost:

It is almost certain that the moon-colleges of Hera in pre-classical Greece were institutions for studying the moon's phases and relating them to changes within one's own body...

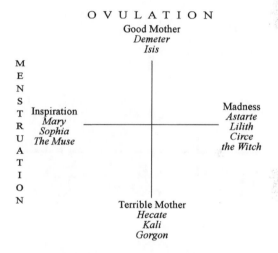

Erich Neumann's Jungian archetypes mapped onto the dimensions of Redgrove and Shuttle's theories of menstruation.

Interestingly Cecil Williamson is mentioned in the acknowledgements of 'The Wise Wound', for his *'informative conversation'*. Peter Redgrove is known to have visited the witchcraft museum in Boscastle on numerous occasions, often bringing with him parties of art students from Falmouth (Patterson, 2014). His visits inspired a poem ('At the witch museum'), and in 'The Wise Wound', Shuttle and he express deep sympathy with witches:

We hope that you will see how natural witchcraft is, how important to all women and to men also, and how a great natural ability of human beings

115

has been suppressed by Church and State for centuries...witchcraft is the subjective experience of the menstrual cycle. By means of witchcraft women have been able to structure their cycle and know it. Because it is a woman's reality...it has been denigrated ceaselessly by men, who fear women and who wish them to under-achieve...In the Middle Ages it has been estimated that nine million women were burned as witches for exercising their natural crafts...They were persecuted and burned by the Christian Church of that time, who wished only men to have power and ability, by men worshipping a male trinity.

Portrait of Peter Redgrove by Paul Broadhurst. Redgrove bore a striking resemblance to Aleister Crowley who, he believed, may have been his father.

Shuttle and Redgrove are clear that it was women's self-knowledge that the witchhunts had sought to eliminate:

It is moon-knowing and womb-knowing and woman-knowing that these two infamous monks of the Malleus (Maleficarum) wished to expunge from the face of the earth...

Near the end of the book they discuss horror films, in particular 'The Exorcist', which they describe seeing in Falmouth, and Hammer Horror's disturbing 'To the Devil a Daughter'. Later editions of the book include a recommendation to use a 'Menstrual Mandala' or menstrual diary, and a restatement of their original thesis:

116

To masculinist science and religion, women are essentially breeders of children. They only have an ovulatory function. Their other half, the menstrual half, is neglected. In this side of their being they are the conveyors of imaginative and creative energies and initiators into creative modes of sexuality. This was, and is, our message.

'The Wise Wound' was cited on multiple occasions in the last of the MSG booklets (1979), particularly by Asphodel Long and in subsequent articles by Monica Sjöö. It also went on to influence Wiccan writers like the Farrars (who, as we shall see, visited Redgrove in Cornwall) and Doreen Valiente:

> One of the most epoch-making books in the advance of feminist witchcraft, to me at any rate, has been one which has dealt with the hitherto taboo subject of menstruation. I refer to 'The Wise Wound' by Penelope Shuttle and Peter Redgrove (Valiente, 1989).

However writer and editor Cheryl Straffon remembers readers expressing misgivings about the fact that the book seems to reflect a rather male perspective (pers comm). Redgrove's overriding influence as the main author was confirmed by his biographer Prof Neil Roberts (pers comm.): *Redgrove was surprisingly much more obsessed by menstruation than Penelope Shuttle was, and although her contribution to 'The Wise Wound' was crucial, I think it is fair to say that it was primarily his project. He believed that the cycle influences men who live with women as well as women themselves. For the rest of his life, every month he constructed what he called a Menstrual Mandala, a circular chart based on Penelope's cycle, in which he recorded various aspects of his life.*

Notes 1) The head of Complementary Studies at Falmouth Art School at the time was Lionel Miskin who, as his boss, had a close and supportive friendship with Redgrove. Later in the 90's, Miskin's large totemic sculpture, 'hare-woman', would be installed and become a popular feature in Graham King's Museum of Witchcraft.

14. When the Moon Bleeds

'The stone circles of Land's End contain a very clear message...they were built in a culture dominated by the feminine principle, in an era where women were the shamans who guarded the mysteries and led the rituals'. Fritjof Capra (TLH 81, 1978)

Margaret Thatcher became the British Prime Minister in 1979. For many, the Thatcher years were marred by conflict and social unrest, and Neo-pagans of all persuasions became caught up in the increasingly febrile political atmosphere.

In 1981 (Lammas) a new pagan magazine called 'Wood & Water' (W&W) featured a review of Sjöö-Mor's book 'The Ancient Religion of the Great Cosmic Mother of all'. Adjacent to the article was a notice for a march from Cardiff to Greenham Common entitled 'Women's Action for Disarmament: Women for Life on Earth'. Famously, the core group of marchers would end up occupying the iconic US cruise missile site for more than ten years.

Nuclear anxiety was intensifying, and it spilt onto the pages of W&W when Sjöö provoked a vigorous exchange in the next edition of the magazine (Samhain). The two-part article, which cited Shuttle and Redgrove's book, was entitled 'No Real Change: continuing sexist assumptions in the 'New Age''. It was partly aimed at the male-dominated 'Ley Hunter' magazine:

> Frank Capra wrote a letter to The Ley Hunter pointing out that most male researchers of Neolithic monuments have overlooked the fact that they were 'built in a culture dominated by the Female principle'...his letter was not well received by the Ley Hunters who revel in what they see as the Masculine principle of straight geometric lines...John Michell and others use again and again a highly phallo-centred language and imagery when talking of Earth and cosmic energies...

Correspondence relating to Capra's letter ran on for many months. Paul Devereux, who had taken over from Paul Screeton as 'The Ley Hunter' editor in 1976, whilst not overly defensive, took issue with some of Sjöö's comments:

It is a fact that standing stones were conceived by some early cultres as symbolic of the phallus. To report on this is not to use 'phallo-centred language'...

Janet Bord, speaking forty years later, does not recognise Sjöö's accusations: *I would not have said that The Ley Hunter, or the earth mysteries field in general, was male-dominated then. There were plenty of women in the field.*

Cheryl Straffon, though, is not so sure: *I don't think there were many women involved. There was Monica, Jill (Smith) and, to a lesser extent, myself. Monica saw herself as being quite central to Earth Mysteries. She was profoundly interested in the sites, and the alignments.*

Paul Devereux had moved to London to go to Ravensbourne College of Art in the mid 60's and had exhibited as an artist throughout the 70's. One of his first decisions on becoming editor of TLH in 1976 was to be explicit about the involvement of the magazine with Earth Mysteries in its broadest sense, and to introduce much more empirical methods of testing its key hypotheses.

Statistician Bob Forrest (left) and John Michell (right) in West Cornwall

Critics of ley-theory had, for example, claimed that most of the alignments could be explained by chance: ie the sites line up by accident rather than by design. It was an issue taken up with good-humour by statistician Bob Forrest, who published his findings in TLH (1978) and explored West Cornwall with John Michell on more than one occasion: *My first actual meeting with John was late at night at Penzance station at the end of October 1977. A tall slender figure emerged from the shadows, saying "Mr Forrest, I presume". We were there to do an interview about ley lines for the Canadian Broadcasting Corporation, John to put the case for leys, myself to act as the sceptic.*

The choice of Land's End for a venue was, of course, determined by John's book The 'Old Stones of Land's End', and by the fact that the alignments revealed in John's book had been subjected to a computer analysis by Pat Gadsby and Chris Hutton-Squire (of 'Undercurrents Magazine'). This analysis... demonstrated, statistically, that John's alignments were <u>not</u> merely chance effects.

Bob Forrest and John Michell at Men an Tol

It became clear, though, that there were still statistical problems thrown up by how John had selected his database of Old Stones. Basically it was an issue of why he had included some stones in his book but not other stones, which were not on his alignments, and which were thus irrelevant for him, but very relevant for a statistician...

Forrest returned to Cornwall on another field trip with Michell in August 1985: *My main memory of this latter expedition actually has nothing to do with old stones and statistics, but with John and that famous car of*

*his. We were driving down a lane somewhere, with the roof folded back.
My late wife Maria was in the passenger seat, and I was in the back with
our two young daughters, who were giggling at the fact that they could
see the road through a small hole in the floor of the car. Then it started
to rain. 'John', the children cried, 'Can we put the roof up – it's
raining?' 'Sorry girls,' came the reply, 'it's stuck – but there's an
umbrella in the back you can use.' So they did, giggling even more
furiously all the way. They remember John and the expedition with great
fondness to this day* (artcornwall.org)

Another who remembers John Michell at around this time is Alan
Bleakley (b1949), who was living in Newmill, West Penwith. *John
stayed with me and my wife Sue for several days, at least once. He
smoked a huge amount of dope, and was stoned a lot of the time, but he
was still a very erudite and interesting guy. So he had two sides to his
character: one side was completely sceptical, the other was producing
this amazing writing.*[1]

Having grown up in the Newquay area, in the late 60's Alan Bleakley
obtained a degree in zoology and psychology, before training as
psychotherapist in London, and returning to Cornwall to organise, with
wife Sue, psychotherapy and counselling courses for Exeter and
Plymouth Universities. He contributed three substantial articles to The
Ley Hunter in 1979 (TLH 85), 1982 (TLH 93) and 1983 (TLH 95), and
in fact also claims some credit for the provocative letter (above-
mentioned) by physicist Fritjof Capra (TLH 81, 1978): *We had met
Capra at a conference in Dartington and instantly hit it off. His 'Tao of
Physics' had only just been published and he was getting quite famous.
He said 'I'd love to come to Cornwall and see the stone circles'. We
said 'well jump in the car and come back with us'. So he stayed for a
couple of days and we showed him around the stones and told him about
the lunar cycle and menstruation, and he was completely taken by this,
and five minutes later he'd written it all up for The Ley Hunter. I didn't
mind but in writing that letter he'd stolen virtually everything we'd told
him!*

Alan Bleakley's first full article for The Ley Hunter, 'When the Moon
Bleeds' (TLH 85), explains the origin of these ideas more fully:
Whilst working on aspects of possible late Neolithic/early Bronze Age
usage of stone circles in Cornwall, I constructed and acted out with friends
a ritual created of poetic insight at one such stone circle. Its basis involved
a vision of the rising and setting sun at Midsummer Solstice, seen through a

121

lunar web, the latter created and ritually held within the circle itself, through sympathetic techniques. Its goal was a stab at spiritual fertility of the surrounding land, through containment of lunar currents within the circle, thus allowing solar currents free play. The specific form of the ritual involved, in short, a crescent of nine people as, symbolically, NineVirgins or Maidens, representing nine aspects of the Moon. Facing the crescent was a Dionysian figure as link with the external solar current, whose principle I enacted in drama. Behind me lay the full Moon, mysteriously shrouded in cloud, but later to reveal her glories for a brief few minutes on an otherwise heavily overcast night. The Moon was thus concealed outwardly, and contained ritually, within the circle of nineteen stones, with the drama enacted by the persons as placed above.

He describes being astonished to find that the ritual *'created of poetic insight'* bore an uncanny resemblance to a cave painting described by Robert Graves in 'The White Goddess', and therefore that *'intuitively they had constructed a ritual about 15,000 years old'*.

Bleakley highlights the fact that Cornish stone circles are unusual in commonly having 19 stones, suggesting a *'local cult that was firmly in the grip of the androgynous image of the sun-through-the-moon that is born of the great mother'*. He speculates as to the significance of the number 19, suggesting that the cult in question may have observed a 19 day month, within a 19 month year, noting that, *'19 squared is the only number that fits neatly into a solar year of 365 days, with 4 days left over, presumably associated with an annual feast'*.

At the time he wrote the first TLH article, Bleakley was sceptical as to the existence of leys, and said as much in a presentation he gave at a Moot in Brighton. But he subsequently received a phone call from poet Peter Redgrove, who had read it with interest: *Peter got hold of my number and phoned us up out of the blue. He said 'can I come round to meet you and Sue?' So he drove to Newmill, but he was actually looking for a coven. I said 'no, Peter I'm not really interested in that at all. I'm really more interested in the relationship of this to creativity and writing'. Peter was very different to John Michell. John was a loner, and he would never have wanted to be involved with any kind of collective ceremony. But Peter desperately wanted to be in a collective. He wanted like-minded people around him.*

Peter had been strongly influenced in Cornwall by the anthropologist John Layard, who in turn had been in analysis with Carl Jung himself. Sue and I both asked to go into therapy with Peter. He agreed and said

'I'm not going to do anything but teach you how to write'. So we just worked on my poetry and it had an instant impact. And woven through it was a mutual interest in ceremony.

Despite this interest in 'ceremony', the Bleakleys were always wary of being drawn into Wicca. Instead, as the first Ley Hunter article indicates, at the time of meeting Redgrove, their approach was more creative, spontaneous and experimental: *At the time Peter's idea of ceremony was of the Golden Dawn-type. Our idea was more intuitive. I'd built a sweat lodge without really knowing what it was. I called it an Earth Lodge. So we did a sweat lodge with Peter and we did a 'kiva' ceremony with him.*[2]

Following the success of 'The Wise Wound', Redgrove had befriended leading Alexandrian Wiccans, Janet and Stuart Farrar. Sue Bleakley realls: *Peter came to visit with some witches from Ireland: the Farrars. She kept getting out a mirror and looking at herself, and Peter later said 'she was probably just checking her aura'. He (Stuart) took loads of photos. We've still got an amazing photograph that he took of me imposed on a giant amythyst.*

Alan: *Peter really wanted us to like the Farrars, but actually I found them pretty creepy.*

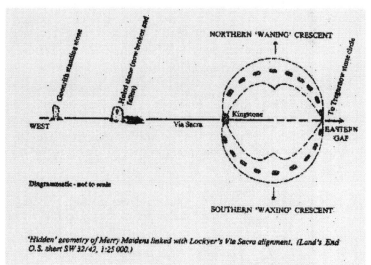

An illustration from 'The Merry Maidens' by Alan Bleakley TLH 93 (Summer 1982). One of Lockyer's alignments suggests the presence of a kingstone that divides the remaining 18 stones into two groups of nine.

Resisting the allure of Wicca, the Bleakleys had become more interested in native American spirituality instead, and in his third Ley Hunter article, 'Stone Circles as Medicine Wheels', (TLH 95) Bleakley describes the visit of Hyemeyost 'Chuck' Storm to Penwith.

During his visit Storm, a Cheyenne medicine man[3], taught the Bleakleys the rudiments of his tradition: the 'Sacred Count of twenty numbers'. In the article Alan relates this to the stone circles of Penwith, noting that Boscawen Un has 19 outer stones and one inner stone, so 'completing the Sacred Count'. He concludes with a resounding call for 're-enchant-ment':

> What I am not arguing for here is a rigid application of a template –
> 'fitting' every circle to a pre-arranged plan, but rather a poetic truth of
> temple …This involves a re-claiming of the stone circles as ceremonial
> sites, a reversion to former use. In this is a re-claiming of 'lost' parts of the
> soul, like our old gods and goddesses, 'lost' to monolithic and monotheistic
> thinking, lost to positivist science, and to art in the service of politics and
> economics; and finally lost to religion as the heavy hand of imposed
> dogma.[4]

Alan Bleakley: *It was via a chance meeting with Arnold Keyserling[5] at Dartington, that we first made the connection with Hyemeyost Storm. After he stayed with us in Cornwall, he invited us to go on a 'vision quest' near his home at Nevada City, California run by his sidekick Rainbow Hawk. We did so and invited him back to Cornwall.*

In Newmill, Rainbow Hawk facilitated a 'Delicate Lodge' ceremony which took place over several days. Sue Bleakley: *Rainbow Hawk was really lovely: a mixed-blood Algonquin. He and his helpers brought the lodge, and the lodge poles, and everything with them. The lodge was a big tent, laid out beautifully with thousands of little stones: you had to carefully creep into the delicate lodge, and you felt like an oaf! Lots of people came from all over the country, and we were all camping out in the landscape for 3 days. We fasted and we were not allowed to talk to each other.*

Alan Bleakley: *By now, Sue and I were running radical psychotherapy training courses at weekends through the IDHP (Institute for the Development of Human Potential), with diplomas awarded by the University of Reading, and many of these people joined a group to study an amalgam of the Earth Mystery teachings of the medicine wheel, and traditional 'Celtic' teachings such as the Tree Lore (as in Robert Graves' The White Goddess).*

We distanced ourselves from Chuck Storm, but stayed friendly with Rainbow Hawk and developed an interesting working and study group, doing ceremony on Celtic quarter days, equinoxes, solstices, and full moons; basically celebrating the West Cornish landscape and its heritage as a massive burial site.

It was almost a theatre group. Once, for example, we decided to spontaneously put on 'Gawain and the Green Knight'. We agreed to go away and read it overnight, and then perform it the next day. And we did a May Day ceremony using a maypole.

Alan and Sue Bleakley c1985 shortly after creating a large stone circle in their garden at Newmill. Alan is leaning against one of the stones, playing a drum.

The Bleakleys also took a special interest in local holy wells: *Sue and friends cleared out Madron Well and got it working. We discovered the pipework was the responsibility of the Bolitho Estate, and the run-off had become blocked. The estate tried to ban us from going near it, but we ignored them, and planted a rowan tree near it.*

Sue also used to visit Ithell Colquhoun at her home in Paul: *I gave healing to Ithell. It was lovely. I knew she was into magic. I must have seen her 5 or 6 times. I remember I used to put my hands round her and we'd be quiet together, and she'd say what she sensed and I'd say what I sensed.*[6]

125

The Bleakleys' ceremonial group which, having grown out of exper-imental psychotherapy sessions was always an unconventional form of Paganism, fizzled out towards the end of the 80's. Sue: *People started trying to take authority. People were empowering themselves against others. There was no real love. No real heart-felt warmth.*

One of its legacies, however, was CAER (Centre for Alternative Education and Research), started up at Rosemerryn in Lamorna by Jo May. Alan Bleakley: *Jo joined the IDHP group, and he was also part of the ritual goup. After he'd done a year with the diploma course he developed CAER into a growth centre, and he picked up on some of the stuff we'd been doing and he developed it in his own way.*[7]

Another legacy was a substantial stone circle created in the garden at Newmill: a contemporary monument which has survived to the present day: *It was a major project. We planted a tree circle around the outside of it, with all the trees of the Celtic Tree Calendar. Even the Cornish Archaeological Unit came over to photograph it. It was catalogued as a folly.*

For Sue in particular, the native American influence has persisted, and to this day she remains a peace-pipe carrier and active with the Healing Trust.[8]

Notes 1) John Michell later wrote the foreword for Bleakley's 1989 book 'Earth's Embrace'.

2) Alan Bleakley explains the kiva ceremony performed with Peter Redgrove: *You can do it anywhere that's dark. You flash a really bright light on and off quickly so you get an afterimage, and in the afterimage the person looks completely different. The idea is that this is a way to peel back the layers and get at a person's past life.*

3) Chuck Storm's reputation was built on his book 'Seven Arrows' (1972), which has, more recently, been exposed as largely fictional, together with his claims of Cheyenne ancestry. Storm is now viewed by many as a 'plastic shaman'.

4) Bleakley's powerful call for a more fully balanced self - seen as a need for 'healing' and a descent into the unconscious (or shadow) - is explored in detail in 'Fruits of the Moon Tree' (1984). The book emerged out of therapy sessions with Redgrove under the influence of James Hillmans 'Re-visioning Psychology'. Bleakley makes frequent reference to the four dimensions of the medicine wheel which he maps against Jung's four dimensions of the psyche.

5) Arnold Keyserling was, at the time, chair of the European Association of Humanistic Psychology.

6) In 1982 the Bleakleys attended a Shamanism conference in Alpbach, Austria. As Sue explains: *I met a Philippina healer there. She belted me hard on the chest saying 'get that self-pity out' and the next minute there were rays coming out of my hands. And that's when I started doing healing.*

7) Annie Spencer was another member of the group. Based in Bath now, she has continued her ceremonial practice up to the present day.

8) Cheryl Straffon remembers attending ceremonies on the Bleakley's land at Newmill in which Sue passed around a peace-pipe to share. The Bleakleys' involvement in 'ceremony' was already lessening by the time Straffon had moved to Cornwall, however, and probably as a result, they did not become hugely involved in Meyn Mamvro, CEMG, CASPN or the pagan moots (see later chapters) though Alan did contribute an article (The Fires of Bel) to the second edition of MM.

15. The Sacred Play of the Year

Devereux's Ley Hunter magazine only occasionally reached out to new readerships interested in native American spirituality, Goddess spirituality, or 'third-strand' witchcraft. Other periodicals emerged that purposely engaged with these growing constituencies, however. 'The Cauldron' became one of the longest-running and most respected, after being launched by Michael Howard in 1976. Howard, based in Wales and then Devon, was a frequent visitor to the Museum of Witchcraft in Boscastle in subsequent years.

Magazines appearing later in the decade were more overtly political than The Cauldron.[1] 'Wood and Water' (W&W), already mentioned, championed Goddess spirituality and Eco-paganism, whilst 'Pipes of P.A.N.' (Pagans against Nukes) focussed more on feminism and nuclear disarmament.

The first full edition of W&W (Lammas 1979) describes how it was started following a trip by the editors to Carn Euny Holy Well in Cornwall, which they had found in a poor state of repair:

> This isn't just a spoiled well. It embodies a whole range of evils that between them are destructive of nature, the land, and ultimately ourselves …Jo O'Cleirigh would rightly like us all to become 'Ecopagans' but I wonder whether there can be any other kind?

Alan Bleakley and Peter Redgrove, as well as Monica Sjöö, Ithell Colquhoun, Jill Smith and Cheryl Straffon all contributed to 'Wood & Water' in the 80's. Based in Cornwall, the above-named Jo O'Cleirigh was one of the most articulate of all the writers in the early editions, however. Then, as now, sporting conspicuous Greenpeace badges and pentangles, he was an early adopter of Ecopaganism and Goddess spirituality, and he came to both by a fascinating route.

Born in Plymouth in 1933 O'Cleirigh was evacuated during the war to East Cornwall. When he was 18 he went on National Service, and in 1952 was posted to Egypt, a visit that stimulated a life-long love of ancient history. On returning to Devon he volunteered at the City Museum in Plymouth and at archaeological digs all over the UK.

Jo O'Cleirigh's first excavation in Egypt. Tell El-Farain (Buto) 1965. He is wearing the safari hat.

As he explains, in 1959 he enrolled for extra-mural courses at the Institute of Archaeology in Bloomsbury: *The great thing about the lecturers was that they were directors of excavations all over the world. I met Veronica Seaton-Williams at the Institute. She was an eccentric Australian lady who had a concession to dig at the Nile Delta, at a place called Tell El Farain, or Buto, which was an ancient city site of the snake goddess Wadjet. I did 4 seasons there: 65, 66, 67 and 68. In 1965 whilst I was in Buto, I met Michael Roaf from Oxford - a really lovely chap - and he was reading 'The White Goddess'. I looked it up when I came back, and got my own copy. He got me thinking about the Goddess.*

O'Cleirigh also came close to training as a priest: *In the 60's I was a very radical Roman Catholic. My sister and myself went on all the marches in London. We were part of CND, and the Catholic Libert-arians. In the end it couldn't hold me, though. I particularly had problems with the sexual teachings of the church.*

Living in Chelsea, O'Cleirigh remembers picking up copies of 'Gandalf's Garden' in the late sixties (its office was in the World's End, Chelsea), but he also bought the first edition of 'The Waxing Moon', and set out to meet its editor: *In 1970 I visited Joe Wilson, who turned out to be a sergeant in the USAF, living in married quarters in Bicester.*

129

I went to one of his monthly meetings there. Joe Wilson was the first witch I'd ever met. I became a member of The Pagan Movement and through 'The Waxing Moon' I also got in touch with Ruth Wynn Owen. I met her a number of times and had quite a correspondence, and got to know about Y Plant Bran which was her family pagan tradition. At a time when Alex Sanders was acting the fool, Ruth Wynn Owen seemed a very sane person, and I was influenced by her a lot.

Jo O'Cleirigh's wooden Goddess: present when he first accepted Paganism as his faith, and here photographed in the red and yellow Woodcutters' Hut in Lamorna.

Later that year O'Cleirigh moved to live with a friend: the potter Alan Caiger-Smith, in Aldermaston: *I took myself through an initiation in the cottage at Aldermaston about the feast of Samhain in 1970. I accepted Paganism as my faith. It was a private ritual with a little wooden goddess figure from the Phillipines that I bought in the King's Road. And since then I've never had any doubts.*

Joe Wilson and Ruth Wynn Owen both offered alternatives to Gardnerian and Alexandrian Wicca. O'Cleirigh was also exposed to a ritual group that is also considered part of this third strand: *Ron White put*

130

something in 'The Waxing Moon', and I got in touch with him. He said that 'The Regency' were meeting in Queen's Wood (Highgate) and I should go.

So I attended some of their ceremonies and I got to know John Smart, and we corresponded with one another. Years later he turned up in Boscastle, running a café. It was the first time I'd been involved with public ritual. They were about the first people to do it.[2]

Ruth Wynn Owen and The Regency were well acquainted: *The Regency met in her flat for a while. Certainly there were similarities between The Regency and Plant Bran rituals but Ruth was very much into the idea of the Welsh god Bran. I got interested in Bran and the use of the alder leaf, which I incorporated into my own personal sign.*

Inspired to visit Lamorna after reading Colquhoun's 'Living Stones', in 1975 O'Cleirigh moved to live in a tent behind The Wink pub, before, the following year, finding a brightly painted red and yellow caravan surrounded by thick woodland. It was a magical, fairytale place referred to in Colquhoun's book as 'The Woodcutter's Hut'.

It was here that O'Cleirigh wrote the first of several other articles for Wood & Water (published in 1979), which describe the influence of Robert Graves:

When in the 1960's I began to realise that my religious views were being transformed into the pagan mould…one thing which held me back was the sheer complexity of the pagan inheritance, and its motifs: what was one to make of it all?....My guide here was the poet Robert Graves in that inspired though difficult book 'The White Goddess'…

'The Theme, briefly, is the antique story which falls into thirteen chapters and an epilogue, of the birth, life, death and resurrection of the God of the Waxing Year; the central chapters concern the God's losing battle with the God of the Waning Year for the love of the capricious and all-powerful Threefold Goddess, their Mother, Bride and layer-out.

My Roman Catholic upbringing had already introduced me to some of the elements in this theme, principally the divine child born in the dead of winter - the star Child called Jesus by Christians. His birth, life, death and resurrection is part of the Christian inheritance. But digging deeper into the history of religion we discover that this same divine figure may be recognised in the earlier Osiris, Adonis, Attis, Tammuz, Dionysos and the rest of the 'year gods'; only the names are different.

The theme is a way of picturing forth the great transformative energies of Nature in a seasonal sequence of little one act plays…

Drawing by Jo O'Cleirigh of his hut in the Lamorna Valley (1981)

This brings a complex and inter-related life supporting system - the Biosphere, into the range of popular human comprehension, and makes it possible for us humans to focus our emotions on our relationship with Great Nature, presenting it to us in a way in which we can feel our oneness with it, and respond to that feeling.

and moved thro' the circle and descended into the ground ~ the fougou (Goddess descending into the Underworld or Hades. She moves thro' the p... the innermost part (at 35') and then blew the candle out ~ remaini... t. Then we all descended one by one in the dark, groping our way to... squatted or crouched on either-side. (still carrying incense.

others.

Kern Benewan.

Fougou.

N
W E
S
FIRE

Nemeton Book of Ceremonies: contemporaneous notes made by Jo O'Cleirigh, recording the ritual at the fogou that included Ithell Colquhoun as a participant. Kern Benewan refers to The Maid (kern-maiden or goddess figure), who leads the ritual and enacts the descent into the underworld.

Whilst at Lamorna, O'Cleirigh formed Nemeton, a ritual group that included Ithell Colquhoun as an occasional member. O'Cleirigh had joined the Fellowship of Isis, a Goddess-celebrating organisation founded in Ireland in 1976: *In 1979 I met Brownie Pate through the Fellowship of Isis. She introduced me to Ithell, and we (Ithell and I) met 6 or 7 times during that year. Later on October 31st 1980, she took part in a ritual with Nemeton group.*

The ritual involving Colquhoun, who at the time was a spritely 74 year old, was performed on Samhain - described as 'Calan Gwaf' in Cornish - in the damp darkness of the underground fogou at Jo May's house at Rosemerryn (see photo): *The Nemeton rituals were influenced by The Regency, and what I picked up myself relating to Cornish folklore. For example I was interested in the spiral 'Snail Creep' dance, and I introduced the Cornish names of the feasts. And we used some other Cornish words, like Mys Metheven, (Month of June), and Mys Ebrel (Month of April) Mys Hwevrer (Month of February).*

133

WOOD&WATER 7
Special Cornish Edition **35p**

Wood and Water 7 (1980) with guest editor Jo O'Cleirigh, including contributions by Ithell Colquhoun, Brownie Pate, Jo May & James Whetter. The cover depicts Menacuddle Well and the Goddess Ceridwen 'in the robes of a Cornish bard'.

134

Another ritual was described in Wood & Water, in a special Kernow edition edited by O'Cleirigh in 1980:

> Footwear is removed at the narrow entrance and the one who represents the Maid enters and from a bowl sprinkles river water around the circle of thick grass. She is followed by someone who goes about with the richly smelling incense. Each of us is asperged and censed as we step within...

>we arise and go straight into a spiral dance inwards moonwise to the Maid standing in the centre then outwards unwinding the Spiral sunwise. This is a silent form of INVOCATION in which we all try to grow in awareness of the presence of deity in all of us...Then, as a token of our love, each one steps forward singly, kneels to the deities, holds the goblet of milk and honey aloft, pours their LIBATION on the central stone, each one making their own silent prayer if they wish.

> The Love Feast follows, and the Maid with her dark waist-length hair and who is from the sister Celtic country of Cymru, moves about the circle and places the spiced cake in each ones' mouth and offers each the cup of wine - only the night sounds about us and a great peace. All receive the Kiss and Blessing of the Maid, and we talk quietly and happily together in a close huddle. The rite ends as the lamps east, south and west are put out, the north is left to burn and that way we leave...

In 1982 (Beltane) O'Cleirigh floated the idea of starting a Pan-Pagan School (PPS): *I was in Egypt, in Alexandria, at the Greco-Roman museum and there was this bust there of Demeter-Selene and whilst looking at it I got the idea of starting the Pan-Pagan School. It really came to my mind because Alexandria had had the Great Library there.* The W&W article in question included the following:

> We re-affirm the ancient pagan view that all life is sacred, and that the spirit is manifested in the physical and not separate and in opposition to it...(The aim of PPS) is to help more people to understand this basic life-affirming view of the various pagan traditions, both those of the surviving native peoples, and of the new pagan groups...

O'Cleirigh called for articles, books, artwork and ritual objects to be brought together to help 'add to the pool of pagan knowledge', and he offered to put people up in his red and yellow hut in Lamorna. The following year he organised a special gathering to which many influential eco-pagans came: *In 1983 we had a summer school at Bel Bucca's place in Wales. It was very cheap. Monica Sjöö came to it, and Daniel Cohen, Jill Smith, Pete Brown, Jan Henning, Bel and others.*

The Pan-Pagan School also brought O'Cleirigh into contact with Miriam Simos, a West Coast American writer better known as Starhawk. On the strength of her book 'The Spiral Dance' (1979), which had made Wicca more accessible and politically relevant, Starhawk was fast on her way to becoming the most famous pagan of her generation. Jo O'Cleirigh explains: *I had various people who visited me. Lauren Liebling who knew Starhawk, and wrote poems in Spiral Dance, came to visit me in Lamorna. She actually slept on the floor of the caravan, which I wouldn't advise as it's so small!*

Lauren stayed for about a week, and she then sent Starhawk over. Starhawk came in 1984 (August). She had been doing lectures in Germany, and I agreed to meet her off the Roscoff ferry in Plymouth. She hired a car and we drove down to Lamorna, and I got her free lodging at Rosemerryn with Jo May.[3]

I took her walking along the coast. We went out to Nanjizel. We waded out to sea and we went into a cave and did some chanting. Then we arranged through the Quay Bookshop (Penzance) to do a ritual at Boskednan in the stone circle. We all met at Men-an-Tol. We had flaming torches, and quite a few people came from different directions, and we did a beautiful ritual there that night.

Starhawk wanted to go to Tintagel, so we drove to Tintagel, looked at Merlin's cave and walked up on the top, and then we drove to Glaston-bury. Through Gothic Image we'd made an arrangement to do a ritual on the Tor, so when we drove into Glastonbury there was a great big

mass of really exotic people - including Monica Sjöö - with great big carved staffs and robes! So we went up the Tor and the idea was for the ritual to bring the consciousness of the Goddess back to Glastonbury. Which I suppose it did really.

I couldn't stay any longer, so I took Starhawk to meet another friend, Daniel Cohen, editor of Wood and Water, and they went to meet the Greenham women. But I did stay in touch with Starhawk over the years.

In the spring of '84 (May 5th) O'Cleirigh had been initiated into Gardnerian Wicca, in a ceremony with four people present. O'Cleirigh: *I was very, very lucky because got my first degree in the upper room of the Clapper Mill which is in the Duffy and the Devil story. This was with a lady called Katie Ryder, originally from Doreen Valiente's coven in Sussex. My second degree was later with a coven called 'The Crannog' run by a lady called Donna Dibb. They were Alexandrians based in Bodmin.*

During summer '84, O'Cleirigh had also written (in Wood & Water) of plans to open a 'Centre of Gaia'. James Lovelock had moved to Coombe Mill near Launceston in 1979, the year his first book on Gaia was published (Lovelock, 1979). His theories were taken up with enthusiasm by many pagans. Using Fellowship of Isis contact lists, O'Cleirigh had been corresponding with Margot Adler, another celebrated American authoress (cf Adler, 1979): *Through Margot Adler I got in touch with Mark Roberts in Texas. He was expecting to be given a large sum of money and we were going to set up a Centre of Gaia in West Cornwall. But it fizzled out to nothing.*

Notes 1) In the early 80's Mike Howard's 'Cauldron' magazine did attempt to embrace eco-paganism, and included eg an article by Doreen Valiente on Gaia, ley-lines and earth energies (No 24 Samhain 1981). The piece prompted a lengthy, if tangential, response by Cecil Williamson in the next edition: *I can recall that morning long ago in Castletown when a letter from Mrs Valiente fell through the letterbox of my witchcraft museum... Gerald Gardner was like Tony Benn who in pursuit of his own interests has split the labour party. Gerald did the same for the re-emerging witch cults after WW2...*

2) Here O'Cleirigh is referring to ritual in open, public space rather than rituals intended for the public as participants. As Ken Rees explained (pers comm.): *The original Regency did not advertise at all to my knowledge. Everyone networked with each other in those days so many people on circuit would have dropped in as guests via word of mouth, some of whom formed an inner core. The Regency post-1970, did advertise in a small way via the pagan rags around at the time. As all of these had a very small circulation I doubt if many, if any, came along through such efforts. By the time we held the rituals (late evening in the woods) very few public were around and those that were completely ignored us. Everyone participated fully throughout: there was never ever any question of an audience as such, and the idea of filming or photography would have been complete anathema. Thankfully, it was all before the days of Instagram, etc.*

3) Some have indicated that 1985 marked Starhawk's first visit to Britain, however O'Cleirigh's meticulously kept diaries confirm his claim that this visit to Cornwall took place a year earlier, between 30th August and 1st September 1984, and included a visit to Menacuddle Well on the first day. O' Cleirigh and Starhawk arrived in Glastonbury on Saturday 1st September, where Monica Sjöö and a contingent from Wales, met them, and climbed the Tor to perform the ritual. They stayed at 2, St Edmunds Cottages. The following day, which was Sunday 2nd, O'Cleirigh visited Chalice Well with Sjöö and Starhawk, before Starhawk left for London to meet Daniel Cohen and visit Greenham.

16. The Awakening

*'Pagan witchcraft travelled from Britain to the US as a branch of radical conservatism;
it returned as a branch of radical socialism'* (Hutton, 1999)

In 1979 the most influential art critic of her generation - cosmopolitan
New Yorker Lucy Lippard - turned her back on the metropolis, and
came to live in rural isolation on a farm on the edge of Dartmoor.
Lippard, and her book 'Six Years: The Dematerialisation of the Art
Object' had, in the late Sixties, defined the range and meanings of
Conceptual Art, including the various spin-offs from it like Video Art,
and Land (or Earth) Art.

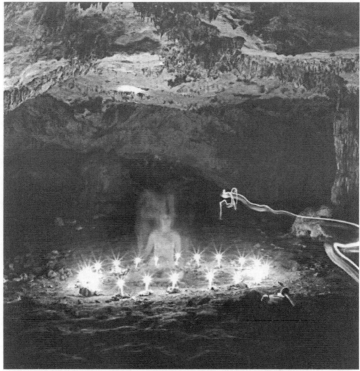

'Grapceva Neolithic Cave Series' created by American artist Mary Beth Edelson in
Yugoslavia (1977). Her trip was inspired by reading Gimbutas'‘Gods & Goddesses of
Old Europe'.

Her close friends artists Nancy Holt and Robert Smithson had visited Dartmoor several years before (Tate Etc, 2012) and Lippard's book 'Overlay' (1983) was written as response to her own stay there. As she told me in 2010, she'd originally had a different idea in mind: *I came to write a novel. I had a wonderful time writing it and never particularly had an urge to publish it. But then I fell for the stones. It was just coincidence that I ended up in such a place: I didn't know they existed. I started hiking on Dartmoor and - oh my God - there they were! I conceived it (Overlay) at the end of that year. I got really interested in it and I was thinking 'how do I deal with this because I'm not an archeologist?'* (artcornwall.org)

Lippard would later write about the significance of place and the importance of a sense of belonging (Lippard, 1997): *It was the intimate knowledge of the farm and the area I lived in that really started the whole 'place' business. It's very British...I got so obsessed about place whilst living in this farm in Devon that I wrote a short story which I never published about a woman who got so involved in a place that she disappeared into it. She went into the land and never reappeared... It was near Totnes. Ashwell Farm near Halwell. We never went to Halwell. It's close to Dartmoor. I inherited their retired cow-dog that was a border collie and he and I explored everyday. And you could walk - this is what I loved about Britain - you could walk through farm-yards and people would just say 'hello'. As long as you didn't leave the gates open and your dog didn't chase the stock, you were fine.*

'Overlay' is three-quarters art, and one-quarter archeology. The most striking thing about the book is the way it demonstrates the porosity of the categories of Art, Earth Mysteries, Paganism and Archaeology during the 70's. It also shows that artists based in the US, such as Mary Beth Edelson, Ana Mendieta, Robert Smithson and Carl Andre, for example, had many of the same concerns and methods as the British artists already discussed in this book. As Lippard explains insightfully:

Artists working today from models of the distant past are consciously or unconsciously overlaying their knowledge of modern science and history on primal forms that remain mysterious to us despite this knowledge.

The use of ritual by many artists in the 70's is exemplified in her discussion of Mary Beth Edelson:

The feminist development of ritual in art came in response to a genuine need on both the personal level (for identity) and the communal level (for a revised history and a broader framework in which to make art).

140

Her description of Alfred Watkins and ley theory is perceptive if flippant *'if leys don't exist, then Alfred Watkins was a very good conceptual artist'*, but Lippard is a big fan of Gimbutas' 'Gods and Goddesses of Old Europe' (1974) and Stone's 'When God was a Woman' (1976). Frequently making reference to John Michell's 'Old Stones of Lands End', Lippard errs towards the 'educated imagination' of alternative archaeology. She clearly favours Michael Dames views on Silbury Hill and Avebury over those of Aubrey Burl, for example, and dedicates several pages to comparing them.

> …I kept wondering how anyone so involved in his subject as Burl could resist giving it more life. I kept wanting to pat him on the back and say 'Go ahead man, live it up. Speculate a little'… Dames' is a visual theory which is probably why I am so taken with it…

Photos of Mên-an-Tol, Chun Quoit and numerous sites on Dartmoor taken by Lippard herself adorn the inside pages, and a number of artists associated with Cornwall and the South West are name-checked. This includes Monica Sjöö, who is the only painter in the book. Jill Bruce (Smith) is also mentioned, along with her husband Bruce Lacey:

> Assuming that prehistoric art was created not for esthetic reason but for a specific purpose Bruce and Lacey are convinced that rituals worked through contact with energies since lost to 'evolving humans'. In the mid-70s they set out to reestablish that contact, and have sometimes been mysteriously effective.

Ironically, however, by the time Lippard's book came out (1983), Jill Smith had already moved away from visual art and the London art world, at least as she had known it as partner to Bruce Lacey.

In 1982, a group of her friends were planning to meet for the summer solstice at the Callanish Stones on the Isle of Lewis. Smith had already started travelling alone - without Lacey - to visit sacred sites; sleeping outdoors cocooned in nothing more than a sleeping bag and a simple plastic sheet.

She decided to turn the journey to meet her friends into a pilgrimage, which she later called 'The Awakening' (Smith, 2000 & Smith, 2003). It started at Boscawen Un in West Cornwall: *I went down to Cornwall, and travelled up through stone circles all the way up the country. It's not exactly like a chakra system, but I'd got very involved in Tibetan Buddhist teachings, a cleansing practice visualising different sites in your own body. So Cornwall, Boscawen Un, was in the feet. It was like I*

was becoming the land. I was becoming Britain. These places were coming into me, like an internal map. And it was massively powerful.

I remember sleeping outside with no tent, spending days at each site. I would travel by coach then walk perhaps 15 miles to each ancient site in pilgrimage, and then sleep there for a few days. I would just nestle down into the earth. The earth really had become my mother then, and it enfolded me and kept me safe and secure. When I got up here (Isle of Lewis) I walked off the ferry and went and slept in the heather, and it felt like I'd come home. I'd never had that feeling before.

Having done lots of photography with Bruce, I stopped using a camera. I didn't want to experience everything though the lens of the camera. I wanted to be totally in it. But I had a frock with me on that first journey. It was a garment on which I sewed things. At each site I'd leave a little coloured disc, and I'd take something from the site, like a little plant and I'd sew it on the frock.

After the 'Awakening' walk I came back to East Anglia. But I didn't live with Bruce, so I'd given up everything, I'd even left my daughters. I lived in a caravan in a field. I went through a winter that was very heavy-going: a kind of shamanic death and rebirth. I made sense of it by turning it into a journey. Every dark moon and full moon I went to a long barrow or a chambered cairn or a well. And it kept me sane and I came through it.

The 'Awakening' journey took about six weeks and it was followed in 1984 by another that was even more ambitious, particularly as it was completed with Smith's newly-born son Taliesin (W&W42 (1993)): *At one of the fairs we'd got talking to a woman about Arbor Low. The 'Gypsy Switch' journey goes around Arbor Low which is the hub, like the hub of a wheel. She gave us a diagram. It relates to the zodiac.*

Others of Smith's 'journeys' had a political dimension: *I heard of people who were doing 'The Walk for Life' from Faslane to Greenham Common. So rather than travelling the whole thing with them, I did my own journey from Orkney and joined the walk at Coventry, again without a tent. I hitched. It was linking Neolithic sites of power, with nuclear sites. It was this thing about healing, because we really thought there was going to be a nuclear war.*

142

Illustration by Monica Sjöö in 'Pipes of Pan' (Lughnasadh) to accompany her
article on the protest of 1985.

*My 'Goddess awareness' evolved from my experience of the power of
place. I had a friend called Lynne Sinclair Wood who was Australian. A
very powerful woman, she introduced me to Monica Sjöö and the
politics of it all. That woman-power thing. And going to Greenham, and
feeling the amazing power of women, that was amazing. Starhawk was
part of that too.*

Monica Sjöö had been present in Wales - at the Tipi Village - during
the latter stages of Smith's pregnancy, and Smith had visited her near
St David's shortly after son Taliesin had been born (W&W71, 2000).
Writing in Pipes of Pan (Lughnasadh 1985), and using typically
impassioned language, Sjöö describes the protest a short while later
that she, Jill Smith and Starhawk were all involved in:

> On the 29th of April (1985) Jill and I and her baby Taliesin hitched from
> Pembrokeshire in South Wales/Cymru, where I live, to meet up with other
> women at Avebury in Wiltshire…Avebury with Silbury mound and
> Kennet Long Barrow is perhaps THE most anciently powerful centre of
> the Goddess in Northern Europe and has had great influence on our lives,
> both mine and Jill's. We are both artists deeply moved by the Goddess
> within us and in the sacred landscape.

> Starhawk suggested we cast a circle, ground ourselves and do a Spiral
> Dance at some point in the night….We chanted and drummed and danced
> in great joy and finally we all slept curled up close together on our
> Mother's belly (ie on Silbury Hill) and all around Her….I feel that it is no
> coincidence that the Greenham Common Cruise Missile base and
> innumerable other military bases as well as these firing ranges are situated
> in the vicinity of our Mother at Silbury and not far from Stonehenge. It

143

feels to me as if the phallic missiles are there to yet again threaten Her womb. I feel that it is the Goddess at Silbury and Avebury that magically empowers the women at Greenham, that She is rising within us in this Her hour of greatest need... that She is calling us to action.

Homeless, and having been essentially nomadic with her young son for more than a year, Smith lived with Monica Sjöö in Wales for several months at the end of 1985, before eventually finding a place for herself on the Isle of Lewis in February 1986, where she has been ever since.

Cover art for 'The Pipes of Pan' (1985) by Monica Sjöö.

Of course it was not only women who were caught up in the political ferment of the 80's. Writer and folklorist Steve Patterson (b. 1965), has recently written the biography of Cecil Williamson (Patterson, 2014). Cornwall-based now for more than twenty years - before which he was living in Plymouth - he attended the Stonehenge Free Festival as a teenager in 1983 and 1984. Famously, the police tried to prevent the event in 1985 and set up a cordon around the monument, resulting in the violent confrontation known as the Battle of the Beanfield. Patterson and

144

his friends avoided the trouble but were diverted to a field near Devizes instead. As he remembers: *There was a growing interest in the Green movement, CND, sexual politics, gay rights, alternative housing and alternative education during this period.*

Alongside these political ideologies, paganism started developing as a more theological element. In the 50's and 60's Wicca was very much for the aspiring middle classes. It was conservative, with a big and little c. But a big change happened when it got exported to the States. That's when it got politicised. And the voice that consolidated all of this was Starhawk. She brought together magic and radical Green feminist politics. These things just hadn't been bedfellows up to this point.

This was the end of the old school Wicca, and the old initiatic covens. Eco-feminism became the prevailing ideology through the Eighties. But the other thing that was present at the festivals was a proto-shamanism - before it was called that - then it was the 'Path of the Great Spirit' or the 'Red Road'.

At around the time Jill Smith gave birth to her son at Talley, Steve Patterson met some of her fellow tipi village dwellers: *As a young lad (17ish) I used to go round the free festivals and the peace camps, and I'd take nothing but a blanket with me. I'd just rock up there, and people had camp fires in the evenings and I'd always be taken in by someone.*

Monica Sjöö and Jill Smith naming Taliesin for the Goddess at St Non's well.
June 1984.

*At Molesworth Peace Camp I was taken in by some people from Talley.
And they talked about ideas to do with the Earth Mother, and living in
harmony with the land, and about 'prana'.*

*Then they started to build a sweat lodge, and one of the guys told me
that it symbolises the meeting of the red road and the black road - the
red road is the path of the native peoples in tune with the land, and the
black road is the path of the white man. It was a basically a bender
made of a willow and hazel dome, with tarps over the top, and a sauna
inside. They heated up the inside of this dome with hot stones, and we all
went inside - nude - and there were smudging ceremonies with burning
sage, done as a purification thing.*

*So as they were chanting these prana chants, a point came when I felt I
was going to explode, and I had to get out! I crawled out of the heavy
tarps - it was like crawling out of the womb – and two guys outside
poured cold water over me. My body seized up and I went into spasm,
and I remember being on all fours and looking up at the stars and
everything seemed so far away.*

*I sniffed out my clothes in the darkness, and in the morning I thought
'that was really strange', but I realised that I'd undergone some kind of
transformation. For a several days afterwards I was walking about as if
in a state of grace. I remember looking out over the Cambridgeshire
fells and I could almost see this prana spiralling and moving. And
looking back on it I had no language to explain it at the time, but it was
a true consciousness-changing shamanic experience.*

17. Belerion

Far way from the peace camps, one man's passion for Cornwall's ancient sites drove him to visit them all simply in order to document them properly. It was solitary labour of love, which culminated in the books 'Belerion' (1980), and 'Cornovia' (1985).

Craig Weatherhill (b. 1950) is, like many in this book, a polymath, with diverse skills spanning art, creative writing, cartography, folklore, language and archaeology. He is also living proof of the interdependency of all these fields of enquiry. He wrote to me in 2017: *My entire conscious recollection is of being brought up in Cornwall, specifically St Just, and very much shaped by my surroundings. At the age of 8, an old St Just lady gave me a first edition of Hunt's book of legends (c.1880) and it fascinated me. I realised that many of the stories were set within a few short miles of where I lived, so I set out to find the locations. I found that the archaeology and the legends were interlinked and, later, that language and place-names were all part of the same story, too. So they also became part of my studies.*

Weatherhill joined the RAF in 1972, with the intention of becoming a cartographer, but in 1974 he obtained a job as a draftsman with Carrick Council, and it was then that he started visiting the sites in West Cornwall, diligently surveying them all.

Surprisingly, Weatherhill never met John Michell, but his research shared with Michell's 'Old Stones of Land's End' one common reference point: *What started me on the surveys was Vivien Russell's 'West Penwith Survey' (1971), a catalogue list of all known sites and monuments in West Penwith, existing or otherwise recorded. I realised that hardly any had been accurately planned. Henderson and few other antiquarians had sketch-planned a few, but what was needed was as accurate a record as possible of what was actually on the ground at each site.*

As much of my spare time as possible was spent down in West Penwith doing just that. All in all, I surveyed over 200 sites, from small barrows 5m across, to the massive cliff castle at Treryn Dinas: one of my

*favourite sites, and chock-full of legend. I'd been surveying the curious
Treen Common stone circle when I was seen by the landlord of the
Gurnard's Head Hotel, and he introduced me to Peter Pool. Peter, in
turn, introduced me to Vivien Russell herself, and I thought the world of
her. She was, by then, pushing 80, had no TV in the house, wore cord
jeans and smoked Woodbine plains.*

Vivien Russell's West Penwith Survey (1971) was a key reference work for both John
Michell's 'Old Stones of Lands End' and Craig Weatherhill's 'Belerion'.

*Between them, they taught me a lot, and I joined the Cornwall Archaeo-
logical Society, and met people like Charles Thomas (Prof of Cornish
Studies Exeter University). Vivien's list included many field-names, and
Peter, of course, was fluent in Cornish and had written 'Cornish for
Beginners', so my interest in the language really began there.*

*I had no intention of writing any books, but did help out in 1979 when
the Cornwall Archaeological Society (CAS) wanted an updated version
of their 'Principal Antiquities of the Land's End Peninsula' book.
Charles Thomas and Peter Pool, the original authors, were too busy to
deal with it, so I offered to do the work. In 1980, a new publisher started
up in the area. Peter contacted me and said: 'With all these surveys
you've done, no one knows all these sites better, so why don't you write
a proper field guide to West Penwith?'. So I did and that was
'Belerion'!*

148

Full of illustrations and photographs, Belerion by Craig Weatherhill was the first of several guidebooks to the sacred sites of Cornwall published in the 1980s and 1990s.

Organised chronologically - ie proceeding in four sections from the Neolithic to the Early Christian period - it is the most carefully researched, and academically correct, of all the modern guidebooks covering the sites of West Cornwall. It is also chock full of Weatherhill's meticulous plans and drawings.

Although he refers to the 19th Century folklorists (especially Bottrell), and some of the stories attaching to the sites (eg the ghost at Pendeen fogou) Weatherhill resists being drawn into any wild speculation, or extensive discussion of leys, energy lines or pagan rituals.

Instead he does point out a large number of interesting historical facts. For example, the title of the book, 'Belerion', is a Greek word, which dates from the Iron Age, when Cornwall had a flourishing tin trade with the rest of Europe:

> This famous Cornish tin trade was of great interest to the Greek geographer Pytheas of Massilia (Marseilles, then a Greek colony)
> … he was faithfully quoted by the first century BC Sicilian-Greek historian Diodorus Siculus. So here we have one of the oldest written records of Britain; a factual account of Penwith and its tin trade, and a remarkable illustration of Iron Age life:
> *The people of that promontory of Britain called Belerion are friendly to strangers and…are civilised in their way of life. They carefully work the ground from which they extract the tin. It is rocky but contains earthy*

149

veins, the produce of which they grind down, smelt and purify. The metal is then beaten into ingots shaped like astragali and carried to a certain island lying off the coast of Britain which is called Iktis...

The island of Iktis is almost certainly St. Michael's Mount and it is known that the 'foreign merchants' were the Veneti, Breton Celts closely related to the Cornish.

Weatherhill also points out that, during a later historical period, Boscawen-Un stone circle is thought to have been of special significance:

> The stone circle appears to have been used as recently as the Dark Ages, for the ancient Welsh triads name a 'Beisgawen yn Dumnonia' as the site of one of the three principal gorsedds (bardic meeting-places) of the Island of Britain.

Fittingly, Weatherhill himself was made a bard shortly afterwards:
When 'Belerion' came out, and because of all the survey work I'd also done, Peter nominated me for Bardship so, in 1981, I became Bard 'Delynyer Hendhyscans' of the Cornish Gorsedh (the Bardic name means 'draughtsman of archaeology'.)

'Belerion' was followed in 1985 by 'Cornubia', a book that followed a similar format, but which took as its subject ancient sites throughout the whole of Cornwall.

20. Meyn Mamvro

'Meyn Mamvro' magazine was launched at 'Visions and Journeys' gallery in St Just at the Winter Solstice (December) of 1986. The intention from the outset was to cover a range of material, as the first editorial announced:

> Meyn Mamvro aims to provide a forum, an outlet, for an exchange of ideas and interests in the fields of earth studies, archaeology, Cornish culture and paganism. These different categories are not mutually exclusive – what they all have in common is a respect for our land, a great interest in the monuments and sites of the past built on it…

The words are those of its 'editress', Cheryl Straffon who had recently moved to West Cornwall. Straffon (b.1948) was brought up in Calstock in the Tamar Valley, and went to King's College, London to study English and Comparative Religion.

As Cheryl Garside, in the early 80's she contributed a series of articles to The Ley Hunter on Dartmoor, Exmoor and Bodmin Moor, carrying out field trips with Arthur Straffon who she would later marry. As she explains: *I was part of the scene that emerged in the 60's and 70's, given its impetus by people like John Michell. John and I inevitably met in London - we clicked because we both had Cornwall in common - and I knew Paul Devereux who at the time was doing a lot of his early work on alternative archaeology. I went to one of his evening classes in Kensington on some of this material, and so we became friends.*

Straffon, who also studied for a DipEd at Cambridge University, came to take up a job as the librarian at St Just Library: *I moved back to Cornwall when I was 38 (1986). I was used to the idea of a regional Earth Mysteries magazine, but when I looked around I was surprised that there wasn't one for Cornwall. There were a few people who were interested in these things, but they were not connected at that time. There were the Earth Mysteries magazines and Paganism magazines, and I brought both into Meyn Mamvro and it seemed to touch a nerve. It brought together all these isolated people who started to subscribe, and write for it and link up with each other.*

Meyn Mamvro

ANCIENT STONES & SACRED SITES
OF WEST PENWITH

Issue 6 £1.35

THE CELTIC CYCLE • CORNISH CROSSES
STONES CENTRE, INSCRIBED & MISSING
ANCIENT DREAMS • DRYADS • WELLS
LEYS & EARTH MYSTERIES • PAGANISM

Cornish for 'Stones of our Motherland', the name, as well as the content and stapled A5 format of the periodical have remained largely unchanged for thirty years. The painting of the Goddess on issue 6 is by Gabrielle Hawkes.

At the time, she saw Paganism and Earth Mysteries as inseparable. This was unlike others, such as Paul Devereux: *It wasn't as though he (Devereux) was against Paganism, but he didn't want it to intrude on what he was increasingly beginning to define as a pseudo-scientific discipline. I think he thought that it muddied the waters a bit. To me it was vital because the sites were nothing unless we began to understand the people who used them, and what they might have used them for. And*

152

that's how my interests came together. But there weren't many of us. Most of the EM mags were very definitely not into the spirituality-side 'you don't go there, you know!' [1)]

Eclecticism thus became a key characteristic of Meyn Mamvro, and one which helped ensure the magazine's longevity. As with Jo O'Cleirigh, contact with pagans in London had played a role in encouraging Straffon's wide interests: *I was not brought up as a Christian - my parents were atheists - but I was always interested in a spirituality that was earth-connected. If I had to be labelled, in my younger days, I was a Pantheist, like the Romantic poets who saw spirit in nature everywhere.*

But the Sixties saw the rise of the Neo-Pagan movement, which was still quite hidden. The turning point for me was an evening class in London with Ken Rees called 'Mythology, Folklore & Witchcraft'. All the hippies that went would go to him and ask where they could join a coven. He couldn't be open about it, because he was doing a Local Authority class and it would have been closed down! It was a very different world in those days - Paganism was still very underground.

But one day Ken called me at work. He said 'I was very interested in what you were saying in the pub. Would you be interested in coming to something in Highgate woods? Bring some good walking boots and a candle in a jar, and we'll meet at the tube station at 10 o'clock'. He was very non-specific. I agonised as to whether I should go, but I did and it was a working coven, a spin-off of the Regency coven that met there. This was my first experience of ritual and it blew me away. [2)]

I stayed with them for a year and a day, and learnt all the basics. Then the group broke up, but I felt I'd now got enough knowledge to carry on, so I started a small group of interested people, one of whom was Ken. We formed a little mini-coven and used to meet in our garden in South London, and we did that for about a year in the early 80's.

The garden in question belonged to Arthur Straffon: *I moved into Arthur's house there, and we built a stone circle with stones we'd brought up from Dartmoor and Cornwall. When we were moving to St Just, the removals men were boxing things up and I said 'I've got something in the garden I want you to take'. I nipped outside and deconsecrated the stones quickly, but the removals men couldn't believe it 'you want us to take these rocks to Cornwall?'*

153

When Ken knew we were moving down he gave me Jo O'Cleirigh's contact details. Jo was living in the woods in Lamorna, and he cleared a lovely space in the woodland behind his caravan, and that's where the stone circle went.

Jo and I worked together and attracted other people who were interested as well. He was the only person in Cornwall I knew, who was as experienced as I was.

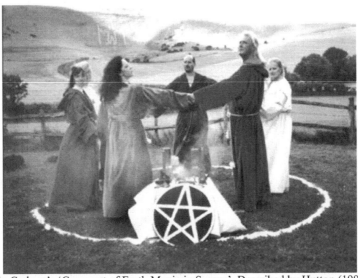

Kevin Carlyon's 'Covenant of Earth Magic in Sussex'. Described by Hutton (1999) as 'benevolent and public spirited', they performed public rituals on several occasions in West Cornwall.

Early editions of Meyn Mamvro magazine were well received and the number of willing stockists rapidly multiplied from two (originally Visions and Journeys, St Just and The Quay Bookshop, Penzance) to eighteen. Some outlets were not so accommodating. The refusal of the small folk museum in Zennor to stock it on the grounds that it was an 'affront to Christians' was reported in the local media (newspapers and radio). It provoked a proud and defiant response from Straffon, who quickly found herself becoming a spokesperson for Paganism (MM 4):

> As a faith Paganism holds the Earth sacred, as our Mother who sustains and nurtures us, and believes that all fellow creatures should be respected not exploited. To pagans all life is interconnected and love for our Mother Earth and thanks for what she gives us is expressed in ritual and celebra-

154

tion...The ancient sites are held as sacred places to be approached with reverence and curiosity. The ancient ways are sources of wisdom and understanding and should be followed up and kept alive...If paganism means caring for our Earth, the ancient sites and the traditional ways then we are indeed proud to be called a pagan magazine.

Straffon was thrust into the spotlight on a few other occasions in the early days of the magazine. Kevin Carlyon was a media-friendly witch - often in the tabloids - who knew Alex Sanders during his final years. Based in St Leonards-on-Sea, Carlyon also, incidentally, acted as the printer of both Meyn Mamvro and The Ley Hunter. He and wife Ingrid performed open, public rituals in Cornwall on three successive summer solstices (Merry Maidens (1987), Men an Tol (1988) and Nine Maidens (1989)) and also at Halloween (Nine Maidens, 1991).

As well as receiving front page coverage in the Cornishman newspaper, in 1989 two vicars were invited to challenge the Carlyons on their beliefs live on Radio Cornwall, (MM10). The appearance was then followed by Straffon, who was concerned to convey the fact that Paganism was not in conflict with Christianity, and should n't be presented in that way by the media.

Straffon herself continued to perform rituals, though her own group was more discreet than the Carlyons', and was never explicitly mentioned by name in Meyn Mamvro.

Cheryl Straffon: *We had a small, mixed group called 'Lor Hag Mor' which means 'Moon and Sea'. It was always semi-closed in the sense that new people could join but they had to be the right people. It grew out of the work with Jo, but it was re-envisioned because I was getting more into Goddess. We did ritual drama that was linked to legends in the Cornish landscape. So for example we used the beehive hut at Bosporthennis for a Lammas ritual to do with the death of the Corn King. Lor Hag Mor was a very powerful group and the people involved in it were very committed. Arthur Straffon was involved initially but then we separated.*

Steve Patterson: *Cheryl's rituals around the standing stones were some of my very first ritual experiences. This was when I first started coming down to Cornwall.*

155

The Lor Hag Mor group on Bosporthennis, discussing the symbolism of the corn dolly. Luhnasadh, 1991. Cheryl Straffon is kneeling next to Arthur to the right of the photo.

For many years, from 1987, Straffon also organised public May Day celebrations around a maypole she had erected near her house on Carn Bosavern.

Notes 1) Whilst Devereux was wary of ritual, others, who were part of The Ley Hunter's inner circle like the first editor Philip Heselton, called for more focus in this area (eg TLH 100).

2) Ken Rees first attended The Regency rituals in Queens Wood, Highgate, during 1974 and 1975 as a participant observer, ie as a pagan involved in post-graduate sociological research. He subsequently became friendly with key members of The Regency like Ron White. According to Rees, the spin-off group Straffon refers to may have been P.A.N. (Pagans Against Nukes) who used the same site in the wood in the early 80's. Ken Rees: *P.A.N were very political and did `earth magic' from time to time. In fact, I did organise the odd festival rite for P.A.N. I also wrote a Halloween ritual for Cheryl's group.*

21. Drinking from a Golden Bowl of Light

The edition of MM that reported on the first of the Carlyons' rituals, also contained an understated but poignant tribute by Jo O'Cleirigh to Ithell Colquhoun who, on 11th April 1988, died at Menwinnion Nursing Home in Lamorna.

During the last year of her life she had received regular visits from O'Cleirigh. He recalls their conversations: *I didn't talk to Ithell much about high ritual magic, because I'm more into the down to earth craft – paganism. She was more into the Golden Dawn, but where she did touch on Paganism was in her animistic attitude to the land and the sites, so we tended to talk about that. And we talked about Egypt. I know she went on a 600 mile Nile cruise, and the funny thing is that the woman that led the cruise was Dr Veronica Seaton-Williams who I knew.*

I used to go to Menwinnion with Alison Reynolds. Alison and Medland came to live in the chalet at Chy an Goverrow when I was there. They got into making gigantic drums and didgeree-doos and were in a group called Thelemic Pulse. I found out that Medland had shared a house with Attaturk, Aleister Crowley's son in Penzance, and they had their own version of Thelema. Because of their mutual Thelemic interests they and Ithell had a lot to talk about. Before she died, Ithell gave Alison her own copy of 'The Living Stones', annotated with the real names of the people.

In a simple ceremony that included Alison and Medland Reynolds, after her death, Colquhoun's ashes were scattered from a clearing on the clifftop adjacent to Lamorna harbour.

Jo O'Cleirigh's tribute in MM mentions Colquhoun's sense of isolation, and includes a quote from one of her poems:[1]

Pagans still feel they are such a minority and yet Ithell was a lot more isolated than we are now. She often expressed her frustration to me at finding so few people over the years in Cornwall who shared her feelings. She did though, take part in one beautiful rite we held some years ago in Lamorna.

Sadly, the recent resurgence of interest in seasonal pagan celebrations in W. Penwith, a study group of PAN-PAGAN SCHOOL and MEYN MAMVRO itself, all came too late for her participation; she was already ensconced in a home for the aged.

Two weeks before she died, we visited lthell for the last time and talked long about the return of the Old Ways in Cornwall, in which she took a keen interest. That day, she tried hard to keep us beyond our time.....

And now, 'She has directed her eyes to the West,' and passed to Amenti, to Tir-nan og and the Apple Orchard. 'May she live forever!'

> '.....forgive me that I forgot your timely libation!
> I was drinking from a golden bowl of light
> I was bathing in a diamond spray of sea
>
> Do not strike with your lightning-rod but stand
> Robust, a wand enduring in my hand.'

1) Taken from 'Grimoire of the Entangled Thicket' (1973)

22. Journey to the Stones

Cheryl Straffon's magazine was helping to address any lingering sense of isolation, and in looking for articles she was fortunate in being able to tap into a growing network of accomplished writers all inspired by the prehistoric landscape of Cornwall. Like Craig Weatherhill, they were essentially a different generation to Colquhoun, Michell, Wilson and Redgrove but this second generation all, to a lesser or greater extent, drew from the insights and ideas of the older writers.

Ian Cooke's first book, 'Mermaid to Merrymaid: Journey to the Stones' (1987) is structured around nine suggested walks across Penwith. The book is peppered with examples of Cooke's own artwork, as well as allusions to astronomical and megalithic alignments, the ritual year and magic.

Cooke (b1937) had had a spell in the army – posted in Hong Kong – before studying at Kingston School of Art and working as a printer in Kingston and Surrey. In the late sixties he moved to Cornwall. He recalls: *'Dalton's Weekly' had an end-of-terrace house for sale in St Just for £950. Then later the old school house at Men-an-Tol came up for auction. I went to the auction straight from the potato fields. I'd been picking potatoes and was filthy dirty! I moved in in about 1980. The first year I was there, I opened it up and put some of my pictures on the wall, and I was surprised that there was a steady flow of people wanting to buy them.*

It was after a visit to Gavrinis in Brittany that Cooke started to see the antiquities of Penwith in a new light. His art changed, becoming full of visionary, abstract designs, and he started reading about pre-history in the local libraries. In this regard he recognises a debt of gratitude to Craig Weatherhill: *Belerion was one of the first books I bought. It was that and one or two other pamphlets that started me off.*

Cooke continued to visit and revisit the sites of Penwith, studying them at different times of the year. One of his most interesting early finds was at Boscawen-Un. *The central stone has two axe heads carved into it which I discovered early one morning. It was midsummer, about 4.30 in*

A print by Ian Cooke (1985) depicting Boscawen-Un stone circle. The sun can be seen striking the centre stone, and energy radiating out to the other (19) stones, creating new life all around it. The zig zags are inspired by Bronze Age pottery.

the morning. There aren't many archeologists who are up at that time in the morning!

Cooke's most profound insights have tended to come at times like this when he has been alone at the sites. Perhaps for this reason he remains sceptical about group ritual activities: *I went once with Cheryl and some others to Nine Maidens. It was Cheryl's husband that was leading the ritual, and they had a big incense burner. But I didn't get into it. It's too much like organised religion. But each to their own!*

161

His book 'Mermaid to Merrymaid' includes a notable section on the evolution of the family, based on Engels' idea of the original women-dominated 'matrilineal clans'. It explores the relationship of the moon to menstruation and the Goddess, and in another section, focuses on the Celtic god, Bran, noting his association with Caer Bran and the Mên Scryfa stone.

There is also an extended section on fogous, a topic with which Cooke, thanks to his original research, has been associated ever since:

> The one possible function that has consistently been 'glossed over' or 'guessed at' has been that Fogous were intended for ceremonial purposes concerned with the religious beliefs of the pagan Iron Age. There are several features built into the architecture of Fogous which are very difficult to explain satisfactorily outside of some kind of ritual purpose. The tiny restrictive 'creep' doorways leading into the larger tunnels and chambers; the obvious degree of permanence intended for the structure which was the most durable building of the community; and the most odd feature of all the curvature and orientation of the principal passageway. I think that these last two characteristics give the clues to the function of these 'caves'.

He would explore this issue in more detail in a later publication.

His own work having influenced Cooke's, in 1988 Craig Weatherhill became the Conservation Officer for Penwith District Council. It was a job that at times seemed like a David and Goliath struggle. Craig Weatherhill: *During the days under the Dept of the Environment, there was little problem with the overseers of heritage. But 'English' Heritage (EH) took over in 1984, and there were problems from the start.*

Weatherhill believes English Heritage (EH) facilitated the destruction of a Bronze Age landscape on Truthwall Common and failed to intervene when it was apparent the Cadburys Creme Egg Hunt was resulting in damage to numerous Cornish sites. But the most remarkable incident related to the Iron Age village of Chysauster: *One capstone in the fogou had become unstable. EH said it would cost £80,000 to repair it: labour costs, they claimed. I said it would cost nothing – we had a 300-strong Cornwall Archaeological Society, including good archaeologists and people skilled in traditional granite construction. One block and tackle, and we'd have a nice, stable fogou again. 'We don't want them,' said the voice in London. 'We want people who know what they're talking about!' Peter Pool then got the tip from the then custodian at Chysauster that EH were planning to go and fill the fogou in. So he and*

The Merry Maidens featuring a mayflower surrounded by 19 stones. Linocut by Ian
Cooke. 'One horse is being consumed by the winter, the other is coming out in the
spring. The raven is a symbol of Bran'.

I got onto Radio Cornwall to publicly blow the gaff, but the fogou was craftily filled in one weekend a month or two later anyway.

By this time Weatherhill had moved away from his surveying work, and would bring out his first Alan Garneresque novel 'The Lyonesse Stone' in 1991.

23. Secret Shrines

Ian Cooke's 'Mermaid to Merrymaid' was the first book of its kind to be reviewed in Meyn Mamvro. 'Secret Shrines', by Paul Broadhurst (MM5 Spring 1988) followed closely behind it, however. Several years in gestation, its first edition is a huge, sumptuous volume, with introductions by both John Michell and Colin Wilson.

Book launch for Secret Shrines at St Clether. L to R Robin Hanbury-Tenison, Paul Broadhurst and Colin Wilson. Hanbury-Tenison is an explorer, and founder of 'Survival International'. Photo: Paul Broadhurst.

Broadhurst had originally hitched down to Cornwall from London via Glastonbury Tor in 1969. Only 17 at the time, he settled in Boscastle, a stone's throw from Williamson's museum: *I had done some candle-making, so rented a stall outside Camelot Pottery and started selling candles. Then I moved into a little shop round the corner.*

For a while Broadhurst also worked as a photographer, involved with a number of publications, including a newspaper that he helped set up in Launceston. He combined the job with his own, more personal, research: *At a sale at Jeffrey's in Lostwithiel was a box of books for a fiver, and in that box was a copy of the Quiller-Couch book 'Ancient and Holy Wells of Cornwall' (1894)....I wondered what had happened to them in the intervening 100 years, so I started hacking my way through the undergrowth and rediscovering them. There was a terrific buzz to that.*

Not only are they the oldest sacred sites on earth, far older than megaliths, but they seem to have absorbed the entire history of humanity...

I used to collect the water from each holy well in wine bottles and have them on a rack in my cellar. They all have different mineral content. But it's not just the minerals. There is more going on. Anyone who goes and sits quietly at a remote holy well, will sense that there's an amazing atmosphere about it. They're like portals into another time-zone.

My mind started to open up and I became more sensitive to subtle energies. At the time I was reading Ithell Colquhoun. I was always into the esoteric side and had a group of friends, like Penny Harris the artist, who visited Ithell at Menwinnion. At the time everyone you bumped into was into stone circles, it was the hippy era – the last dregs of it anyway.

I started writing up the notes I'd collected over a few years, and with a lump in my throat I wrote to Colin Wilson, one of my heroes. He was so nice. He said 'come down for supper, bring the manuscript, and we'll see what we can do'. I knew about John Michell's stuff, because everybody did, and Colin said 'the man you want is John'. Colin gave me his address and phone number.

I wrote to John and he wrote back and said 'Wow, what a fantastic project!' He loved Cornwall. So, like Colin, he said 'come up, and bring the manuscript'. He said 'you won't find a mainstream publisher' (we tried Thames and Hudson), 'so just do it yourself.' He did it in the old Victorian way – where you gather your subscribers until you've got enough to pay the printer. I printed some flyers and he gave them out to all his friends and I got a fantastic list of subscribers: Lord this and that: all the aristocrats. I spent quite a lot of time in Notting Hill after that.

Secret Shrines book launch at St Clether holy well. Picture includes Tony Roberts (Glastonbury author) and John Michell (sitting with striped trousers), plus Jamie George of Gothic Image (central), talking to Cheryl Straffon with husband, Arthur.

Mark Thomas who used to run the Quay Bookshop in Penzance was a great focus in those days, and every time I was down there I would drop in and see him. He mentioned that he knew a woman, Cheryl, who was starting a magazine. So I went to see her, and it was n't much later that she did her own version of the book.

Though written in the late 80's, Secret Shrines is infused with a vision-ary quality that harks back to Michell's best work of the Sixties. Indeed, in all his books Paul Broadhurst shows a natural affinity with this first flowering of post-war Earth Mysteries. This is evident eg in the book's unflinching endorsement of ley-lines, for example: *'their existence cannot be in doubt'.*

Referring to Lovelock's Gaia theory, very early in the book Broad-hurst makes a heart-felt plea for the environment:

It is only in comparatively recent times that the great nature religions, that were the living demonstration of th(e) interaction between the human

167

species and its environment, were supplanted by different modes of thought…It is high time we began to see clearly…that which was understood intuitively by the peoples of earlier times.

Matriarchy	Patriarchy
Lunar knowledge	Solar knowledge
Intuition	Intellect
Right Brain	Left Brain

Binary opposites contained in Colin Wilson's essay, derived from Robert Graves' 'White Goddess' and Robert Sperry's split brain research.

In his introduction, John Michell strikes a similar note, whilst Colin Wilson's effusive essay, again, restates the theme of the lost knowledge and skills of the ancients (see table).

In the main body of the work, in which Broadhurst describes visiting many of the holy wells of Cornwall, he, at one point refers to his own writing as *'a bottomless sea of purple prose'*. Certainly as well as leys, 'Secret Shrines' is full of references to earth energies, elementals and water spirits (the naiads). For example, referring to Celtic rites he says:

(The) rhythms of the celestial bodies were also recognised as affecting the countryside in a more localised fashion, concentrating pulses of energy into the fusion points on the Earths surface. At certain phases of the Moon, or when there arose some critical relationship between the heavenly bodies which directly affected the flow of Earth-energies, these forces were at their most potent. Waves of unseen elemental energy would course across the landscape as the magnetic flux of the Earth reacted to the changing influences of the planets and stars. Cascading currents generated by the invisible interaction of the great bodies would cause the sacred shrines to assume a special potency as this power was concentrated at the old sites, drawing in the local people who knowingly channelled the pulsing energies in a magical rapport with Nature.

These particular times, when the old sites are alive with the Cosmic Breath were specially revered as the time when the priest or priestess could summon up the nature forces in a particularly potent manner. Versed since childhood in the Mysteries and trained by 'the hoary headed eld of old' in the magical techniques the initiate would thus dip into the mystical cauldron of inspiration, communicating with the concealed regions. The well-spirits, or Naiads, were particularly venerated as beings of great wisdom and secret knowledge, for they existed independently on a plane beyond our visible world unrestricted by our mundane concepts of space

168

and time. Communication with these levels of being gave access to knowledge of past, present and future, and the wells became the focus for such activities famous in the time of the Druids as centres of hydromancy...

24. The Sun, the Serpent and the Troytown Maze

In 1986, whilst in the throes of getting 'Secret Shrines' published, Paul Broadhurst was introduced to Hamish Miller. The meeting would prove more auspicious than either could have imagined.

Miller had enjoyed a successful career as a businessman in Sussex, but moved to Cornwall aged 56 (late in 1982) after a life-changing near-death experience (NDE). Hamish Miller: *When I look back now to the time before the NDE, I feel it was a completely useless life, even the Jaguar and all the paraphernalia that goes with the world of business...So, I moved to Cornwall...* (Twinn, 2010).

Whilst starting part-time work as a traditional blacksmith, Miller took up dowsing in 1983 as a result of meeting the founder of 'Fountain International', Colin Bloy, at a talk in Devon. Based in Brighton, Bloy claimed to be a healer as well as a dowser. As Miller recalls: *Colin Bloy introduced me to the whole concept of the earth having energy...He felt he could give healing to places by applying healing to the 'hara', or the energy centre. His method was to find the energy centre of the area he was trying to balance and then to apply a conscious acknowledgement of it – or as he said – just give it love* (Twinn, 2010).

Bloy, following Guy Underwood's 'Patterns of the Past', had spent more than a decade dowsing for energy lines at sites across the world. Inspired by Wellesley Tudor Pole's WW2 'Silent Minute', he had become convinced that directed in the right way human thought could, itself, influence the ley-system and *'enhance the dowsable energy field'* (Pers.comm., Paul Broadhurst 2017).

In fact, as a dowser, Hamish Miller was largely self-taught and through a process of trial and error – whereby he tested patches of ground in his own garden – he developed his own theories about earth energies: *The line in the garden began to have a characteristic feel. It had at that time*

maybe 20 different bands of energy, but it started to expand. The next week I would work with it and it had grown to 40 or more…In due course, I came to realize that it was actually responding to the fact that I was working with it…and that the whole earth energy matrix was dynamic, and it was changing in real time…(Twinn, 2010)

In St Mabyn, Miller, who was already in contact with the Penwith Fountain Group,[1] introduced Broadhurst to the ideas of Colin Bloy. Paul Broadhurst: *It was early November, 11/11, I think. I got an anonymous letter saying Hamish Miller will be talking about dowsing at St Mabyn Village Hall. At the time Hamish was deeply into a different type of dowsing to do with subtle energies, earth energies, auras, that sort of stuff, so by the end of the evening he'd got everyone in the hall walking around with coat hangers! It is something that anyone can do to a better or worse degree, but when you realise that it's not you who is doing it, and when you get results you aren't expecting, you start to realise there must be something in it. It was the first time I'd done dowsing with a real dowser.*

Broadhurst had been alerted to the existence of the giant ley-line originally described in Michell's 'View Over Atlantis': *I used to get up early on May Day morning and go to Brentor (on Dartmoor) and wait for the sun to rise. I did it for about five years and I found it a profoundly moving experience. Later on, someone mentioned it being on the St Michael line, and that's when I looked up John Michell's stuff.*

Broadhurst, in turn, introduced Miller to the Michael line, and it soon became the focus of their collaboration: *A few weeks after we met at St Mabyn I was sitting in Merlin's Cave in Tintagel, one of my favourite places, and I got this very strong impression that Hamish and I had to do something together. It was so over-whelming I got in the car and drove straight down to his forge in Lelant. We started talking, and we went back to his place a few miles away, and we literally stayed up all night long, talking about all the things we were interested in. At the time he had never heard of the St Michael Line, so I had the pleasure of introducing him to it, and come the dawn, we had the germ of an idea, and thought: 'Let's go to St Michael's Mount now!'*

It was February 1987: *As we dowsed across between the Mount and Marazion we found this huge band of energy. I don't know if we were sensitised because we'd been up all night, but we thought 'wow it looks like there is a big line coming out of the Mount. What do we do now?'*

We thought 'there is only one thing we can do and that is follow it and see where it goes', and it led to Leedstown.

There is a church there built by Benson, the Bishop of Truro, and we walked in and there was this incredible, buzzy atmosphere, like it was full of electricity. We went back the next Sunday, with our dowsing rods clanking at our sides. The vicar looked up and said 'can I help you?' We said 'we're following a leyline from St Michael's Mount'. 'That'll be the Michael line then?' We were absolutely dumbfounded. 'Oh yes I know all about that - that's why they sent me down here. If you'd have come in here 6 months ago you'd have been sick because there was such a noxious atmosphere in here. I'm the exorcist by the way, and because the church is on the Michael line the Church sent me down to clean it up'.

He would never have spoken to us if he'd known we were going to write a book about it, he just thought we were a couple of nutters and so he opened up, and I think he did get a bit embarrassed about it later when the book became so successful.

'The Sun and the Serpent' – the acclaimed book in question – was a few more years in the making: *It took multiple outings over 2 or 3 years. We were both completely broke at the time. We would go to the pub in Hayle and empty out the coppers in our pockets to see if we could pay for another half pint. And if we had enough money to put some petrol in the tank we would, and go and do it. I was bringing up three children and Hamish was trying to earn a living repairing prams in his forge. We were really on our uppers so it really became an act of stupidity or dedication: you can choose the word depending on what side of the fence you're on!*

As it was nearing completion Broadhurst and Miller became diverted by another project that would have them mired in controversy for years. Cornishman Donovan ('Don') Wilkins, was – unwittingly – behind it. Unlike Broadhurst and Miller whose turn would come later, he was already a celebrity dowser, and in spring 1989 a three-part series dedicated to his work 'Donovan the Diviner' would be aired on BBC2.

Donovan Wilkins discusses the ancient phenomenon of water divining. (BBC2, 6.30)

'Science refuses to acknowledge the strange and ancient phenomenon of water divining...' Donovan the Diviner on BBC2: recommended viewing in The Guardian. May 18th 1989

Paul Broadhurst: *Don was the world's greatest water dowser. He literally transformed people's lives. When you walked into his house he had a hazel twig on his wall. You'd say 'Nice twig Don'. He'd say: '£120,000: that's what that 'twig' has earnt me. When people say that dowsing is rubbish, I can point that out!'*

Don told me how he discovered earth energies. He was near Duloe stone circle finding water for the farmer, but he was getting interference. He was worried he was losing his powers, but then he looked over the hedge and saw the stone circle and realised he was picking up a line of earth energy from the circle. Earth energy is largely created by underground water, the pressure of water passing over fissures which are lined with crystal, creates a highly energetic field.[2]

Earlier, in November 1988, Wilkins had taken his famous dowsing rods to the Scilly Isles. Paul Broadhurst: *The locals asked Don to restore the old labyrinth on St Agnes, on the Isles of Scilly. It had become a shapeless mass even in those days, so Tim Hicks who owned the land asked Don to go down. Don was like a god on Scillies – he never had to buy a drink or pay for B&B – because he'd given them water.*

When they wanted the labyrinth reconstructed they asked Don, and Don asked Hamish and me and Ed Prynn – well known megalith maniac. And the four of us trolled over there and had an incredible time.

173

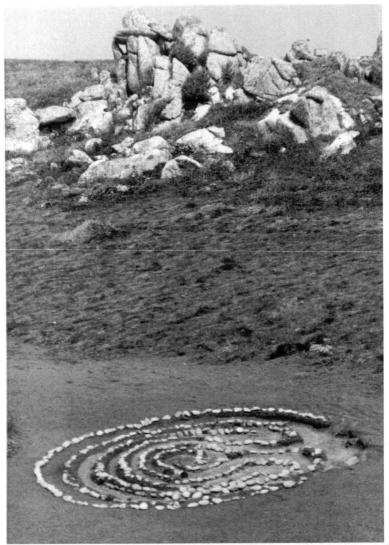

Troytown Maze, St Agnes c1980 before its restoration by Don Wilkins and 'Fountain International'. Photo Paul Broadhurst.

By the time we'd got there they'd levelled the site because it was in a terrible mess. They took the stones away and levelled the ground, so there was a flat piece of land there ready to be rebuilt. We spent a few days selecting those lovely egg-shaped boulders from the beach and bringing them up.

174

But the interesting thing here is that when we first got to that site Hamish and Don started dowsing it. Hamish said 'My God. The shape of the labyrinth is in the earth. You can dowse it!' and so they did. The story is that it was built by a bored lighthouse keeper. But no, that lighthouse keeper must have been invited to build on top of something that was already there.

The hilarious bit is that Don used to use a carbon-fibre dowsing rod, one of the strongest materials on the planet, and when he got to the centre it snapped like a twig. And Don just stood there with his eyes bulging and said 'I've never found energy stronger than that'. So we rebuilt it according to its proper place, and the locals used to come out and bring us sandwiches and pasties and stories about how they didn't go to church when they were lads, they used to come to the labyrinth instead, and it was a tradition that went way back.

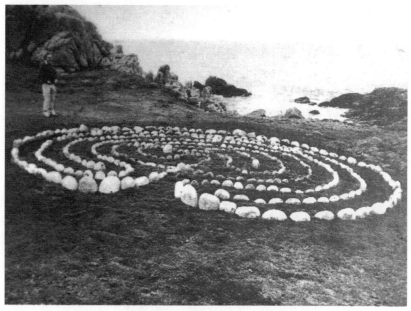

Troy Town Maze, St Agnes
(Restored)

Hamish Miller admiring the newly restored Troy Town Maze (photo as displayed in the Museum of Witchcraft in 2016).

The restoration was announced in April 1989, in 'The Fountain', a magazine then edited by Paul Broadhurst. Cheryl Straffon reporting in MM8 (Spring 1989) seems relaxed about the whole thing:

....Troy Town landscape maze on St Agnes, has recently been completely restored by dowsers Don Wilkins, Paul Broadhurst, Hamish Miller and Ed Prynn ...The maze has gradually deteriorated over the years from its original labyrinth shape, but 3 days hard work by the team replacing the stones has brought back the earlier design. Perhaps the most exciting discovery was that under the maze was found the remnant of an earlier one in the form of buried stones and pebbles indicating that the maze was not just constructed by Amor Clarke in 1729 but that he probably turfed over the earlier one and built on that.

But not everyone was so sanguine. Paul Broadhurst: *It wasn't long until the ley hunters heard about it, and were fuming. Evidently we'd destroyed an ancient monument. But of course none of them had bothered to speak to Tim Hicks to find out why he didn't want the archaeologists there: but he knew it would take 10 years for them to do anything.*

ANNOUNCEMENT

Fountain International report that they have totally removed the remnants of Britain's only stone labyrinth, on St. Agnes, Scilly Isles, along with the subsoil. During this procedure, apparently, the remains of an earlier labyrinth were found and no record was made of it. They returfed the spot, dowsed what they believed to be the correct labyrinth pattern, which they marked on the turf with aerosol paint, and then built a new labyrinth.

Jeff Saward of Caerdroia Project is investigating the situation and will report in TLH 108. Interim, this magazine wishes to publicly deplore such unilateral and precipitous action.

Statement in 'The Ley Hunter' Spring 1989 (TLH 107) condemning the rebuilding of the St Agnes Maze, which had been announced by Paul Broadhurst in 'The Fountain'.

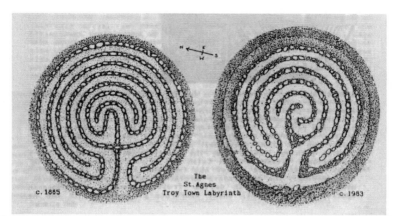

Illustration in Caerdroia 22 (1989) showing the deterioration to the St Agnes Maze that had taken place between 1885 and 1983. In the same article Jeff Saward indicates that Fountain International's new maze was, incorrectly, several feet wider than the original.

Jeff Saward of specialist maze journal 'Caerdroia' expressed concerns that the Fountain International team had found but failed to adequately document the second older labyrinth under the first. He quoted Paul Devereux:

> ... 'your actions have been those of destruction, not reconstruction and it is inevitable, because you posture as 'ley line' workers, which you are not, that all those of us working damned hard in Earth Mysteries will get tarred by your act of ignorant – and arrogant – vandalism. Your actions were merely an outward sign of your belief-system thinking'.

Paul Broadhurst: *Nigel Pennick was writing for the broadsheets, and thanks to him the St Agnes story got into The Guardian and it was quite vitriolic. Whenever you're dealing with new ideas and fresh research you court controversy.*

Despite the furore, Broadhurst and Miller returned to finish their book, 'The Sun and The Serpent'. It had very much drawn on Broadhurst's previous experience as a journalist and writer: *I did all the writing. Hamish wasn't a writer. Hamish was the dowser. I'd been a reporter and a newspaper man, and I was used to taking notes and photos. We published it in the time-honoured tradition of 'Secret Shrines', and John (Michell) supported us. John was nobody's fool. He was a scientist, but he was a mystical or spiritual scientist.*

177

The book is a deeply Romantic work, even more so than 'Secret Shrines', and it very much kept John Michell's original vision alive. In writing the introduction, Michell gives Miller and Broadhurst his ringing endorsement:

> The signs of an approaching climax of revelation are rapidly increasing, and this book is one of them. It was not written by the authors' own decision or for their own benefit. They were impelled to do it by forces in nature which are now active in disclosing knowledge, long hidden, to a generation that desperately needs it and is now ready to accept it.

In the first chapter, Broadhurst describes the alignment of the St Michael Line with the Beltane sunrise: Beltane being a time when beacon fires would have been lit along its length to celebrate the return of Bel, the Sun God. He also acknowledges Ithell Colquhoun's influence and contribution, and describes dowsing as a 'latent sixth sense'.

The first print-run – limited to 888 copies – of The Sun and the Serpent is delivered to Paul Broadhurst's home. Photo: Paul Broadhurst

The main body of the book seems to sparkle with innocent, wide-eyed wonder, as Broadhurst describes 'the dowser' and 'the navigator' setting forth to pursue the huge earth current, as it proceeds further east from St Michael's Mount.

Within a few miles, the two men realised that rather than follow the straight alignment of the ley as had been predicted, the current was *'curving away from its expected route'* and *'meandering like a giant snake'*. At points along the journey it also narrowed, converged and plunged into the ground, creating star-shaped pentagrams of dowsable energy.

Hamish Miller in 'Sun and the Serpent' contemplating a pentagram or 'node' below Brentor on Dartmoor.

It passed under the modern Chapter House of Truro Cathedral, under the tottering boulders of the Cheesewring, and the lonely peak of Brentor. On reaching Glastonbury it changed direction at the Holy Thorn of Joseph of Arithmathea, then passed through Gothic Image Bookshop, before appearing to coil around the Tor itself:

> It flowed round the hill in a totally unpredictable fasion, delineating a complex shape that seemed to have no rationale...like a vast electrical transformer with its coils of wire wound around a central magnetic core, the volcanic mound seemed to be a generator and transmuter of natural energies that exerted a powerful effect on human beings...

179

Eventually, a year after they started their quest, in February 1988, Miller and Broadhurst had managed to follow the energy line as far as the immense Neolithic temple of Avebury in Wiltshire. Here, in the midst of the sarsens, they were struck by a fresh revelation:

Another current joined it (the Michael line), crossing in the centre. There was no doubt. There was another serpent. One that appeared to be a different frequency but just as powerful...the second serpent seemed gentler, smoother and altogether more feminine than its counterpart...What if we had discovered the female equivalent of the Michael force? If the Michaelic energies had an affinity with high places...then it was possible that their more feminine counterparts would seek out openings in the womb of the earth...The energies were of different polarities. One type was Solar in influence, traditionally associated with St Michael, the other was Lunar, indisputably feminine and connected with the Earth goddess whose Christian counter part was St Mary.

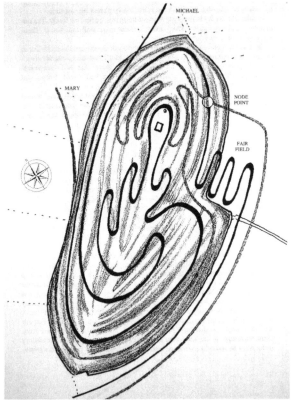

The Michael line interlocking with the Mary line on Glastonbury Tor: a complex 'chalice' pattern discovered on Miller and Broadhurst's second visit to 'Avalon'.

180

They realised that the dowsable pentagrams were node points where the Mary and Michael lines crossed each other. They also realised that they would have to return to Cornwall to dowse the Mary line from its beginning west of St Michael's Mount at Carn Lês Boel. This they did, and eventually they followed both serpentine currents up as far as Hopton in Norfolk.

Paul Broadhurst kept John Michell up-to-date with their research as it progressed: *When I told John that there were two lines and they wiggled all over the place he smirked a bit in that old Etonian way and said 'it doesn't surprise me because it's the caduceus isn't it?'. He wrote about it in the introduction.*

When he first went to Glastonbury and discovered the Michael line he painted a mural in the cafe there of the twin serpents. I didn't already know about this, so we weren't trying to fulfil anyone's vision when we discovered the second line, but it makes sense.

When the book was published, Miller and Broadhurst were not expecting the response they had: *We were expecting all hell and high water to break out because we were challenging all sorts of preconceptions. We thought 'the historians and the scientists aren't going to like this'. But it was the Ley Hunters who didn't like it. They were vitriolic. Incredible. I'd never seen such an explosion of hatred! We thought 'what's going on here?' I'm a great admirer of Paul Devereux's work. But he took against it so vehemently that they devoted whole pages of the Ley Hunter to denouncing the book, and he got all his writers to rubbish it.*

Notes 1) Sheila and Trevor Nevins, based in Perranuthnoe, led the 'Penwith Fountain Group'.

2) Paul Broadhurst has another anecdote concerning Don Wilkins: *Ed Prynn wanted every type of megalith in his garden. He wanted a holy well, as that was the only thing that was missing. I said 'you should speak to Don'. So Don came with his stick, and he put some pegs in the ground then said 'theres one coming in there, and one coming in there. They're 110 ft down and there's about 200 gallons a minute of pure potable water'. So he got his drilling rig in, and thump, thump, thump, through the granite for about an hour and a half. And then at about 100 ft the sound changed and became more hollow, then all of a sudden this great geyser of muddy water shot up into the sky. Everybody was completely covered in it, and the Western Morning News photographer who was beside me looked like the creature from the black lagoon! He'd got it to within a foot.*

25. The Dragon Project

At around the same time that 'The Sun and the Serpent' came out (1989), the world's pre-eminent Earth Mysteries magazine, 'The Ley Hunter', moved to Cornwall. As its editor Paul Devereux explains, he and his wife Charla hadn't really planned it that way: *It was an accident. We were going to move to Monmouth, and we nearly bought a house there, but we had to go to Cornwall to do some research near Land's End, and for entertainment we'd look in estate agents' windows. As fate would have it, we found a three-cornered house in Alma Place and we fell in love with it. The house we were going to move to would have been nearer to motorways and communications, but we gave all that up and*

TLH 110 spring 1990. Produced shortly after Paul & Charla moved to Cornwall, it included a summary of the findings of The Dragon Project to date.

cancelled the purchase, much to the anger of the owners. There was a lot of work needed to the Alma Place house, but we moved there anyway. It was wonderful living there: just doing everyday things like going to the Post Office and glimpsing the blue sea between the buildings on the way. I wasn't a stranger to Cornwall. I'd visited it several times before as it's a very rich archaeological region, of course. And I've always been naturally interested in the St Ives School of Art. It's not entirely to my taste but I'd been interested in Peter Lanyon, and one of my tutors, John Dalton, was a great friend of his.

Devereux was also already acquainted with a few Cornwall-based writers, including Cheryl Straffon who he first met at an evening class in the 70's: *I used to teach at a school during the day in London, and ran evening classes on what was then called Earth Mysteries, which I'd do two or three times a week. They were in Kensington, Swiss Cottage, and the Institute of Adult Education in the West End. Places like that. I first bumped into Doc Shiels at a Fortean Times conference. I remember howling with laughter. He was such an entertainer. I was friends with Bob Rickard (founding editor of Fortean Times). And of course there was Colin Wilson. I had quite a few meals with Colin. I remember reading 'The Outsider' when it first came out, and I thought it was a fantastic book. I asked Colin to contribute an article on the 'Windsor Horror' to The Ley Hunter. On one occasion, I bumped into him in New York. He'd been doing a workshop at the 'Open Centre'. I asked him what topic he dealt with in his workshop. He answered, 'Well, me of course!'*

After taking over as editor of TLH in 1976, Devereux had set about systematically testing some of the central assumptions of post-war ley-theory. It was a project that would preoccupy him and a number of collaborators for more than a decade: *Interest had grown in the psychedelic Sixties and everyone was dowsing themselves insane! But some of us bothered to research where the idea of leys and 'energy lines' came from.*

It wasn't the politically correct thing to do, but in 1977 we launched 'The Dragon Project' when it became clear that no-one had actually done any accountable research on 'energy lines', or 'Earth energy' in general. It was simply an idea that was floating around that people were taking for granted. It emerged at the same time as transistor radios with their printed circuit boards, and I think that image had a lot to do with it.

184

Radioactivity in Cornwall

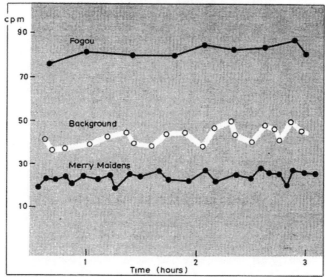

Geiger anomalies at Cornwall. Cornwall is granite: background Geiger readings would be expected to be higher than at Rollright, and indeed were around 40 cpm. But readings in the vicinity of two granite circles in a granite landscape gave readings substantially below this background; an effect that is quite mystifying. The level noted in the fogou (underground cavern) is above background, which is in keeping with other observations in enclosed spaces, such as caves

Dragon Project research reported in The New Scientist (21st October 1982) by Don Robins. This data had been mainly collected by Alan Bleakley. [1]

Don Robins, who was part of the project, recalls the nature of Earth energy as it was debated at a meeting in a pub in Paddington in November 1977:

> The protagonists of Earth energy suggested that it was a kind of synthesis of various forms of electromagnetic and mechanical energies, which arose from the Earth's crust and interacted with solar and cosmic radiation. At certain times, on midsummer day for example, the energy became conc-entrated at certain points or nodes, or along lines between nodes; or so the theory went. Some protagonists went on to suggest that people with psychic powers, or dowsers, could detect those foci of energy, though ordinary mortals might be aware only of a vague 'atmosphere'. Some suggested that ancient, Neolithic people were receptive to the influence of those centres of energy and built their shrines and sepulchres upon them; …. All very vague, perhaps; all too mystical for comfort…The Earth energy hypothesis, said Paul Devereux, demanded formal scientific study. [1]

Ultrasound at Rollright

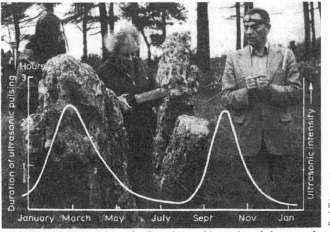

At Rollright, Oxfordshire, the duration and intensity of ultrasound pulsing is greatest at the equinoxes, with little effect detectable at the solstices. Dragon Project investigators are John Steele, a Californian archaeologist, left; Geoff Blundell of Audio Ltd, centre; and Leslie Banks

More Dragon Project research in The New Scientist (1982). [1]

The initial structure of 'The Dragon Project' emerged as a result of this meeting, and was later described in detail in 'Places of Power' (Devereux, 1990):

> It was decided to run the effort as a two-pronged approach: a 'physical' programme measuring known energies, and a 'psychic archaeology' programme using dowsers and various forms of psychics on site. Dr G.V. 'Don' Robins agreed to help co-ordinate the physical work and John Steele the psychic research…I took on overall coordination…

The 'psychic archeology' arm of the research furnished interesting but unreliable data. Don Robins' 'physical measurements' arm proved more productive, however, with fluctuating radiation levels, anomalous ultrasound and radio signals, and novel light phenomena all being recorded. Paul Devereux: *We had to conduct measurements for three months at and around the Rollright Stones (the site that was our defacto headquarters in the field) doing really detailed Geiger-counter checks to find out what was an anomaly, because cosmic radiation and radiation from the ground varies so much everyday. Granite is radioactive, and, as we found, a little dolmen encased in granite has a higher than background reading. We even did this in the King's chamber in the Great*

Pyramid which is clad in granite, and has a radiation reading about five times higher than the desert around it.

During the 70's and early 80's, The Ley Hunter had been a refuge for some daringly outlandish, even crackpot ideas but this was changing and, Devereux had become very wary of what he described as 'unaccountable' researchers.

> The Dragon Project worked with many psychics and dowsers. It is as a result of ten years' work in these areas that my dissatisfaction with 'energy dowsing' has emerged: it is not some off-the-cuff prejudice – no-one has looked at on-site energy dowsing work more comprehensively than I have (TLH 110, Autumn 1989).

By the end of the 80's a rift had opened up between the new generation of energy dowsers and those Ley Hunter stalwarts who, through experience, had become more sceptical. Broadhurst and Miller's 'The Sun and the Serpent', despite having John Michell's endorsement, became very much a test case.

Paul Devereux inside the granite-clad inner chamber of the Great Pyramid.

Tom Graves, poacher turned gamekeeper (he was himself a dowser), was one of the first to attack the book (TLH 113 Winter 90/91):

> Research is not real or significant until it's done properly. So I simply do not believe the claims that Hamish Miller and Paul Broadhurst make in 'The Sun and the Serpent'...They have not covered a single site in real detail. They physically cannot have covered the ground of the two 400 mile

187

Mary current and Michael current…Their diagram of the Avebury district implies many weeks of work, but the book makes it clear that it was all done in a day. And all too obviously, much of what they see is what they expected to see.

Yet 'The Sun and the Serpent' is merely the least bad of the new genre of so called 'energy dowsing research'. Some of the new stuff is unbelievably bad with the worse excesses of the New Age – its mindlessness, its elitism, its intellectual laziness, its crass instant enlightenment – displayed for all to see.

Their reputation already tarnished by the St Agnes maze incident, for Nigel Pennick, it seemed clear that Miller and Broadhurst's involvement with Fountain International brought with it a more sinister agenda:

This book…adds yet another jumble of divined lines to the ever-growing chaotic palimpsest of scribbles that dowsers have claimed to be real…importantly the so-called St Michael Line from Cornwall to Suffolk, the basis of this book, was disproved categorically by Michael Rehrund in 1975. It is not a ley, for only small sections of it consist of aligned sites…

…this magickal current is responsible for obliterating, as recently as 1989, the only ancient stone labyrinth in these isles. These are the plain-to-see dangers of any self-appointed new priesthood, and this book may well become a bible for such cultists…It is hoped that Monica Sjöö's new book on the New Age will shed more light on the dangers of these cults…

During the period he was living in Cornwall, Devereux became increasingly worried about the credibility and status of Earth Mysteries. Though he didn't say it at the time, he is now more candid about the effect that 'The Sun and the Serpent', and books like it had: *It (Earth Mysteries) became devalued. It became a corridor of mirrors. People would pick up stuff in a magazine, then would go on and proselytise it even more and you'd get far away from any reality. The big St Michael Line nonsense was nonsense, but it was read widely and believed in. In my time in Cornwall the position of this imaginary ley line moved sideways five miles according to those who wrote about it. Let's just say it was a moveable New Age feast!*

The original idea was John Michell's. He'd stretched a taut horsehair across a map of southern England linking a site in East Anglia with Land's End and passing through Avebury and a handful of other sites. If you run a line 400 miles through Britain you are inevitably going to hit a lot of ancient sites, including the most popular church dedications of St Michael and St Mary. The so-called St Michael Line was remarkable

for how few sites it hit. Then it got caught up with dowsing and energy lines. Oh dear. Life is too short. What a waste of time and mental energy!

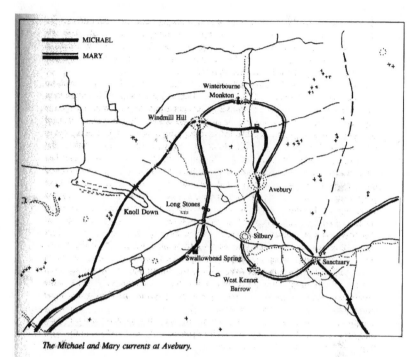

The Michael and Mary currents at Avebury.

The Avebury district diagram from 'The Sun and the Serpent': object of criticism by Tom Graves

I'd met Sig Lonegren in America. He was talking about beams of energy coming down from space and hitting the ground and turning right angles. Look, it was bonkers, there's no two ways about it! And these New Age energy dowsers never put themselves under test to see if there is anything objective about their claims.

Devereux now, in 2016, is not completely averse to dowsing: *Objective dowsing where you're looking for lost objects or water can occur in gifted people. It is a form of what I call primary sensing.*

At my evening classes I used a row of plastic cups holding, variously, salt or sugar or unadulterated water. They all looked identical. I'd ask

189

people to see if they could dowse the difference. It turned out one old guy could dowse it accurately every time. But most people, all the people in the classes actually, could do no better than chance. In Cornwall, Don Wilkins, felt that a lot of energy dowers were either kidding themselves or else dowsing water without understanding what they were picking up.

Though they were near neighbours in Cornwall, Devereux and Hamish Miller were never able to see eye to eye, despite attempts by Cheryl Straffon to reconcile them. She recalls: *There was a big schism in the Earth Mysteries movement between the dowsers, and those, like Paul (Devereux), who were really renouncing the notion. I had a foot in both camps, and could see both points of view. In fact I tried, memorably, to bring them together. I was living in St Just at the time, and I invited Paul and Hamish over for a meal to try and broker a peace deal between them, but it ended very acrimoniously!*

Paul Devereux: *Hamish didn't even acknowledge me last time we met, because I had dared to challenge him. Dowsing from a car or aircraft, or making unaccountable claims – you don't do it. It becomes self-delusion. Then if you write a book or do a workshop, you get acolytes, and you simply spread your own delusion. We see it politically today: if you repeat a lie or misunderstanding often enough, it becomes taken as fact.*

Straffon explains her position: *Dowsing is a useful tool to reveal things about the ancient sites, like helping to find stones that have gone missing. But I'm not into the idea of energy lines. I'm not denying it, but so what? What does it achieve? Where does it take us?*

The whole idea of The St Michael line, came into the public conscious-ness through the work of Hamish and Paul, and people still talk about it now as if it's an actual fact. But it isn't. These Michael sites do not actually align. But it is a key to unlocking the mind and way to enter an alternative reality.

Paul Devereux: *Due to the 'New age-ification' of Earth Mysteries we lost a lot of serious, research type of people; people who would have taken Earth Mysteries in a more accountable direction. There's stuff out there that is mysterious and needs looking at. But it got lost in a swamp of nonsense and New Age-ism. And so I thought bugger this, I'll go and do my own thing! Since 1979, I've now written 27 books. More people*

read The Sun than a more serious broadsheet, so if you want a big sale you write a load of tosh. It's the way of the world unfortunately. I've always tried to stay intellectually honest.

Surprisingly, Paul Broadhurst ended up being grateful for the negative press, but TLH, which for so long had been the lynchpin of the Earth Mysteries movement, was beginning to implode. He told me: *It was fantastic because everybody all rushed out to buy 'The Sun and the Serpent' to see what the fuss was about. 90% of our correspondents said 'this feels right. It's not just a projection by two nutters'. That just made it worse because then it was all guns blazing at us, and in the end it did destroy Devereux's magazine because it became so dogmatic.*

We found it quite amusing. They'd (TLH) spent most of the last decade rubbishing the establishment, but they didn't realise that they'd become the establishment, and they were impervious to stuff they didn't like, the things that didn't fit their paradigm. This is the way of the world. It wasn't long 'til their magazine folded and the whole thing fell apart. But I have to say, looking at all the surviving magazines, everybody now is into dowsing because it gives you the opportunity to interact with a site according to your talents and skills. Not everyone is a great dowser, but the difference with Hamish, is that his mental discipline was exceptional. He trained himself through meditation to attune like a radio dial to a particular frequency.

Book sales of 'The Sun and The Serpent' were helped further when, in 1992, Channel 4 commissioned a documentary based on the book. Paul Broadhurst: *'The Sun and the Serpent' was syndicated all over the world. It was filmed by a local production company: John Neville and his wife. It was a re-enactment, and they used the same title which helped the book sales. Now it's gone into folklore, and it wouldn't have done that if we'd made it all up. If it doesn't have a resonance of truth it doesn't last.*

It was always a source of bewilderment that Paul Devereux took so strongly against 'The Sun and the Serpent'. I suppose at this time, with the book still popular and in print, all we can say is that the proof of the pudding is in the eating. For almost 25 years now hundreds of dowsers have verified our results...

By the time 'The Sun and the Serpent' was published, Miller and Broadhurst had already started planning the follow-up. 'The Dance of

the Dragon' which came out ten years later (2000), describes their quest
to follow an even longer alignment called the St Michael and Apollo
axis, first noted by the French brothers, Jean and Lucien Richer. [2]

The adventure took Miller and Broadhurst and their female partners,
from Skellig Michael off the Irish coast, through Cornwall, France, Italy
and Greece before they finally ended up in Israel, as they tracked the
course of the massive earth currents, the intertwining Apollo and Athena
lines, over several years.

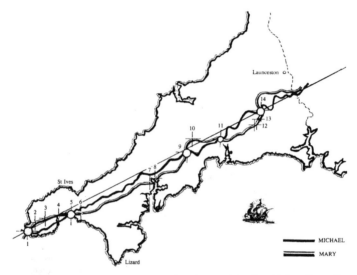

Map of Cornwall showing the winding paths of the Michael and Mary lines (from 'The
Sun and the Serpent')

In fact they had first encountered the Apollo line as early as March '89,
when they had attended a Fountain Conference on the Mediterranean
island of Rhodes, in the company of John Michell. Miller and
Broadhurst had taken Michell's ideas and followed them, literally, to
their ultimate conclusion. Paul Broadhurst: *John came with us to Rhodes
and enjoyed following the Apollo Line with us across the island. They
were fun days; the world is a sadder place without John's gentle
humour, open-mindedness and scholarship.*

192

Notes 1) The Dragon Project's attempt to adopt a more 'accountable' research methodology, was rewarded by a double publication in the New Scientist magazine in 1982: Don Robins, "The Dragon Project and the talking stones" *New Scientist,* 21 October 1982, pp. 166–168, 170–171 and Paul Devereux & Robert Forrest, "Straight lines on an ancient landscape" *New Scientist,* 23/30 December 1982, pages 822–826.

2) In 1992, soon after 'The Sun and The Serpent', Paul Broadhurst also published 'Tintagel and the Arthurian Mythos', which portrays Arthur as the embodiment of a sun god. In it Broadhurst, for example, demonstrates that Tintagel and Stowes Hill on Bodmin Moor are both on a line with the the rising and setting sun at the time of the solstices:

'the ceremonial observances that took place at the Winter solstice would have been the most critical of the year, for if the Sun God and his earthly reflection the Sun King were not in harmony with the sacred land the terrestrial paradise could be transformed into a wasteland'.

26. CEMG

In 1989 CEMG (Cornish Earth Mysteries Group) started up. Cheryl Straffon recently wrote on the MM website: *Meyn Mamvro included a note in its ninth issue that some readers might like to consider starting up a local Earth Mysteries Group with meetings in the winter and field trips in the summer. The result was that MM organised a talk by Paul Broadhurst and Hamish Miller…which was well attended, with about 50 people present, and a Committee was soon formed.*

Logo designed by Andy Norfolk

The committee included Paul Devereux and his wife. Cheryl Straffon: *Andy (Norfolk) and I were really the two people who got the CEMG off the ground. He also got CASPN (Cornwall Ancient Sites Protection Network) established. When Andy resigned as chair I took it over and it's become a big part of my life.*

Andy Norfolk (b. 1952), who has contributed visionary cover art to Meyn Mamvro for many years (from issue 19 onwards), moved to Cornwall that same year (1989). Like Straffon, he'd come to Paganism via Earth Mysteries: *In the 70's my wife and I were traipsing around all the ancient sites armed with John Michell's 'View over Atlantis'. The idea that we are living in the ruins of this lost civilization really caught the imagination of people at the time, even though John's view in this regard was, shall we say, 'optimistic'.*

194

Andy Norfolk leading a CEMG group in the late 90's. Photo Cheryl Straffon.

He was also inspired by Guy Underwood's 'Patterns of the Past': *I discovered I could dowse when I was 18, about the time we starting visiting the sites (in 1970). I was in the Birkenhead area, and we went to see Paul Screeton and got to know quite a few people in the Earth Mysteries community. Then I went to Leeds Poly and did Landscape Architecture. Earth Mysteries was spread across the country at the time. Philip Heselton, and John Billingsley were up North, and Bob Trubshaw was more Midlands-ish, there was stuff in Kent, and along the South Coast. There were people beavering away all over the country.*

Norfolk became a pagan after reading the sacred texts of all the main religions, and he did so without ever being involved in Wicca or its variants: *Wicca was the most public face of Paganism in the 70's, but there were also people who were influenced by OBOD. (Order of Bards Ovates and Druids) and Ross Nichols. And there were other people who were just finding their way into thinking about the world in way that was pagan in essence. I knew a lot of people who saw the world as alive in a very real sense, and reacted to it in that way, and they wouldn't have called themselves Wiccans, witches or druids.*

He recalls the first of the CEMG meetings, and the controversy provoked by 'The Sun and the Serpent'. As a dowser he was, in fact, sympathetic to its ideas: *I thought it was an interesting and brave book*

at the time. I'd done a lot of dowsing around Stonehenge and Avebury and I knew perfectly well that there were a lot of these lines around. Since then I've dowsed the Michael and Mary line and the Athena and Apollo line down here. On the West Cornwall dowsing outings we discovered that the lines had moved quite a lot; they were not where Hamish said they were. It's a big and complicated world and trying to fit it to a single theory may not work well. It's best to keep an open mind about it.

A CEMG outing with Don Wilkins, visiting Chun Quoit. Photo Cheryl Straffon.

Don Wilkins was often asked by Norfolk to give talks, and lead outings as part of CEMG: *Don Wilkins first discovered dowsing when he was riding his bicycle because he kept falling off at the same place, on a track near Carn Marth! He worked out it was a dowsing reaction, because he legs would tense on the pedals and when he passed the water line he would flip off the bike. That's when he discovered he could dowse for water...*

27. Monsters of the Id

The flurry of 'second generation' Earth Mysteries books continued with 'Monstrum', Tony 'Doc' Shiels' own 'magnum opus' which appeared in 1990. It was another book with a foreword by the ubiquitous Colin Wilson.

Interviewed by Allen Saddler for The Guardian in 1977, in the 80's Shiels had befriended the crew of Greenpeace's Rainbow Warrior whilst she was berthed in Falmouth for several weeks. Several of his paintings were subsequently used to decorate the boat's interior.

Often reporting on visits to Ireland and *'the conjuration of wurrums'*, Doc had his own column, 'Words from the Wizard', in 'Fortean Times' (FT) magazine. Inspired by Charles Fort's investigations of odd and anomalous phenomena, Fortean Times had been started in 1973 by Bob Rickard, and it had a close and supportive relationship with The Ley Hunter. Paul Screeton (TLH editor 1969-1976), for example, is credited by Rickard as having *'urged on the first few uncertain issues'*, whilst Screeton, Devereux and other Ley Hunter regulars also contributed articles to it.[1]

Whilst Shiels never wrote for The Ley Hunter itself, he did correspond with ex-editor Paul Screeton and, later, appeared in his 'The Shaman' magazine five or six times between 1982 and 1986. Doc Shiels: *Paul Screeton once came to my house in Ponsanooth with Paul Devereux. I was absent, but they kindly left a bottle of strong cider on the kitchen table…*

Shiels, who was often reliant on others for transport around Cornwall (he didn't drive), also saw a lot of Peter Redgrove during the late 80's and early 90's. Paul Broadhurst: *Peter Redgrove was an occultist as well. I met him and Doc Shiels at a book fair in Truro. What a crazy day! He (Doc) never stops drinking Guinness and his capacity for it was exceptional. I remember Colin (Wilson) being there too. Doc Shiels sat in the back of my MG midget, shouting and screaming as we went along the street. It was hilarious.*

Doc Shiels in Lough Leane 1981. Photographs of Shiels' coven appear in various publications, eg Luhrmann's 'Persuasions of the Witch's Craft' (1989). Though they didn't meet in person, in 1991 Shiels sent Jo O' Cleirigh similar, related, photos.

Both partial to a drink, Shiels and Redgrove also often met in pubs in and around Falmouth. However Neil Roberts, Redgrove's biographer, has noted that Redgrove's journals indicate that he was rather intimidated by Shiels, and nervous of his charisma. At the time Redgrove noted: *'He (Shiels) does have a very powerful aura, that of a hypnotist'.*

Reviewing 'Monstrum' in Meyn Mamvro Cheryl Straffon said:
MONSTRUM – A WIZARD'S TALE' by TONY 'Doc' SHIELS is a gallimaufry of a book – a great rambling farrago of Cornish dragonlore, pagan magic, surrealism, monster-hunting and the supernatural…Like the earth aspect itself, the book weaves in and out of reality and illusion, a shifting perspective of the natural and the supernatural. Much of it is set in Comwall…and gaily roams over aspects of occultism, shamanism and witchcraft, including modern-day followers of the "old religion", a few of whom he claims are "actually native-born, hereditary followers of pagan Celtic witchcraft... that is to say, their beast-horned god was (is) old Cernumnos who has great power in Kernow'…Correspondences, 'coincidences', and coexistences are compounded in this strange and very curious walk between the worlds, as Doc Shiels goes in search of serpent-dragons and monsters of the id, and keeps "spiralling downwards and inwards to the subaquatic, subterranean regions of physical and psychical worlds…

Shiels would later appear in the BBC2 documentary 'Fear of a Deep Blue Sea', and on Channel 4's 'Fortean TV' (both programmes aired in 1997). By this time he had moved to Ireland, where his children were then living, and had resolved to concentrate his efforts on his first love: painting. Prolific in number and exuberant in style, the iconography of his canvasses refers to his own life and career, his obsession with the sea, and with Moby Dick, Mr Punch, Celtic Mythology and Picasso (White, 2015).

The first crop circle sightings in Cornwall were in 1990 – and a spate of them followed in 1991. Photo above by Paul Broadhurst includes Hamish Miller. (MM 17). Prof. Charles Thomas believed they may have been caused by electromagnetic anomalies (MM18).

'Monstrum' was one of a quartet of books published by 'Fortean Times' at the end of the eighties. Also amongst them was 'Lost Lands and Sunken Cities' (1987) by Nigel Pennick. Pennick, as writer for The Ley Hunter and co-founder of the Pagan Anti-Defamation League, is a good example of the continuing close relationship between Earth Mysteries and Paganism at the time. His 1987 book includes a chapter on 'Lyonesse', the land lost under the seas off Lands End, and originally described in Geoffrey of Monmouth's 'Matter of Britain'. Cheryl Straffon republished a large section of the chapter in MM8.

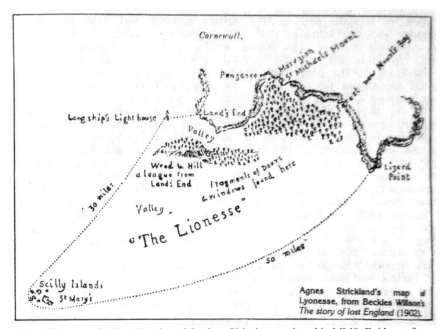

Map of Lyonesse in 'Lost Lands and Sunken Cities', reproduced in MM8. Evidence for Lyonesse includes the fact that Roman historians described the Scilly Islands as having once been a single island.

Notes 1) Interestingly Rickard was also friends with John Michell, and they collaborated on two books with a strong Fortean flavour ('Phenomena: a Book of Wonders' (1977) and 'Living Wonders' (1982)). In both of them, Doc Shiels' 'Morgawr' and 'Birdman of Mawnan' make an appearance.

28. The Valley of Trelamia

Three of the most intriguing articles in 'Meyn Mamvro' were written by Robin Ellis in the early 90's. Similar in character to Doc Shiels' work, they are a blend of 1970's Earth Mysteries and Cornish folklore. 'Spirit of the Lizard' (MM12, 1990) was the first:

> It is well known that earth energy creates dreams and legends in unspoilt places, or where the earth has been opened up. In The Lizard the earth energy is often known as 'Snake Breath'....Listening to the earth-spirit through the openings in the ground has the effect of a sort of naturally occuring L.S.D.; creating electro-magnetic energies, and causing U.F.O's, vivid dreams and visions! Apparitions of a female entity! Gigantic snakes and strange voices! The shining people, and the giant serpents who can talk coming out of the ground in the valleys! Dreams inside the sea-caves full of light! ...Some of the Pellar are part of the mystery. They are the nature mystics and Shamans of Cornwall, and some of them are guardians of these valleys. These Pellar have their origins, supposedly, in a Celtic saint! This saint, whoever she was, seems to have got confused with a local Cornish Goddess; a kind of female pixie, or a Snake Goddess, from remote antiquity! The Black Goddess, Lilith, in Her serpent form perhaps?

Inevitably readers of MM were interested to know whether Ellis' claims were in any way authentic, and it was noted (eg by Andy Norfolk) that the 'pellar' and the 'snake goddess', bear a striking resemblance to a character in an earlier radio play by poet Peter Redgrove.

BBC Radio 4 produced more than ten plays by Redgrove, co-author of 'The Wise Wound', during the 70's, 80's and 90's. The extraordinary 'Valley of Trelamia' was first broadcast on August 6th 1986, and it is a semi-autobiographical account of an Earth Mysteries writer called John, who visits the Lizard peninsula, where he falls in love with the eponymous Rose Trelamia. Rose lives in a remote cottage, and, it turns out, owns one of John's books entitled 'Earthquake Power'.

She shows John her ring. 'It's called a Cornish milpreve', she says. 'It an adderstone. It is worn by a Cornish person who can expel curses; a pellar; a healer. It is said to be made from the breath of a thousand snakes'.

Later John describes his infatuation with Rose in a phone call to fellow writer Clemence: 'I met a remarkable woman Rose Trelamia…She has theories about earth energy creating legends and dreams in unspoilt places, or in places where the earth has been opened up. They're very similar to mine. She calls it 'Snake-breath'. She's a guardian of the valley and a healer'.

Clemence realises that Lamia is 'the name of the great black Goddess, Lilith in her serpent form' and Trelamia therefore means 'the place of the snake'. Clemence tries to warn John that Rose is, herself, the shape-shifting serpent, but it is too late and John disappears, as if swallowed up by the earth.

Whilst it is clearly the case that Robin Ellis borrowed key components of his MM articles from Redgrove's play, the question remains as to where the rest of the content came from, or whether there was a third source common to both writers on the Lizard itself. Writer Steve Patterson is inclined to believe the latter: *I've spoken to Robin Ellis about Redgrove, and he said he didn't know anything about the play. Robin went to a talk by Peter Redgrove in Falmouth, and Redgrove put him in touch with a person on the Lizard, who told him he was part of a pellar tradition down there. That's how he wrote those three articles. I find it hard to believe that someone would create such an elaborate hoax.*

Many of the ideas in 'The Valley of Trelamia' were greatly expanded in Redgrove's 1987 book 'The Black Goddess and the Sixth Sense'. The title refers to a book by Robert Graves (Mammon and the Black Goddess, 1965):
> 'The Black Goddess is so far hardly more than a word of hope whispered among the few who have served their apprenticeship to the White Goddess….she will lead man back to that sure instinct of love which he long ago forfeited by intellectual pride'

Though he does not explicitly refer to Aldous Huxley, Redgrove, like Colin Wilson and John Michell, suggests that there is a historical basis to Huxley's 'brain-as-reducing-valve' theory. Using Oedipus as a symbol of 'questing, visualising modern scientific intelligence', Redgrove proposes that mankind has become 'blind' to all manner of invisible forces (or 'invisibles'): this, because we have learnt to ignore our more primitive non-visual senses, particularly those of touch and smell:

When we fall in love, make friends, influence people, give Tarot
readings, feel compassion, do magic, make prophecies and even converse
with the gods, we are exercising a sensory capability that has been
concealed by the paradigms of science and by a misunderstanding of
religious experience...

He argues that these untapped, unconscious sensory capabilities are the
realm of the Black Goddess, who is depicted historically as the sensuous
lover of Jesus, Mary Magdalene, as Lilith, or as Lamia, Keats' snake-
goddess. Redgrove implies that 'horasis' and the use of other sex-magic
techniques like those described by occultist Kenneth Grant, can theo-
retically, allow us to gain access to them again.

One of the last publications before she died: Osmazone (1983) is a
collection of poems and short prose pieces by Ithell Colquhoun.

Towards the end of the book, Redgrove acknowledges that some women
are already well acqainted with The Black Goddess. In this context he
mentions Surrealist artists like Meret Oppenheim, Leonora Carrington
and of course Ithell Colquhoun. Referring to the Surrealist movement in
general he says:

The women artists from the beginning showed needs and acted in ways
which did not fit into any male myth. They set out to find their firm ground
by affirming the fundamental forces that differentiated the feminine

203

experience from the masculine. Ithell Colquhoun sent Penelope Shuttle, as elder to younger, a copy of her famous Osmazone (a word which seems to mean both 'smelling-place' and 'perfume of the whore'). This happened after Shuttle had sent a copy of The Wise Wound to the distinguished painter...

Redgrove's 'The Black Goddess' is not as widely known as its predecessor but it was still read, enthusiastically, by Monica Sjöö amongst others. Interestingly, its content overlaps with 'Earth's Embrace: Facing the Shadow of the New Age' by Redgrove's fellow Jungian Alan Bleakley (1989). In it Bleakley calls for a deep psychology that fully embraces myth, and he is critical of the more superficial humanistic psychologies of Maslow, Reich, Rogers, Perls, Berne and Schutz, which are seen as overly concerned with *self-indulgent and egoistic personal development'* and with approaches *'that are explicitly secular – rarely concerning themselves with religious questions...'* [1]

Bleakley's book, which includes a foreword by John Michell, came out 22 years after Michell's original article in IT pronouncing the dawning of the Age of Aquarius. The irony is that already, by the end of the 80s, there were signs of a huge backlash against the whole concept of the New Age which, for many, had become a term of abuse.

Notes 1) Nevill Drury (2004) has identified these psychologists, many of whom worked at Esalen in California in the 60s, as being the key figures of the 'New Age'. Amongst other concepts, Maslow is associated with 'peak experiences (of which Colin Wilson was an enthusiast), Reich with 'body armour', Perls with 'Gestalt therapy' and Schutz with 'Encounter groups'.

29. Land of the Goddess

Following Paul Devereux's move to Cornwall, on 15/16th September 1990 a historic Ley Hunter moot, organised by Cheryl Straffon, took place at CAER at Rosemerryn, Lamorna.

Leyhunter Moot as reported in Meyn Mamvro, illustrated by Monica Sjöö's 'West Kennet Long Barrow-Abode of the Light/Dark Mother' (1989)

Despite some resistance from Devereux, Straffon invited Monica Sjöö. Cheryl Straffon: *We became good friends. There was a big overlap in our beliefs and interests, but she was not an easy woman. Anybody you talk to about her will say the same! But she was a Goddess-celebrating woman, with good political beliefs. She got a lot of flak for her art especially 'God Giving Birth'.*

At the time Sjöö had started delivering workshops on 'New Age Patriarchy' alongside Jill Smith and Maggie Parks. Parks had joined protests at Greenham Common in the early 80's, where she remembers Wiccan ceremonies led by American Dianic witch Jean Freer. Then in the early 90's, Parks moved to Cornwall and, with Vron McIntyre, became joint editor of the women's spirituality magazine 'From the Flames'. Sjöö herself was a regular contributor, despite the fact she was still coming to terms with a tragic double bereavement. Maggie Parks explains: *There'd been an amazing American magazine called 'Womanspirit' which ran from 1974 to 1984, run by two women who lived in the wilds of Oregon. It had been very influential for our movement and we thought 'well, we could do that!' The first issue of 'From the Flames' came out in 1991 and we produced it for a decade. I first got to know Monica in 1985, but shortly after this her young son Leif was killed in a car accident in France. Then she discovered that Sean, her eldest, had lymphatic cancer. It was really these two sad losses that got her writing about the New Age, and then the book 'New Age & Armageddon'. I was really quite close to her through that process.*

WRASAC (Womens Rape And Sexual Abuse Centre) stall at the New Age Festival in Perranporth (1998). Cheryl Straffon (central – white sweatshirt) with Maggie Parks and Geraldine Andrew, left, and Monica Sjoo, right of her. Maggie Parks was founder of WRASAC [1] and co-editor of women's spirituality journal 'From the Flames'.

The book's full title was 'New Age and Armageddon: The Goddess or the gurus?' (1992), and excerpts were pre-published in 'From the Flames'. In the book, for once, Sjöö was united with the ley hunters against a common enemy. Whilst Paul Devereux, as an empiricist, was concerned about their lack of accountability, Sjöö, as a feminist, railed against the way many 'New Agers', for all their talk of love and light, seemed to support patriarchy and the military-industrial complex:

> The most frightening aspect of the the New Age is its adoption and perpet-ration of a mishmash of reactionary patriarchal occult traditions and thinking of both East and West all of which have in common a hatred of the Earth, authoritarianism, racism and misogyny.

In accepting the teachings of gurus or Secret Masters they thereby perpetuate established Christian dualities (spirit v matter, light v dark, white v black, God v Goddess):

> Earth was the sewer of the devil to the Christians, and woman's body a latrine, because she gives life and by doing so binds the male spirit into the bondage and snares of the flesh...The sun god is the warrior who battles eternally with the 'serpent of darkness' and overcomes Her with his phallic metal sword'...

Although also castigating rebirthing,[2] channeling, New Age shamans, and the Findhorn community, Sjöö considers Sir George Trevelyan, and his advocacy of St Michael, particularly reprehensible. Interestingly, Trevelyan – who as a friend to Margaret Thornley had, in 1972, unveiled the plaque to her on Chapel Carn Brea – was the main speaker at the Harmonic Convergence event at Glastonbury in 1987:

> To Trevelyan the object of the exercise (Harmonic Convergence) was to attune ourselves and to raise our consciousness so that the spiritual light could flood into the darkened Earth and drive away the 'beings of darkness'.

For similar reasons Sjöö joins the ley-hunters' chorus of disapproval for Colin Bloy's Fountain International:

> The Fountain group tries to diffuse violence and petty crime through the use of meditation...They broadcast thoughts of love using the ley system of geomagnetic energies...

However, having been earlier inspired by 'The Wise Wound', in 'New Age & Armageddon', Sjöö is approving of Peter Redgrove's work, and cites 'The Black Goddess and the Sixth Sense' in claiming, poetically, that 'our non-visual dark senses are organs of womb-knowledge'.

Monica Sjoo self portrait 'wearing my dakini mask' 1993

In 1993 Straffon and Sjöö were involved in the first 'Goddess Tour' of Britain. Cheryl Straffon: *Jamie George (Gothic Image) did regular spiritual tours, and one of his tours was of Cornwall. He'd have a 'resident minstrel' on the tour: Julie Felix, folk singer from the 60's. Julie was getting 'into Goddess' and she had a contact in America, Lydia Ruyle, and together the two of them decided to launch a tour similar to Jamie's but for women only. I led the Cornish leg, and Monica Sjöö led the Welsh leg of the tour.*

Monica embraced the dark side of the Goddess, but Julie was the polar opposite: all light and joy and celebration. So they were driving all around these little lanes in Wales and though Monica lived there then,

she got hopelessly lost. So to lighten the mood Julie put on some music and videos about loving the Goddess. But Monica was getting more and more uptight, and eventually she stood up and faced everyone and said 'there's too much fucking love and light on this bus'!!

Sjöö had become worried that, as Goddess spirituality was becoming more popular, so its message, too, was becoming diluted.[3] Cheryl Straffon: *There was a great ferment of discussion at that time – people cared a great deal about where this new movement was going to end up.*

Fittingly, in 1993 Sjöö and some other activists interrupted a service at Bristol Cathedral, to protest against patriarchal attitudes in the Church. Cheryl Straffon: *Monica picketed the Cathedral and was roundly condemned by most pagans. But she put her money where her mouth was. To me, politics and spirituality should go together.*

The British and U.S. Goddess movements had different paths. A lot of the British women were involved with Greenham Common. There was a great schism really because a lot of the political women's movement was sceptical about the Goddess movement. We were a minority. There were not that many that were both spiritual and political and those that were came together through the 'Matriarchy Research and Reclaiming Network' (MRRN). This was very much a newsletter that was used as a way of networking.

Cheryl Straffon had come relatively late to the Goddess movement, but, as editress of Meyn Mamvro and – later – a second journal 'Goddess Alive!' (launched 2002), she more than made up for lost time: *Jo O'Cleirigh actually first got me into Goddess spirituality. He'd got hold of the book 'Gods and Goddesses of Old Europe' by Marija Gimbutas (1974) who wasn't known over here at that time. When I read it, it blew me away. I had no idea that worship of a Goddess went back 30,000 years and that there was so much evidence for it that had been suppressed or minimised up until then.*

Gimbutas influenced so many others particularly American women researchers who did a lot of reclaiming of these Goddess cultures. Miriam Dexter and others brought out books that were right in the line of what I was interested in. This was the whole rise of the Neo-Goddess movement both in America and in this country.[4]

Tarxien Goddess (1994). Oil painting by Monica Sjöö in Cheryl Straffon's house.

Monica Sjöö provided the introduction for Cheryl Straffon's book, 'Pagan Cornwall: Land of the Goddess' (1993). In it Sjöö expresses misgivings about the Ley Hunter Moot in Cornwall:

> I had been nervous to come since my relationship with the male-dominated Earth Mysteries movement had been fraught, to say the least, over a number of years. I have always had a kind of love/hate relationship to this movement, but at the same time I see myself as an integral part of it. I have been inspired by it and angered by it from the very start.

> I wrote the first draft of what was over the years to become "The Great Cosmic Mother" book already in 1975, and one of the impulses for writing it at the time was my frustrations with what I saw as the denial of the Goddess and women's ancient wisdom in the Earth Mysteries movement... All of this is the background as to why I personally welcome this book about the Goddess in Cornwall, especially since it is written by someone so central to the Earth Mysteries movement...

Speaking to me in 2016, Straffon described the context of 'Pagan Cornwall: Land of the Goddess'. As she explains, it is a book which drew extensively from her researches for Meyn Mamvro: *I was motivated by the fact that all the histories of Cornwall that I'd read were*

210

based on hierarchy, battles and killing and I didn't see Cornwall that way. But archaeologists were not looking at spiritual practices and beliefs then. They are now, and they're discovering things that we were talking about 20 or 30 years ago. In fact down here the Cornwall Archaeological Unit was always more open. Charles Thomas was very open to alternative ideas. He always subscribed to MM. Peter Herring was another one who was very open.

Early in the book Straffon restates Gimbutas' thesis and examines the archaeological record for evidence of Goddess worship in the Palaeo-lithic and Mesolithic periods. Here Straffon refers to stone carvings found all over Europe, like the Goddess of Laussel, the Goddess of Lespugue and the Goddess of Willendorf. She comments that the Goddess was revered for a 'vast aeon of time', before the rise of the patriarchal religions such as Judaism, Christianity and Islam, then adds:

> The societies that celebrated this all-embracing Goddess for 20,000 or so years were probably matrifocal rather than matriarchal, that is, women-orientated rather than female-dominating, for the evidence points to an egalitarian and co-operative society that honoured and revered the female qualities. But while these societies existed in the area of what we now know as Europe and the Near East, to the north a very different kind of society was gathering strength. These aggressively patriarchal peoples wielded the battle-axe and the dagger, rode horses expertly, and worshipped not a Goddess of the Earth, but Gods of the sky and thunder. They were war-like, hierarchal people, and when they invaded Old Europe in three waves (circa 4000 BCE) they all but obliterated the peaceful Goddess-loving culture.

In the 'further reaches' of Europe this process happened more slowly, however, and so the Bronze Age in Britain saw the continuation of the megalith building of the Neolithic:

> The Goddess was still celebrated, but now she became divided and existed in relationship to a male God who became her son and her consort, in an eternal cycle of life that reflected the agricultural society of the Bronze Age Peoples.

A collection of Goddess figurines in the home of Cheryl Straffon, West Penwith

In Cornwall this process continued as far as the Iron Age, when the underground fogous were built *'which may well have been used for ritual purposes to continue to celebrate the power of the Goddess'*. However, just under 2000 years ago, this changed, and the Goddess was banished:

> With the coming of Christianity and the establishment of the One God the Goddess had nowhere to go but underground...In Dumnonia the great mythic cycle of the Goddess continued to be celebrated in the season round of festivals and events...many of the old ways of manifesting her magic through spells and hedge lore continued to be practised by the village wise-women and white witches right up to the early years of the 20th century [5].

After the first 'Goddess tour' of Cornwall, in summer 1993, Cheryl Straffon led another in 1994, this time describing it in MM25 (Autumn 1994):

> The tour started at Rocky Valley near Tintagel, and here we walked down the valley to the ancient mazes carved in the rock walls. The maze was a symbol of the journey into the inner self, an appropriate motif for the start of the inner spiritual journey of the tour...From here we drove on down to the magical land of West Penwith... Here we visited places potent with women's energy: Sancreed Well, the entrance into the womb of Mother Earth where we did a blessing and welcoming ritual; Carn Euny Courtyard House settlement where we quietly meditated and chanted in the Beehive Hut, the women's voices powerfully filling the circular space; the Merry

212

Maidens stone circle where priestesses of the moon goddess may have danced, and where the present-day women also danced a spiral dance; Madron Well where we hung pieces of cloth on the trees, honouring the Goddess and her powers; and the Mên-an-Tol where we crawled through the holed stone, chanting "She changes everything She touches, and everything She touches changes" helped through the symbolic birth canal first time by Katherine, a midwife from Oregon...

1) In 2017 Parks was awarded an OBE for her pioneering work with women.

2) In the context of her bereavement, Sjöö is particularly critical of the unethical conduct of two 'rebirthers', who she believes exploited her eldest son, Sean, at a time when he was at his most vulnerable.

3) Sjöö's diaries indicate her discomfort during the 1993 Goddess Tour. They note that, because of its cost, the party was mainly made up of privileged white women. She did not take part in the 1994 tour.

4) The Goddess Trilogy (1989-1993), three films made by Donna Read in collaboration with Starhawk, documents this period in the US. In Full Circle (1993), for example, Starhawk says: '*Our focus is on the sacred in the world not outside the world. The Goddess is imminent. She is the world. She is us. She is nature. She is the changing of the seasons. She is the Earth itself. It is as if the universe is one living being which we are all part of. That's what we call Goddess'*.

5) Gemma Gary: *Cheryl's Pagan Cornwall, Land of the Goddess (1993) was a book that was very influential for me, especially with regard to seasonal rituals. My first copy was a gift from my mother (a student of Alan Bleakley), and so it has always been very dear to me.*

30. Harmony

In Cornwall in the early 90's there were indications that pagan celebrations of all kinds were becoming more open and more public. In 1991, for example, Straffon was able to comment enthusiastically on the revival of Mazey Day, which had been banned in Penzance in the 1890's because of a perceived fire risk (MM16 (Autumn/Winter 1991)):

> …there was some criticism that 'Mazey Day' was an invention, but in fact it was soundly based on the celebrations which only died out in the early years of this century. These celebrations included blazing tar-barrels, bonfires, and a serpent-like dance through the streets…This dance was revived, and it must have got close to the original feel of the day's celebrations, as witness the letter to 'The Cornishman' from one disturbed Penzance resident: 'What has the country turned into? I think someone should stand and denounce this paganism!

Straffon saw Mazey Day as one of a number of signs that Paganism was coming out of the shadows:

> This summer has seen festival celebrations at Harmony Pottery with bonfires, musicians and circle and spiral dancing, new Women's Groups and ritual magic groups have been starting up. There have been excellent meditation and mask workshops, and local groups who follow the Old Religion continue to practise their faith at the ancient and sacred sites. None of this is in conflict with other beliefs, but neither is it hiding away now!

The above-mentioned Harmony Pottery is on four acres of land in Scorrier near Redruth where, that year, Geraldine Andrew had started organising popular ritual events which continued for more than a decade.

Andrew, who grew up in Surrey, became one of Straffon's closest friends and collaborators during this period. She moved to Cornwall at the age of 25 (1969) when she set up the pottery which continued producing ceramics up until 1988. As she told me: *I was wanting to get away from London. As far away as possible. I ended up coming to the 'Western edges', like many of us did.*[1]

Bosporthprennis Lugnasadh 1992. Lor Hag Mor enact the ritual death of the Horned God (or God of the Waxing Year). Just visible is a blue rope delineating a Cretan labyrinth design in the grass. Later versions of this ritual retained the labyrinth, but only Goddesses were embodied (eg Demeter (cf Goddess Alive! 2002), and Tialtu (Daughters of the Earth, 2007)).

Andrew originally attended one of the Beltane celebrations organised by the Straffons on Carn Bosavern, and inspired by the maypole dancing, decided to hold similar events at her pottery. She was, essentially, new to Paganism and to ritual, but she drew inspiration from a number of sources, including Starhawk's 'Spiral Dance': *Paganism seemed to fit with my passion for the land. I loved being with the soil and the plants, and I loved Cornwall. I met Cheryl in '89, which coincided with*

215

stopping the pottery. I was spreading my wings in all directions at the time.

She also attended CEMG talks and became fully involved with Straffon's ritual group Lor Hag Mor. She recalls a very moving late summer ritual on Bosporthennis in 1992, for example (see picture): *Arthur was the Horned God and I was the Earth Mother. It was very powerful. I am in the centre of the labyrinth and he comes through it, walking slowly round and round until he reaches me. Then he offers himself to me, and takes off his horns and dies. I embrace him, and he is reborn and transformed, and I lead him out of the labyrinth again.*

Working closely with her friend Marjorie Rowlands, her own events at the pottery, though carefully planned, were more informal, inclusive and family-friendly. They marked the four lunar and four solar festivals, and were always advertised in MM and sometimes in the local papers. *We had a core ritual that we kept to each year but we adapted it, depending who was there.*

As word spread, pagans from all over the country would attend, welcome to camp on the land for several days at a time. Visitors who stayed during this time included influential writers like Monica Sjöö and Caitlin Matthews – the latter of whom came with her young family.

Some of Andrew's events were also important in setting a writer, and co-founder of Troy Books, on her path. Gemma Gary: *My first experiences with group ritual came as a result of meeting Geraldine Andrew when we were both studying art at Cornwall College (c1997). I found her to be exquisitely eccentric, and loved the fact that she owned a two or three feet tall carved wooden phallus, the end of which was pierced with an iron ring for the attachment of a rope, with rotating testicles that functioned as wheels! I understand she was fond of leading this marvellous contraption sun-wise around her vegetable plot to encourage her crops to grow! ...Geraldine's rituals varied from the simple, to the theatrical, but were always beautiful and often based upon classical mythology. One particularly enjoyable ritual, to travel the worlds and meet the ancestors, was presided over by the late Monica Sjöö.* Wiccan Pagan Times

216

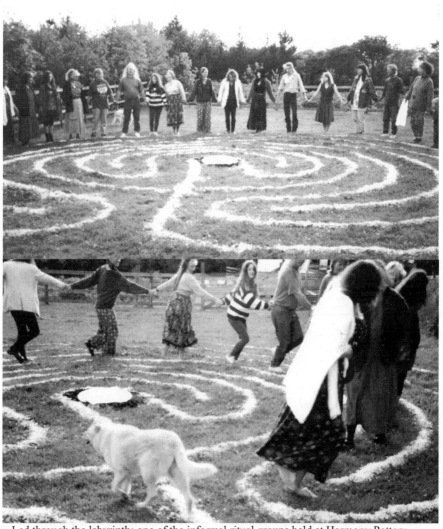

Led through the labyrinth: one of the informal ritual groups held at Harmony Pottery, Summer Solstice, 1994. In the centre of the labyrinth is a circular mirror.

This 'Corn King', along with lots of edible ginger bread men, was made by Geraldine Andrew for the Luhnasadh 1992 celebration at Harmony Pottery.

Sjöö, who Andrew had first met at a CEMG event, encouraged her to show her paintings at the Goddess Conference in Glastonbury. As she became increasingly drawn to Goddess spirituality, Andrew also started separate women-only 'Moon Groups' that would meet once a month in her large, airy pottery studio. Geraldine Andrew: *I was brought up a Christian but that hadn't suited me at all. I didn't work it out until later, but the problem was the omission of the female of course – because all the main religions are patriarchal. I wasn't quite sure what was missing at the time. She (Monica Sjöö) filled quite a big hole, in helping me realise the importance of this sense of the feminine in all of us.*

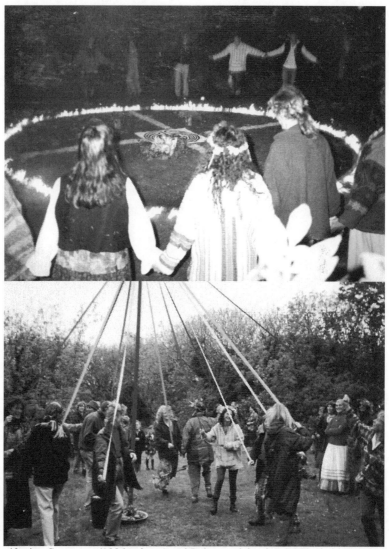

Handfasting Ceremony (1996 - above) and Beltane celebration (1999 - below) organised by Geraldine Andrew.

As her interests diversified, Andrew also organised additional ritual events in nearby Tehidy Woods, together with drumming workshops and hand-fasting ceremonies at Harmony Pottery.

Notes 1) In point of fact, Geraldine Andrew had experienced a breakdown as a teenager, and received insulin treatment and ECT over a period of 3 or 4 years. As she puts it: *I went to Persephone's World – the Underworld – early. Coming here (to Harmony Pottery) was my way of healing.*

31. Mother and Sun

'Caves and tombs are interchangeable with womb, egg and uterus symbolism. Columns of life, trees, snakes and phalli as embodiments of the life force rise from the Goddess's womb, cave or tomb. The Goddess herself rises from the deep...' Marija Gimbutas (1989 - in Mother and Sun)

'Mother and Sun', Ian Cooke's self-published book on the Cornish fogou, appeared late in the same year as Straffon's 'Pagan Cornwall' in a limited edition of 1000.[1] It remains the most thorough study of the fogou ever completed, and like Cooke's earlier work, 'Journey to the Stones' (1987), it is a pleasing admixture of academic exactitude and creative conjecture.

Cooke argues that these mysterious underground chambers have been repeatedly misrepresented and misunderstood by archeologists and historians, most of them writing at some geographical distance from Cornwall. He is, for example, completely unconvinced by their tendency to attribute functions of food-storage or refuge to them, and respectfully explains why. Instead, he is convinced of their ritual function, with the key piece of evidence for this being their orientation to the rising sun; something he tests for himself at several sites, starting with Carn Euny (p207):

> It was June 1985, a few days before the summer solstice. The moming sky was completely clear of any cloud...and by the time I had walked to the fogou I could still see the faint 'fingernail' of the waning moon in the pre-dawn eastern sky. There was a very heavy dew but not a breath of wind as I listened to calls of blackbirds and cuckoos close by, and I could see across fields and low ground beyond St.Buryan to the pale blue sea beyond.... By now (5.30) the top of the Carn was bathed in a soft orange light, as were some of the more distant fields, and at five forty the eye-piercing glare of the rising sun appeared over the horizon... As the sun rose quickly above the sky line it became clear to me that someone, over two thousand years before, had marked out where this end of the passage should be placed so that it faced the first appearance of the sun during the longest days of the year. It was an exciting moment...

Orientation of the
Fogou main passages (1)

(Personal observation except for sites 10 and 11)

Ian Cooke's research on the orientation of fogous as it originally appeared in 'Journey to the Stones'. Key: 1. Halliggye, 2. Carn Euny, 3. Boleit, 4. Pendeen, 5. Porthmeor, 6. Trewardreva, 7. Lower Boscaswell, 8. Chysauster, 9. Higher Bodinar, 10. Castallack, 11. Treveneague

More enchanting descriptions of bucolic landscapes are paired with photos of the morning sun, the bright lens-flares of which seem to scorch the page. Towards the end of the book, Cooke draws from Gimbutas, and suggests the ritual function of the fogou is related specifically to the intensive expansion of tin-mining beginning in West Cornwall around 500BC:

> I see the cult of the fogou as a response to this situation. Tribal chieftains were stimulated by a psychological need to appease the spirits of the earth for what was being done, in a desperate attempt to ensure continuation in the availability of metals 'from the underworld' and a restoration of land fertility.

Cooke concludes, with clear-sighted conviction, that:

The intended function of the fogou was therefore to form a physical bond between the Earth Mother and the Sun, her traditional son and consort, whereby there was the potential, through alignment, for a symbolic act of divine sexual union to take place during midsummer when the sun is at its most potent…The architectural features of the fogou provided a sacred space for enactment of public and private rituals and ceremonies associated with this cult – the more precise forms of which we are unfortunately never likely to know.

The Comish fogou, far from being a simple village larder or hiding-place hardly worthy of preservation forms a class of Iron Age religious structure without precedent in England. It is my hope that 'Mother and Sun' will help to achieve recognition of this probability, and an official deter-mination to preserve more effectively the remnants of an important part of the pre-Christian cultural heritage of Comwall before the effects of nature and man result in total extinction.

John Michell wrote the foreword to the book. Ian Cooke recalls how they became friendly: *John used to come down doing tours, with Jamie George from Gothic Image. He used to visit the studio, and the tour party would come in and look at the art.*

In fact, despite admiring Michell's work, especially 'The Old Stones of Lands End', Cooke had always been more interested in astronomical alignments than site alignments: *I was not particularly into ley-theory. I always felt that you could make ley lines out of anything – an old stone in a field or a hedge. Whether they do exist or not, who knows? I've got an open mind on it. For me it's more to do with the sky: the sun and the moon in particular.*

Just over a year after 'Mother and Sun' was published Cooke took part in a BBC 'Time Team' programme with Tony Robinson at Boleigh fogou. The archaeologists used both geophysics and dowsing to try and locate a collapsed second chamber under Jo May's lawn at CAER in Rosemerryn. They failed to do so, but they did find fragments of contemporaneous Iron Age pottery. Ian Cooke: *Hamish (Miller) went down there with his dowsing rods but couldn't find the chamber, and so people were taking the mickey out of him a little. When we were in the fogou one of the professors said 'of course these places are for refuge, and if they were stuck inside they could dig themselves out'. I said 'if you'd been to Halliggye you'd know that the end is solid rock!' Tony Robinson was good, though. He was the only one with an open mind: open to the fact that they might be ritual sites.*

Inside Ian McNeil Cooke's Men-An-Tol studio, from where he published his guidebooks and the limited edition book 'Mother and Sun'.

Ronald Hutton, now Professor of History at Bristol University, had been more sceptical, however, and was inclined towards the view that, like the Irish 'souterrain', fogous were built as refuges (Hutton, 1991).

A figure of international repute, and a friend to many pagans (he is the proud owner of a complete run of The Ley Hunter magazine, and also subscribed to many of its pagan 'exchange mags'), Hutton was, along-side his main University post in Bristol, also a Reader in History at Cornwall College between 1985 and 1994. The job entailed frequent visits to the Duchy to give classes, as he told me: *This post was itself one fruit of my close friendships in the area, which continue, and I still address the South-Western Pagan Federation Conference in Cornwall every other year.*

In 'Mother and Sun' Cooke implies that Hutton's views on fogous are inconsistent, and even hypocritical:

Hutton's remarks are typical of many supposedly objective scientific writers who select available evidence to fit in with previously formulated theories - a fault of which alternative authors are frequently accused.

In fact the book, 'Pagan Religions of the Ancient British Isles' in which Hutton's comments appear (Hutton, 1991), encompasses many epochs of British history and only fleetingly touches on fogous. Written during

224

the period he was teaching in Cornwall – the book is now best known for the loud note of scepticism it sounds towards the historical legitimacy of nearly all forms of Neo-paganism. To the dismay of many, Hutton's book also threatened to undermine the very basis of Goddess spirituality. Andy Norfolk: *Cheryl (Straffon) is, of course, very Goddess-focussed and at times has been even more so. She got very upset about 'Pagan Religions' and particularly what Ronald was saying about Gimbutas.*

In Winter 94/95 (TLH 121), whilst 'The Ley Hunter' was still based in Penzance, Danny Sullivan reported on the Moot 94, which had been attended by Hutton. Referring to Hutton's controversial book he says:

"Pagan Religions...' had put the skids under a lot of received wisdom with regard to the 'Old Religion', witchcraft and the Goddess in particular. Much of what many neo-Pagans hold to be the basis of their religious revival has little foundation in historical fact.

It was an off-the-cuff remark, but it was one that Straffon wasn't about to ignore. She wrote in to the journal to say:

This is a point that is increasingly being stated as if it were an unassailable fact rather than an opinion of Hutton's that we need to put into perspective.

The comment sparked a huge debate. Winter 95/96 (TLH 124) – incidentally Paul Devereux's last edition as editor – saw several pages of letters, with Monica Sjoo, Jill Smith, Andy Norfolk and Cheryl Straffon all confronting Hutton on various points. In a way it was a storm in a teacup, but it's notable now because the discussion marked a change in the relationship of The Ley Hunter to the increasingly disparate comm-unities it represented.

It also prompted a fascinating and very candid full-length article by Ronald Hutton on academia, archaeology and Paganism, in which he refers to an incident in 1978 in which he was nearly killed after being assaulted by Neo-Nazis.

In 'The Past and the Post Modern Challenge' (TLH 125) Hutton describes three very different generations of archaeologists:

Those that came of age in the 40s and 50s...produced what are now called metanarratives, confident overarching systems of interpretation of the ancient past which justified, explicitly or not, social, political and religious attitudes towards the present.

It seems those who emerged in the 60s and 70s were more concerned with objective rigour, and took a much more scientific approach than their forebears. Those archaeologists who came through in the 70's and 80s have, however:

> tended to find this more scientific archaeology as incapable of establishing absolute truths. Instead they increasingly argue for a plurality of interpretations of particular sites and issues…are bitterly hostile to metanarratives, and question the whole concept of the past as an established fount of wisdom and authority.

Referring to The Ley Hunter and ley theory specifically he says:

> The old clash between orthodox and alternative archaeology was a straight fight between two metanarratives, each insisting upon an absolute validity…the case of radical feminist prehistory or herstory is different because it came out of academe itself…

Whilst he accepts that there is reasonable evidence of prehistoric Goddess cultures, Hutton believes that it does not show that they were the product of a peaceful and egalitarian 'Golden Age'. He suggests that all the indicators point to the Mesolithic and Neolithic periods as being rather violent, and, incidentally, describes archaeological digs at Carn Brea as supporting this.

But his argument is a conciliatory one: essentially, that as long as they fit the data, all accounts of the ancient past are equally valid and one shouldn't claim authority over another. He concludes by drawing on his knowledge of Cornwall, and making complimentary remarks about Ian Cooke, Monica Sjoo, Andy Norfolk and Cheryl Straffon the latter of whom he says *'edits a magazine that contains some excellent material, and who has played her part in the re-enchantment of the landscape'*.

1) Fogou is pronounced 'foogoo' and means cave.

32. Dreamers Seek the Company of Angels

Alongside his work with The Ley Hunter, in the early 90's Paul Devereux had several more titles published. 'Places of Power' – a summary of the Dragon Project research to date – came out in 1990, and 'Earth Memory' in 1991. In 1992, 'Shamanism and the Mystery Lines' appeared; a book in which Devereux sought to deconstruct the whole edifice of ley theory, and to make a clear break with his past:

> I have believed in everything to do with leys in my time. I have plotted them on maps, dowsed them (or convinced myself that I did), surveyed them in the field and tramped through the country-side along what I perceived as authentic alignments...My personal progress through the whole subject has been, at times, a painful one of stripping away cherished ideas...For a period in the mid-70's I doubt there was a single ley-hunter (including myself) who did not think of leys in terms of lines of energy ...however a few of us began to see that we had a complex fallacy on our hands...today the dowsing for supposed linear energies is equated with being spiritual – perhaps a somewhat sad comment on our contemporary spiritual bankruptcy. In reality it's all psycho-showbiz ...There is of course no single entity as 'earth energy'...

As if feeling the need to compensate himself and others for refuting their 'cherished ideas' Devereux proposed a new theory. Lines clearly visible in the landscape, or 'geoglyphs' like those on the Nazca plains of Peru, are found all over the Americas, but their exact meaning has been lost to history. However, drawing heavily from Mircea Eliade, Devereux links them to Shamanism:

> Through archaic techniques of ecstasy, the shaman would enter trance or altered states of consciousness, and travel to the spirit worlds...the shaman specializes in a trance during which his soul is believed to leave the body and ascend to the sky or descend to the underworld...my suggestion is that the lines are surely similar to lines of magical flight marked on the ground, vaguely similar to the flight routes airlines plot across an area.

He proposes that extant linear features of the European landscape eg cursuses, the stone rows of Dartmoor, and some apparent leys may have, at root, a similar explanation.

One of Paul Devereux's paintings: used as the cover of 'Earth Memory' 1991

Alan Bleakley, Joy Wilson (wife of Colin), John Wootton (husband of Brenda) and Cheryl Straffon had all helped collect data for the Dragon Project in Cornwall. Then, the same year as the shamanism book, Devereux reported on the beginning of the final phase of the research ('Sacred Site Dreaming' TLH 116, 1992).

> It is now about 18 months since the Dragon Project Trust dreamwork programme began…Sleeping at places of power or sacred sites is an ancient practice …it is carried out primarily for different types of divination, prophecy and sometimes to contact spirit entities…The Celtic seer would be wrapped in animal hide and laid near a waterfall or spring…But the most famous of all temple sleep traditions seem to have been the dream incubation conducted in the Graeco-Roman world…The Dragon Project had found that sites with higher than natural radioactivity, due perhaps to the presence of radioactive granite, could result in brief but intense altered states of consciousness…Did the ancients use what we would call geophysics for mind-altering purposes in the way that they used hallucinogenic plants? We felt it to be part of the Dragon Projects brief to check for this.

Although eight sites were originally identified as suitable for the research, only four ended up being used: Madron Baptistry, Chun Quoit and Carn Euny in Cornwall, together with Carn Ingli in Wales. Cheryl Straffon: *There were three sites chosen in Cornwall. One was Chun Quoit, where the archaeologist Brian Larkman had observed little coloured lights running underneath the capstone. Another was Madron Baptistry, because people had reported hearing pan-pipes and voices there, and the third site chosen was Carn Euny fogou because people had reported altered states of consciousness in the fogou. In fact I took part in one of the dream sessions at the fogou.*

In 1992, Devereux described already having logged 'between 50 and 100 dreams'. Then shortly before he quit Cornwall, and The Ley Hunter, The Independent newspaper ran an article with the memorable headline: 'Dreamers Seek the Company of Angels'. It described the Welsh site and the researchers that were visiting it (30th January 1994).

> The dreamer's head is next to rocks where the compass swivels violently on the misty peak of Carn Ingli, or 'summit of the angels'. It is the site on top of the windswept crag in Pembrokeshire where St Brynach is reputed to have talked to angels in about 500AD. Before that, the mountain was revered by the druids and other ancient religions....Laurence Main, 43, is convinced of its spiritual powers and, with other volunteers, is camping on the 1,138ft summit to see whether its forces enter people's dreams in any common pattern...

Sacred site dreaming at Madron Baptistry: part of the final phase of the 'Dragon Project'.

In both Wales and Cornwall, the dream research relied on pairs of volunteers working together. The 'therapeute' would watch the 'dreamer' closely, and wake them after a period of REM sleep in order to record the content of their dreams onto an audio cassette recorder.

Probably the most dedicated of the volunteers were Gabrielle Hawkes and Tom Henderson who ran 'Visions and Journeys', the gallery in St Just where Meyn Mamvro had originally been launched. As the project was supposed to be nearing its conclusion, Hawkes wrote, asking for more volunteers (TLH 126-1997):

> Tom and I have been involved in dream research of this kind since 1991. He sleeps; I watch. We have had dream sessions at all times of the year, in most kinds of weather. We have climbed to the top of Carn Ingli in Wales and he has wedged his head against a magnetic rock. Miraculously he slept (but then he always does) and there were dreams. He has slept undisturbed in the dead of winter while bats darted around him inside a Comish fogou. He has slept through a night of rain and wind inside a stone dolmen and been lulled off into other worlds by the trickle of water into the stone font at Madron Baptistry...

> A large body of dreams has already been transcribed and been sent off to Professor Stanley Krippner at the Saybrook Institute, San Francisco, to be professionally analysed for site-specific imagery etc. All but two of the sites have been dreamed out (ie. we have enough dreams from them). The two remaining ones are Chun Quoit and Madron Baptistry on the Lands End peninsula, Cornwall, and for some reason, people are not coming forward to dream at these. This is where you might be able to help. The main qualifications to volunteer for this project if you wish to be a dreamer are; that you can usually sleep in unusual outdoor settings and that you tend to remember your dreams. Insomniacs need not apply.

In what had been a burst of intense activity, 1994 also saw Devereux contributing to the book 'Myths and Legends of Cornwall'. His co-author was Craig Weatherhill, who recalls: *Paul became a friend. He and Charla were living in Penzance at the time. I'd read some of his work, and he'd read mine, and we collaborated on a book that Sigma Press had asked him to write. He rang me up and said: 'I don't know why me, as I know damn-all about Cornish legends. So can you write it and I'll add a couple of chapters on Earth Mysteries?' So that's what we did, and it went out in our joint names. Paul has come up with some quite astonishing stuff over the years and I like the way that does his work scientifically. I liked him, and was sorry when he and Charla moved on elsewhere.*

One of the last articles Devereux commissioned for TLH was by Cornish poet Peter Redgrove. 'Mesmers Vision: the shamanic heart of the Romantic Movement' (TLH 123, summer 1995), is a meditation on the nature of knowledge, particularly as pursued by Geothe, Mesmer and the Romantic poets.

Given that science has produced the twin evils of industrialisation and consumerism, Redgrove calls for a new form of knowledge that is more 'erotic' and that aims not for mastery over the world, but union with nature. In fact Redgrove's poetic vision sounds a lot like the quasi-science of the Earth Mysteries movement itself, so it was a fitting epitaph to mark the end of Devereux's tenure.

Summer 1994 also saw the emergence of a Devon-based Earth Mysteries magazine, inspired by MM and called 'Wisht Maen'. Its first issue included an article by Paul Broadhurst.

33. The moot and the museum

It seems that, during the 90's, not only were like-minded communities of pagans coming together, but they were organising themselves in more formal ways. The Penwith Pagan Moot, a group that continues to meet now (in 2017), became one of the most active and influential.[1]

The Penwith Pagan Moot, gathered together to celebrate the Hallows, Samhain, or Allantide/Kalan Gwav in 2015. The ritual, led by Gemma Gary, also marked the 21st anniversary of the moot – now thought to be one of the longest-running in the country.

Unlike most covens and ritual groups, which require an invitation of some kind, the moot was publically advertised and open to all. The first meeting, in November 1994, is described in Meyn Mamvro (MM) 26:

> About 20 people with an eclectic range of interests were brought together, including Bards, Ovates & Druids, Fellowship of Isis and other Goddess celebrants, Runemasters, Shamans, Eco-Pagans, and Wiccans, including Pagan Federation representatives. Some very useful contacts were made, and future Moots and get-togethers are planned for 1995.

Andy Norfolk was a member and organiser during the 90's [2]:
Adam Bear started it up. That first meeting was at The White Stag in Hayle. Later we did rituals at the ancient sites, and went out to the Merry Maidens and all sorts of places to do them. There was some overlap between the Earth Mysteries group and the moot. There were people who were in CEMG who heard about the moot, tried it a few times but then left, and vice-versa. But we soon had a reputation for being a very big and successful moot, and we were held up (by the Pagan Federation) as an example to others elsewhere in the UK.

Having had a long-standing passion for Ithell Colquhoun's book 'The Living Stones', artist Sarah Vivian moved to live in Cornwall in 1996. She first attended the moot in the company of Cassandra Latham-Jones (see next chapter), and it was this experience, together with visits to Harmony Pottery, that encouraged her to be more overtly 'pagan'. She explains: *When I first came down to St Just, everything gelled. It was the landscape, and the moot, and knowing people who were outwardly and avowedly pagan: people who were actually 'living it'.*

Vivian later took over as the main moot organiser; a role she has performed for over a decade now: *For many years I tried to make it a democracy, including as many people involved in running all aspects as I could. At its peak the moot was about A) meeting for topic and discussion groups each month B) celebrating all eight seasonal rituals and C) organising monthly clear-ups at Ancient Sites. One ritual had over 70 people attending, and many others were around 50. We ran an email listing which at one time had over 200 addresses and reached many more, taking into account partners and friends. This listing was not only to give practical information about meetings, rituals and clear-ups but also for other events and to keep people in touch.*

Vivian also became involved in behind-the-scenes planning: *It was really Cassandra that started doing the rituals. Initially they were quite informal, but they became more elaborate, with a ritual planning group which met up to discuss themes, and draw up drafts that were then rewritten and modified by the group. The planning team would arrive early to get everything set up, rehearsed and prepared. At its height it had about 10 people on the planning committee, and we were putting on whole pageants of things at Sancreed House with five stations to go around in order to travel through the Underworld, and about 20 people in costume.*

No.26 WINTER/SPRING 1995 £1.70

meyn mamvro

ancient stones and sacred sites in cornwall

THE MOON-AN-TOL ● GEREINT - SUN GOD
HOLY HILLTOPS ● SACRED WELLS ●
LEGENDS ● JOURNEYING ● PAGANISM

MM No 26 announced the formation of the Penwith Pagan Moot. Cover art is by Andy Norfolk.

Material for the ceremonies, which at the time were scripted, was taken from a number of sources: *I wrote a lot of them. Other people in the moot also wrote bits and pieces. There are several different invocations that I've rewritten for the location. So I've written in things about Sancreed and Sancreed Well, or the heights of Chapel Carn Brea for example…*

The ceremonies, much like the Harmony Pottery events, were inclusive and engaging, but they could be rather serious: *They're meant to have meaning and feeling otherwise why do it? You don't want people*

234

giggling because that would ruin it for everybody, especially with Samhain when there's always a very serious atmosphere...

As Vivian discovered, from its earliest days the moot was not allied to any one tradition: *Adam Bear called himself a PF (Pagan Federation) representative; but he was also part of the Dragon Group, the Flowering Tree Foundation and O.B.O.D. (Order of Bards, Ovates and Druids).*

John Score editor of the Wiccan and founder of the Pagan Federation – when it was still called the Pagan Front – had died in 1979. He and the organisation he represented had had a reputation for being rather stuck in its ways, but that too was changing. Steve Patterson: *In the 90's you get the growth of the Pagan Federation (PF), and you also get the moots, which were encouraged by the PF. There was a sea-change, as in the 1980's Paganism was seen as a radical anti-State thing. Then in the 90's it got more respectable and more mainstream. Moots became part of this, and they brought together pagans of different persuasions. In fact use of the term 'Paganism' itself seems to have really come out of this time.*

The different pagan traditions shared some basic tenets, however. Andy Norfolk: *Contemporary Paganism has nicked the best bits from everywhere. You'll find common elements to both Wicca and Druidry. There's a story that seems to be true, that Ross Nichols from OBOD (Order of Bards, Ovates and Druids) knew Gerald Gardner. They each had four of the seasonal ceremonies and they combined the two to create the eight that everyone uses these days. That seems pretty likely. I've read the correspondence between them at the witchcraft museum.*

In 1989 Cecil Williamson had turned 80, and had started to let it be known that he was looking to sell his museum. Notices regarding his intentions first appear in MM 9 (1989):

News has reached us that the Witchcraft Museum in Boscastle, North Cornwall is being put up for sale by its owner Cecil Williamson. This museum is a curious melange of genuine artifacts and imaginative reconstructions, but does contain the core of a collection originally built up by Wiccan revivalist Gerald Gardner and subsequently housed on the Isle of Man. Some of this original collection was sold to the States, and there are fears that the rest might go the same way, as a figure of £300,000 has been put on the sale. A campaign has been launched amongst the pagan community to try and raise enough money to buy the collection, though not everyone agrees it is worth saving at that price.

Poster by Adam Bear advertising Pagan Moot events during 1996. In the top left corner is the emblem of the moot itself, whilst below it are those of other affiliated organisations.

In fact it took several false dawns, and the intervention of one single individual to save it. Alerted by an advert in 'Prediction' magazine in 1995, it was Graham King who stepped forward, and the museum eventually changed hands on Samhain (Halloween) 1996, reopening again in Easter 1997.[3]

King, whilst running a camera-manufacturing business, had been led to an interest in Paganism through a love of the ancient sites: places like the Rollright stones, where he would sometimes sleep overnight. He later joined the Pagan Federation, and a Wiccan study group run by Vivianne and Chris Crowley. It was ultimately a chance meeting near Avebury with members of the Dongas tribe – famous for their involvement in the road protests of the 90's – that persuaded King to give up his previous life in Hampshire (Hannah Fox, Cauldron 104, May 2002).

Andy Norfolk: *When Cecil Williamson had the museum there was always a knudge-knudge wink-wink 'dirty old man' aspect to it! And his notes on the exhibits were rather that way inclined. Graham came along as a breath of fresh air, and brought a better way of looking at it. And a lot of people from the moot got involved with helping out up there. I went to help sort stuff, and various people from the West also got involved with helping after the Boscastle flood (in 2004).*

Steve Patterson, now Cecil Williamson's biographer, was another who helped King, as he explains: *When Graham King bought it, he had a team of people to help. Cecil had done no structural work, so Graham needed a team of people to pack everything, and catalogue everything, and strip out the cabinets. None of us had any experience, so we were making it up as we went along! We all used to pile into the living room (now the library) and sleep in sleeping bags there.*

Patterson also remembers the old museum, pre-1996. At that stage, before information was more widely available, many pagans referred to publications by Peter Redgrove's associates Janet and Stewart Farrar: *When I first went I'd not heard of it before. It was always unadvertised, and you never knew if it was going to be open. But I was blown away by it. The Farrars weren't writing about this!*

Cecil's narrative was just so very different. There were two tableaux downstairs: 'The Temple of Tanat' and the 'Witches' Cradle'. Upstairs was Old Hornie and the tar babies, which was glassed off like a diorama. The narrative was all about the idea of the wayside witch. There were no covens. They were solitary practitioners, working in their communities. It was an operative form of magic, but the key to it was a relationship to an unseen spirit world.

The library was one of the innovations brought in by Graham King: *Cecil Williamson always referred to the Witchcraft Research Centre, but*

237

because there was no library, a lot of that would have been in filing cabinets in his house which were destroyed when he died. Much of it may have also gone into the collection of painter, Robert Lenkiewicz. In the 70s and 80s, the museum was still an important resource, but it was a resource that was much ignored. Throughout Cecil's time, Wicca was the hegemony. Because of his interest in traditional witchcraft, Cecil was very much sidelined.

Perhaps because of this, there was also no community: no friend's organisation, and no meetings or talks: *He was his own worst enemy. In his early letters he talks about having yearly gatherings but they never happened. He talked about starting a study group with Ithell Colquhoun, but it also never happened. Cecil said that it was tourist gold that kept the museum going, so he had no interest in trying to appeal to witches or pagans.*

But Graham King, as a business man, was canny enough to know there was this growing pagan movement in the mid-nineties. So he kept the spirit of what Cecil Williamson had in there. But he got rid of the dioramas and put in the Wise Woman's Cottage. Graham took Cecil's narrative and augmented it with the idea of Wicca that was going around in the 90's, so you got a hybrid.

Earth Mysteries writer, Paul Broadhurst, through his long-standing connection to Boscastle, also remembers the Museum of Witchcraft both before and after King's arrival: *Cecil must have been inspired to move the museum to Boscastle because it was the absolute ideal spot. But he actually wasn't there a lot. There was just a little guy – usually asleep in the booth – who woke up when someone came in. The exhibits hadn't changed for a while and it was all very 'News of the World', with the mannequins and the tar babies, but when Graham took it over he completely revamped the whole place.*

Another resident of Boscastle during the 90's was Jo O'Cleirigh's friend, John Smart (aka John of Monmouth) who was a key member of The Regency and author of 'Genuine Witchcraft is Explained: The Secret History of the Royal Windsor Coven and the Regency' (Capall Bann, 2012), a book that, incidentally, describes the last meeting of the group as having happened in 2008 in Cornwall.

Steve Patterson: *John had a cafe in Boscastle (The Spinning Wheel) and was well established in the 90's, so must have been there from the 80's*

onwards, but he wasn't active as a witch or pagan in Cornwall, though he kept in contact with other members of The Regency. He and his wife were on the scene, and knew Cecil and Graham. They were around at the sessions in Boscastle, and we'd go back to their place after going to the pub, so they were part of the same social group. With the Beatles there was an interest in Eastern Mysticism so the The Regency made a big thing about their British roots as a way of differentiating themselves, at a time when the Beatles and others were turning to Eastern gurus, Yoga, Tantra and meditation..

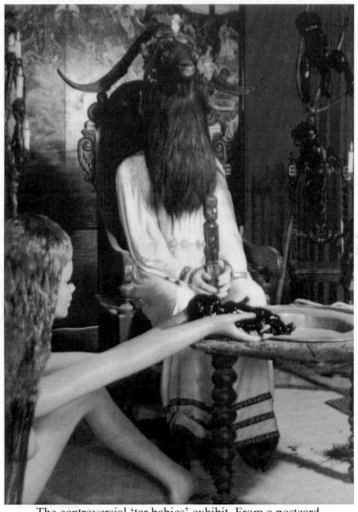

The controversial 'tar babies' exhibit. From a postcard.

239

John of Monmouth aka as John Smart. Briefly leader of the influential Regency coven, considers the very last meeting of the group to have occurred at the Stannan Stones in Cornwall (2008).

The museum, having changed hands, had been transformed into a centre for serious-minded pagans and witches, who visited in increasing numbers from all over the world. But it was a development that was not universally welcomed. Paul Broadhurst: *One business-woman in Boscastle likes to give out pamphlets saying that witchcraft is evil. There's always been a battle between the pagans and Christians there. The people who did the 'Island Parish' TV show spent a lot of time in Boscastle, and they were desperate to stir up a war between the Christians and Pagans. They tried everything to create a confrontation! But in the end they gave up.*

Notes 1) In fact from the end of the 90's onwards there were typically five pagan moots advertised on the noticeboard of MM (eg in MM41 (2000) they were in Penzance, Pendeen, Truro/Falmouth, Camborne/Redruth & North Cornwall).

2) The Penwith Pagan Moot main contact, as recorded in MM, was Adam Bear (1994-96), Cassandra Latham (1997-98), Andy Norfolk (1998-2004), Sarah Vivian (2001 onwards). MM55 notes that in 2004 both Andy Norfolk and Sarah Vivian (temporarily) stepped down as organisers. The first ceremony advertised in MM was Lughnasadh 1995.

3) By sheer coincidence St Nectan's Glen, the waterfall and hermitage nestling in the lush foliage of Rocky Valley only a couple of miles away, also passed over to a new owner at this time. To the dismay of pagans and non-pagans alike, it had been closed to the public during '95 and '96. (MM 25 & 26). The then owner, having resorted to using dogs and barbed wire to keep visitors out, had 'threatened to use razor wire or electric fences' as well (MM 29). Fortunately the site was sold and it reopened in early '97 (MM32).

35. Village-Witch

I make a sharp distinction between Operative Witchcraft and Ritual Witchcraft. Under Operative Witchcraft I class all charms and spells, whether used by a professed witch or by a professed Christian…Ritual Witchcraft - or the Dianic cult - embraces the religious beliefs and ritual of the people, known in late mediaeval times as 'Witches'. Margaret Murray (1921).

Cassandra Latham-Jones, who has lived in St Buryan for more than 30 years, was an early organiser of the Penwith Pagan Moot. She also took a unique role in helping Graham King with his revamp of the museum: *In 1996, I took the moot over from Adam Bear, and originally it was a discussion group. It was still the early days of Paganism, so we were attempting to make it more acceptable, more visible and more valid as a belief system. Then, a few months later when Graham first moved down, he phoned me up and said 'what d'you think the pagan community would like to see at the museum?' I said 'we've got a moot tomorrow night - come down and talk to us. I'm sure you'll get lots of volunteers to help you'. So he came for the moot and stayed overnight in Buryan with me. That winter I remember working hard in the museum during the day then, in the evening, trailing all the way up the steep hill in Boscastle to the Napoleon Inn. People would take fiddles and squeezeboxes up there and we'd have a right old sing song…'*

At the time Latham-Jones was in the process of gradually transforming herself into the contemporary embodiment of a 19th Century wise-woman. It was a transformation as bold as it was unprecedented.

Born in 1950, Latham-Jones was adopted as a baby, and spent an unhappy childhood in East Anglia where she trained as a nurse and was married. Then, after divorcing her husband, she moved to Cornwall to act as a carer to Rowena Cade, the creator of the Minack Theatre. Cade died on 26th March 1983. As Latham-Jones explains in her book 'Village Witch' (Latham-Jones, 2011):

> I made the decision not to attend her funeral…I had already made plans to travel to Greenham Common for an Easter demonstration and I knew that this action would be more in keeping with Rowena's ethos…So when that magical moment happened when thousands of people from all walks of life

eventually joined hands around the US base at Greenham Common, I was honouring Rowena. It was a truly moving experience.

After exploring several other spiritual paths, in the mid 80's Latham-Jones was introduced to witchcraft by two men whom she met at a friend's house in Penzance. From them she learnt about Wiccan deities:

The Horned God simply represents the instinctive natural energies within us... and what I heard about the Goddess gladdened my heart. As a woman it was refreshing to come across a belief that placed the role of women in a more powerful, respectful way. It all made sense to me...To perceive and understand the different season and the celebrations and festivals that marked the progress of the Wheel of the Year...

Latham-Jones was initiated six weeks later, by the same men, on the night of the full moon nearest to Lammas. Jo O'Cleirigh: *Paul and Dymh, two chaps who were into the craft, initiated Cassandra at Boscawen-Un stone circle at around the time I got to know her. They were from Birmingham and for a time they lived in a caravan in Penlee Quarry. They claimed to be traditional witches, and I remember at our first meeting at their caravan (May 3rd 1984), Paul said that one of his teachers had been in Old George Pickingill's coven.*

Latham-Jones: *I wasn't initiated into Wicca as such. I later found out that a lot of Dymh and Paul's material came from the books of Paul Huson* (eg Huson, 1970). *So it came from that more amoral stance (not immoral - there is a difference). It has more to do with cause and effect, and effectiveness. And, as a pragmatic spiritual person that makes much more sense to me, and that's what I worked with for a long time.*

Shortly after her initiation, Latham-Jones embarked on a degree in Drama at Dartington College and, whilst there, ran her own coven, called Caer Sidhe. Jo O'Cleirigh: *Although I was living in Lamorna I used to go up to Devon on public transport for our rituals. When she moved back to Buryan we started the coven again. Cassandra didn't like working skyclad (naked), though we did sometimes do so, sometimes outdoors, sometimes in her cottage.*

Latham-Jones: *I ran an eclectic coven in St Buryan. To me it was about the spirits of place, and spirits of the land where the covenstead was.*

243

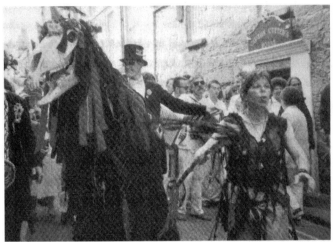

Cassandra Latham-Jones with the original Penglaz oss, its design based on the Welsh Mari Lwyd oss. In Penzance, Penglaz was originally associated with a Yuletide guizing tradition.

Now back in Cornwall Latham-Jones trained as a counsellor and became involved in the revived Golowan festival in Penzance. *I thought I'd perform some weather magic. Weather magic takes huge, huge amounts of energy so you need to find some way of keeping that energy high all through the day and I found that, through my own experience, dance was a way of doing that ...People would say, 'The weather's not looking good for Mazey Day' and I'd tell them, 'Ah, just you wait!'. I have to say, I'm very proud of my 100% record over nearly twenty years...* (julietravis.wordpress. com).

Golowan's Mazey Day 1992 saw the appearance of an 'oss' called Penguise. Then in 1993 the better-known Penglaz made its debut. A mast hobby horse, based on the Welsh Mari Lwyd, it had been made in Dymh's back yard: *It was a smelly and noxious process, because Dymh defleshed it in the natural way: it was maggots that did all the work. It was pretty putrid, but we ended up with a reasonably clean skull* [1].

Whilst Dymh carried or 'rode' the new oss, Latham-Jones, inspired by Padstow's May Day celebrations, became its 'teaser': *We were just dancing alongside each other at first. In time Stephen Hall who was running Golowan said to me 'you need to have a clearer distinction about who you are.*

I want you to wear Golowan white, and when you're teasing with Penglaz, get your head together with Dymh and work out exactly what that's going to look like'. The role of the teaser is to help guide the oss through the crowd, and Dymh made me a 'snapper' which is handy for people who get in the way! If people ask I say I'm a bridge person between the oss and the crowd and in that sense I'm a liminal figure, so it makes sense to cross-dress to accentuate that. Yes I am female, but I dress like a male: like a groom in a top hat.[2)]

C *The* **ornishman** 25|4|96

PAGAN priestess Cassandra Latham, who last week made hospital history when her name was placed on an official register of hospital chaplains, is now a nationwide household name!

For following an exclusive interview in The Cornishman, Cassandra's unusual life and work as a priestess and Wiccan witch, and the adding of her name to a list of contacts for Pagan patients needing a chaplain, caught the imagination of the nation.

Cassandra, who lives at St. Buryan, now has appointments to appear on nationally-screened television programmes, such as the Richard and Judy morning show on Granada TV.

And since the report in The Cornishman, she has been featured on Westcountry Television and in many of the nation's daily newspapers.

"I am very surprised at the interest that has been generated by The Cornishman's report," said Cassandra.

"I thought I was just letting local Pagan people know that if they became a patient in any of the Royal Cornwall Hospitals, then they could ask for a Pagan priestess to visit them.

The Rev. Derek Hollands, senior chaplain at the Royal Cornwall Hospitals Trust, said that Cassandra was not functioning as a chaplain.

"She was nominated as the Cornish representative of the Pagan Federation," he said. "Miss Latham is not employed as a paid or volunteer chaplain for the Royal Cornwall Hospitals Trust, but will be used simply as a referral agency for patients if requested."

Cassandra, who is a qualified nurse and counsellor, said she was looking forward to ministering to Pagan patients at West Cornwall Hospital at Penzance, and at Treliske and City Hospitals.

"I'm here to help people and this will be a way of recognising the needs of Pagans who are sick

Though not officially called a chaplain, this was the role that Latham-Jones made herself available to perform.

Early in 1996, Latham-Jones approached a local Senior Hospital Chaplain. After an interview, he agreed that, as a representative of the PF, she could be added to the list of hospital ministers.

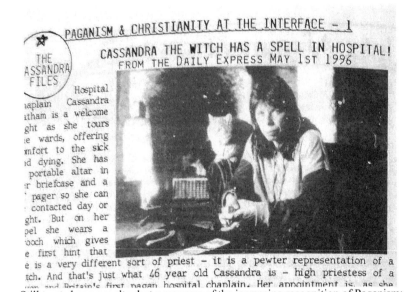

THE ASSANDRA FILES

CASSANDRA THE WITCH HAS A SPELL IN HOSPITAL!
FROM THE DAILY EXPRESS MAY 1ST 1996

Hospital ıaplain Cassandra ıtham is a welcome ght as she tours ıe wards, offering ınfort to the sick ıd dying. She has portable altar in ˌr briefcase and a ˈ pager so she can ˌcontacted day or ght. But on her ɒel she wears a ˈooch which gives e first hint that e is a very different sort of priest – it is a pewter representation of a tch. And that's just what 46 year old Cassandra is – high priestess of a ˌˌ and Britain's first pagan hospital chaplain. Her appointment is, as she

Still treated as a novelty, but a measure of the increasing recognition of Paganism: Cassandra in the Daily Express (as reported in Meyn Mamvro)

By the 90's witchcraft had stopped being newsworthy in quite the same way that it had been (Hutton, 1999), and yet her appointment was a story picked up in several national papers. She was also offered TV appearances eg on the popular 'Richard and Judy Show'.

Shortly before the Museum of Witchcraft reopened for its first season under Graham King, Latham-Jones hit the news again when The Cornishman (on 27/3/97) announced that she had registered as a 'village witch' with the Inland Revenue:

VILLAGE WOMAN IS NOW AN OFFICIAL WITCH!
Cassandra Latham - the 'Witch of St.Buryan' is now a fully fledged 'village witch' - and that's official! For Cassandra, who last year made the national headlines after she had been appointed the first-ever pagan contact for hospital patients in Cornwall who require a pagan chaplain is now registered as a self-employed village witch. 'I got the idea after doing a business start-up course, so I've opened a business account as a witch' she said 'I expect I'll have a lot of explaining to do when my tax forms are sent off!' Cassandra's services as a witch, casting healing spells and doing ceremonies, has made her so much in demand that she has been able to sign off the dole and make a living from her craft. She is a qualified counsellor who also reads Tarot cards and tells fortunes.

The transformation into a professional witch happened quite quickly, and at a time in the 90's when other Neo-pagans were turning away from Wicca and looking instead at traditional witchcraft and other forms of solitary (non-coven) working.

Whilst many now attribute this shift to Ronald Hutton's book 'Pagan Religions of the Ancient British Isles' (1991), Hutton himself links it to Aiden Kelly's 'Crafting the Art of Magic' (1991), to other works by senior UK Wiccans (like DoreenValiente and Lois Bourne), and to newcomers like Rae Beth, all of whom either advocated lone working or returning to a practice closer to that of the cunning-folk (Hutton, 1999).[3]

Talking about her own spiritual path, Latham-Jones said at the time: *I entered a gateway through what now would be called Wicca but I wanted something deeper and older than that. Of course Wicca is very enjoyable but I wanted something more primitive. ... I gradually got more and more solitary. The coven was also becoming more minimal. With my public commitments I therefore had less time for that set up and I became more spontaneous and primitive in my approach. Since I have become solitary that has felt absolutely right for me* (Jones, 1998)

In fact Cassandra Latham-Jones was never really an orthodox Wiccan. Instead, inspired by Williamson's collection in Boscastle she developed her own down-to-earth system, based on folk magic: *The 'wayside witches', as Cecil called them, were quite ordinary people. They didn't swan about looking odd and waving broomsticks about, they just got on with helping - or hindering - and there are lots of examples in the museum of that type of work.*

Nor does her system now involve Wiccan, or indeed any other, gods: *I've got to the point where I don't think I have a religion. I have a strong belief in the spirit world, but I don't require a divinity and I'm not into 'worship'. Sure I'm grateful and I give my 'due tithes' to the spirits, because it's not a good idea not to, so it's more akin to animism where everything has its spirit.*

The similarity of Latham-Jones's work to that of the traditional wise woman - a term she now prefers over 'witch' - is certainly striking. In both cases, of course, there is an emphasis on meeting *another* person's needs and providing a service to them. Indeed, arguably, this is a hallmark of most 19th century witchcraft (as opposed to 'modern traditional witchcraft'). As her disarmingly honest book explains, she

247

makes no special claims to 'authenticity', however (Latham-Jones, 2011).

She describes one occasion when she was involved in investigating a haunted house in North Cornwall. Initially she met the client to talk through their personal issues, which included problems with electrical equipment, anxiety, depression and nightmares. She used a bullroarer to 'raise the energy of the place' and a divination rod to help her perform a 'psychic exploration'. Then:

> I performed a robust cleansing inside and outside the house, and said I'd be back to install certain charms...so I hot-footed it to the Museum of Witch-craft where there is an extensive library of all sorts of pertinent and interesting things to do with the Old Ways....I'm very fortunate to have such a resource practically on my doorstep: I have spent many happy absorbing hours hunting for various spells and charrms, and writing that have been collected over the years.

In a TV programme made for the Open University (2008), she demonstrates the making of a charm by selecting plants from a hedgerow: a process that also involved a simple incantation: *With this spell I intone, flesh to flesh, bone to bone, sinew to sinew, vein to vein and each one shall be whole again. By knot of one this spell's begun, by knot of two it cometh true, by knot of three so shall it be.*

2008 Open University's 'Religion Today'

Charms remain an important element in Latham-Jones' work: *I choose plants for their virtues, for the energies encapsulated in them and for the spirits of that plant...There is a whole school of thought, linked to astrology, regarding which plants are good for protection, and which are good for drawing things to you like money or relationships, and so on. And they're governed by planetary energies which change every hour of the day, every day of the week and every month of the year.*

Whilst some of this lore has been gleaned from books and from sources at the museum, much of it also comes from personal experimentation and a deep knowledge of the sacred landscape close to her home: *I have found that certain holy wells, for example, have certain properties associated with them. Certain sites tend to be dormant at certain times and more active at other times. And this is purely through observation and experience of their energies. So in a sense you have to learn your own lore...Its very individual: someone else might come along and see it slightly differently...*

Her identification with the 19th Century wise woman became an explicit re-enactment when, in 1997, Graham King asked her to provide a soundtrack - the voice of Joan - for the new Wise Woman's Cottage exhibit at the museum. The charms spoken by her were provided by Levannah Morgan, and came from a coven in mid-Devon.

The following year Latham-Jones helped King lay the skeleton of Cornish witch Joan Wytte to rest, an event reported in The Independent newspaper (20/9/98):

Until recently Joan Wytte's skeleton hung unceremoniously in front of a coffin in the Museum of Witchcraft at Boscastle, North Cornwall. But when Graham King took over as curator two years ago he decided that Wytte, known as the 'Fighting Fairy Woman of Bodmin Town' on account of her size and vicious assaults, should be given a belated burial.

...A number of poltergeist phenomena prompted Mr King to call in Cassandra Latham...Ms Latham says she contacted Wytte at a Hallowe'en ritual last year.

'We wanted to find out what she wanted,' Mr King said. 'All sorts of stuff came across. We decided would take her out of the display and bury her somewhere in the woods.' 'We'll place the bones in a wicker basket lined with wool which we have had made for the purpose ... We have some simple grave goods, too: a small bottle of brandy, a clay pipe, a bit of tobacco, and maybe some magic herbs to help her on her way.'

Wise Woman's Cottage at the Museum of Witchcraft and Magic (2016)

The fairy-woman back story that Cecil Williamson had provided for
Joan Wytte, as reported in the article, has proven hard to verify
(Semmens, 2010; Cornish, 2014 -The Cauldron (no.154))

However the whole event is interesting in the way it shows the same eye
for publicity that Cecil Williamson and Gerald Gardner, as a double act,
displayed in the 50's. Whilst Latham-Jones was never officially the
resident witch at the museum in Boscastle, she came close to having that
status and readily made herself available to TV and newspapers at this
early stage in her career. Latham-Jones: *Because I was accepted in my
community I felt I was in a position to have a voice out there. I wasn't
claiming to speak for everyone, but I was claiming to speak for the sake
of paganism and performed that role for the Pagan Federation (PF).*

Her approach has always been to try and normalise Paganism, however:
*I wasn't trying to sensationalise it, like the media wanted me to. In fact
they were terribly disappointed in me in the early days. They'd say
'Where's your robe? Where are your wands and swords?' But it is part
of country ways down here to be working as a village wise woman, so
for me it was a natural thing to do. I didn't see it as something odd.*

Latham Jones has also always sought to demystify 'traditional witch-craft' as much as possible, and is suspicious of many contemporary writers, who use it as a catchall term for a range of modern non-Wiccan approaches: '*Traditional witchcraft' is an appallingly misunderstood term. It's also become a trend that has affected the whole witchcraft scene now, where the humble cunning craft or simple peasant magic, is taken and elevated it to a point that few people can understand. I've heard people say that if you don't understand it you're not meant to. But this to me seems like magical elitism.*

Of course wise women, throughout the centuries, have needed ways to advertise their services. However for Latham-Jones being in the public eye hasn't always been easy, or without consequences. Cheryl Straffon: *I think Cassandra was quite badly bitten by the publicity. She came to talk to me before she went public, and I said that, in my limited exper-ience, there are dangers in doing so. You have to be careful with the media because they will use you for their own ends. Also others will be suspicious of your motives. But she did go public, and she had to cope with quite a lot of criticism not only from people from outside, but from people 'within': other pagans...*

Although he occasionally allowed himself to be interviewed, perhaps for similar reasons Cecil Williamson never did write a book about his museum and its contents. Nor, since William Paynter's failed attempt to find a publisher for his research in the late 1950s, had anyone else tried to publish a volume specifically on Cornish or West Country witchcraft.[4] This would change in the 90s, however, with the appearance of 'West Country Wicca' (Ryall 1989), 'West Country Witchcraft' (Radford & Radford, 1998) and a series of related books by Oakmagic Publications.

Ryall's book is rather strange. Originally written by an Australian for an American publisher, it seems half-baked and insipid, and makes claims for authenticity that are palpably false. Its author, real name Sheila Mileham, then in her sixties and living in Perth, later served time for kidnapping her grand-daughter: a bizarre story that was subsequently made into the film 'Witch Hunt' with Jacqueline Bisset.

The Oakmagic books, which are very readable but now difficult to obtain, were mostly written by Penzance author Kelvin Jones (b.1948). In contrast, they draw much more from an extensive range of referenced

251

historical sources (eg folklorists, newspapers, gaol books, and the Cornwall Records Office).

Oakmagic Publications were a local publishing company run by Kelvin and Debbie Jones

'Witchcraft in Cornwall', 'Cornish Witchcraft: its Lore and Legends' and 'Cornish Charms and Cures' were all in print by 1996, and excerpts of the first had already appeared in MM earlier in the year. Many similar publications from Oakmagic would follow, including a number of reprints on different aspects of Cornish and Devonshire folklore, and an influential study of contemporary charmers (especially Rose Bettinson of Bodmin Moor) by Rose Mullins.[5]

Notes: 1) Dymh's Penglaz oss graced Mazey Day for 13 years. Then in 2007 the midwinter festival of Montol, complementary to Golowan, was created. Latham-Jones recalls: *Dymh and I did perfom at that very first Montol of 2007, but that was the last time that particular Penglaz was seen on the streets of Penzance. In April 2008 I had a phone call from Dymh saying 'sorry but I'm leaving and I'm taking the oss with me.'* Gemma Gary and Jane Cox worked on making a replacement in time for Golowan 2009, but, unknown to them, so too did another team. Gary and Cox's oss was therefore used at Montol in 2008 and 2009, and Golowan 2009 and 2010, but later in 2010 renamed 'Penkevyll'.

2) Gemma Gary, as author of the influential 'Traditional Witchcraft - A Cornish Book of Ways' (2008) was inspired by Latham-Jones' original notion of the teaser: *'Cassandra used to say that the teaser was known locally as the 'Bucca', and that this role should be performed by a bisexual woman dressed as a man. This was the first time I had been introduced to the idea of the Bucca as an androgynous 'Baphomet-type' deity. I would later encounter others who associated the Bucca with the balance of opposites, drawing upon to the duality of the 'white' Bucca, and the 'black' Bucca'.*

3) Hutton also credits Marian Green, writing as Diana Demdike in her own Quest magazine, for this erosion of the hegemony of Wicca. Eg Quest, September 1991:
'Aiden Kelly has demonstrated that Gerald Gardner invented the entire thing...What crumbs Gardner and his companions inherited from earlier sources do not in any way demonstrate a tradition of covens, naked rituals, scourging and binding...Whats important to me is that people are free to find individual and unhampered ways to cherish the Old Gods, the Green Lord, the Sun God, the Moon Mother, the Powers who are shapeless, nameless, vast and Holy. This does not require hierarchies, initiations, degrees or control...They cannot be encompassed by a house nor compressed into a magic circle for they are freedom, wide as the horizon and deep as the sea...

4) A possible exception is the 16 page anonymous pamphlet brought out by Tor Mark in 1981(?) entitled 'Cornish Charms and Witchcraft'. Ruth Leger-Brown's earlier book (1965) also contains some interesting material relating to Devon, collected during a lifetime of living on Dartmoor.

5) Four of Kelvin Jones' witchcraft books have been recently been compiled into one (Jones, 2015). The full title of Mullins' book is 'White witches: a study of charmers' (2000).

36. Womensland

In 1996 'From the Flames' women's spirituality magazine reported on the first Goddess Conference in Glastonbury. It was an event that split the Goddess community and even prompted a protest. Maggie Parks: *They had this three day conference that none of us could afford to go to! It was like the antithesis of everything we thought the Goddess to be; which was revolutionary. We were nearby, at something called Spiral Women's Camp and we did a demo down the High Street about the Goddess not being for sale.*

Throughout the 90's Cheryl Straffon was an occasional contributor to 'From the Flames', along with Jill Smith, Monica Sjoo, Asphodel Long and others [1]. Her involvement in the Goddess tours in the mid-90's had taken her all over the British Isles usually accompanied by her then partner, writer Caeia March. In 1996 the two of them also attended an international Goddess festival in San Francisco. Straffon's travels culminated in 'The Earth Goddess: Celtic and Pagan Legacy of the Landscape' (1997), a book that builds on 'Pagan Cornwall' (1993) in this time providing a gazetteer for the whole of the UK.

Demonstrating Ronald Hutton's post-modern relativism, Straffon creates a Goddess-centred narrative, showing Her enduring appeal through successive epochs:

I have deliberately interpreted the term 'Earth Goddess' in a very wide-ranging way. She proved to be impossible to box in or categorize, as she has changed and shape-shifted into different names and functions over the years. I take Earth Goddess to mean the original Earth Mother, whose body was the land and who later became the protectress of crops and cattle, and was celebrated in the agricultural wheel of the year. Later she became the guardian of the land, the home and the temple, and took on many names and forms.

Later Straffon quotes Doreen Valiente's 'Charge of the Goddess' and reminds the reader that the Earth Goddess only really existed (and exists) in the hearts and minds of her believers:

There are many paths to the centre of this being, the spiritual force of the universe that has been called the Goddess, but in all cases those who

celebrated or worshipped or placated or loved their Goddesses were seeking only to find the truth of humankind's existence within themselves. The Earth Goddess was out there in the land, but she was also within the inner landscape: she was the focus of the individual's relationship between themselves and the forces of the universe that gave them life, nurtured and sustained them, and finally brought this incarnation to an end.

Origin	Source	Goddesses
1 Prehistoric sites		*Unnamed Earth Goddess*
2 Romano-British		*Sulis Minerva (Bath)* *Coventina (Hadrian's Wall)* *Sillina (Isles of Scilly)* *Sabraan (Gloucestershire)* *Brigantia (Northern England)* *Nemetona (Bath)* *Arnemetiae (Derbyshire)* *Dea Nutrix* *Diana*
3 Celtic Myths	Irish Welsh	*Danu or Anu or Ann* *Eriu (Leinster)* *Boann (Newgrange)* *Mebd or Maeve (Connacht)* *Tea or Teamair (Tara)* *Rhiannon* *Branwen or Bronwen (Powys)* *Arianrhod (Mythical Island)* *Cerridwen (Lake Bala)*
4 Legends of Earth Shaping Crone		*Cailleach Bearea or Old Woman of the Mountains (Scotland)* *Cormelian (Cornwall)* *Mol Walbee (Herefordshire)* *Berry Dhone (Isle of Man)*
5 Goddess & Saint		*Bridget or Bride (pr. Breed)*
6 Goddess in the Church	Saxon Norse Christian	*Nerthus* *Eaoster or Ostara* *Freya (Pentland Firth)* *Frigg (Hampshire)* *Mary* *St Milburga (Shropshire)* *St Helen (Yorkshire)* *St Catherine*
7 Goddess Today	Folktales	*Madge Figgy (Cornwall)* *Sidhe or Fairy-folk*

The Goddess pantheon presented in Cheryl Straffon's 'The Earth Goddess'

In the mid 90's Straffon was involved in an unusual residential project in West Cornwall: *Caeia and I became guardians of 'Women's Land' and that was a brief period when I was doing 'separatist' or women-only work.*

As the guardians, they lived together on site, but the underlying concept didn't sit easily: *I've never been truly 'separatist'. If the Goddess is to have any meaning or resonance it should be for everybody. Women's Land was near Mousehole. It was a kind of spiritual retreat and women could come and camp there, and we did a number of ceremonies and rituals there.*

As part of her writing and research, through the 90's Straffon was also continuing to develop her complex ritual language: something that would later be fully described in early editions of her new Goddess journal, 'Goddess Alive!', that she would launch at the end of 2001.

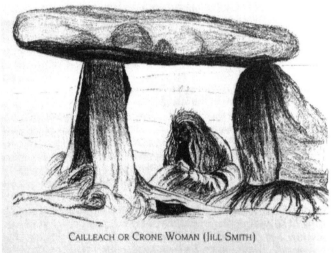

CAILLEACH OR CRONE WOMAN (JILL SMITH)

Cailleach by Jill Smith. From Cheryl Straffon's 'Earth Goddess'

A new partner helped feed her creativity: *Sheila Bright and I came together through an interest in creating Goddess-based ritual. She had had training with Starhawk and the Reclaiming Collective, I had come via straight Paganism. When we came together it was hugely creative because we both brought different but convergent spiritual practices. We were both interested in embodiment, which was an*

ancient Cretan technique, where a priestess would embody the Goddess. And so we both started to create ritual around that.[2)]

Eight rituals were devised that marked the major festivals: *We created a Goddess wheel of the year, and a Celtic Goddess wheel of the year. I think we were creating something quite new.*

The first edition of Goddess Alive! (Winter 2001/2002) describes the Yule ritual, and its place in the cycle:

> Over the course of one year we discussed which Goddesses and their myths we associate with each festival. From these we selected stories which lent themselves to ritual drama and created a "script" for that festival's ritual, with one or more women being honoured to carry (literally, to be possessed by) the Goddess. We are also inspired by the wealth of ancient sites in West Cornwall in which to enact our sacred dramas.

So, for example, as the carefully planned Yule ritual neared its end, and moved from inside to outside, the participants visited a fogou near Pendeen:

> The Sun Goddess went ahead of the women to Boscaswell fogou, put on her yellow sun cloak and golden sun's rays crown, and waited in the fogou. The women gathered outside in the field, calling and chanting with drums and rattles, asking her to return. Soon she did, emerging from the dark mouth of the fogou into strong moonlight in which her pale garments and crown shone spectacularly.

> She spoke words of blessing and returning light, then invited her sisters to help her light her flaming torch. Once the torch was lit, the Sun Goddess held it aloft while the women celebrated, worshipped and danced...

Though the complete set of rituals called upon a range of Goddesses from different traditions, all of them made full use of West Cornwall's sacred sites in this way: *When we devised this wheel of the year, it felt natural to go to places in the land where you could celebrate. We would use Carn Euny for the Samhain ritual. It is a time in Celtic myth when the Otherworld was very close. At the winter solstice we used the local fogou down here in Boscaswell. After sleeping the dreamless sleep we go down in the darkness to call back the Goddess of light out of the fogou who will return with the first light.*

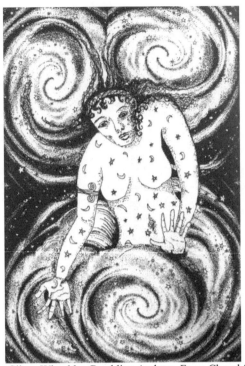

Arianrhod of the Silver Wheel by Geraldine Andrew. From Cheryl Straffon's Earth Goddess.

Most accept that fogous were sites for ritual and ceremony. Ian (Cooke) noted that most fogous are aligned to the North East and the rising mid-summer sun. To me, the reason they constructed their monuments so carefully had to be because they were celebrating the Earth Goddess, and the bounty of the earth, and the one that fed them at the times of the lowest and highest points of the year.

We're talking Iron Age, so it's late. This is the Celtic period now. And we know there is a whole range of Irish and Welsh material describing this period. But by the time the Cornish material was written down it had become quaint stories of saints or witches.[3]

Whilst Straffon agrees ritual practice is about changing one's inner self she does not rule out the possibility of using it to also change the outside world. *You start with the self, but you can still effect changes in the world. If you put a lot of energy into creating an intent and you send that energy out into the world then sometimes it works because all atoms are*

interconnected, and because you're moving energy from one place to another. It's hard work because you're summoning up a lot of energy. Change can happen if enough people want it to.

Nor does change come through political action alone: *I think it has to be both (spiritual and political). Greenham women did a lot of spiritual change. They devised chants and raised energy and sent that energy out for effective change. You have to be political as well as spiritual. It works together.*[4]

Notes: 1) In one FTF article, demonstrating her increasing affinity with Goddess spirituality, Straffon succinctly questions four pagan assumptions including the need for gender 'polarity' and 'balance'. (FTF 13 Summer 1994)

2) Sheila Bright passed on much of this material on to Sarah Vivian for adaptation by the Penwith Pagan Moot.

3) Much of Straffon's research in this area was published later as 'Between the Realms' (2013)

4) Alan Bleakley recalls Peter Redgrove's somewhat contrasting view on this: *Peter said you've got a choice with writing: you go with the will, or the well. The will makes you want to control the world, and magicians want to do this and feel good about the fact they have the power to do so. But for him the secret is the well, which is to drop down into something, going deeply into dreaming or contemplation, so that when you come back up you feel refreshed.*

37. The end of an era

The Ley Hunter (TLH) ceased publication in 1999. Cheryl Straffon marked its passing with a breezy note in the Autumn MM (No. 40 1999):

> It was the end of an era this year when The Ley Hunter, the granddaddy of all Earth Mysteries magazines, finally ceased publication. Tremendously influential in its heyday under the editorship of Paul Devereux, it had in the last few years lost its way, firstly repudiating ley lines and then the whole EM field as well as snidely attacking any other approaches with which it did not agree, including Goddess studies which it seemed to view as some kind of threat. One could say that it was headed up an old straight track with no way back! RIP TLH - we shall miss you![1]

Thanks largely to John Michell, West Cornwall was still a happy ley-hunting ground for many. However, Danny Sullivan, who took over as TLH editor from an exasperated Paul Devereux in 1996, quickly followed him in pronouncing the death of leys, despite the apparent paradox of his doing so.[2]

Ronald Hutton, with hindsight, proposed that the tide turned against leys as early as 1983 with the publication of the book 'Ley Lines in Question' by Tom Williamson and Liz Bellamy. The book had exposed several flaws in ley theory, and as a result, a fissure opened up between the 'mystics' and the 'rationalists' in the movement (Hutton, 2013).

As already discussed, Devereux led the rationalist faction, continuing to publish prolifically, and developing a mixed portfolio of projects: including empirical research, cross-cultural research, and consciousness studies. He has been led most recently to speculate on the ways in which our prehistoric ancestors experienced the landscape: *I worked with Jon Wozencroft, who is a Senior Lecturer at the Royal College of Art. We decided we should go into the landscape, and use our eyes and ears as if they are Stone Age eyes and ears. That was the premise on which we did our work in the Preseli Hills - the Carn Ingli range of rock outcrops, where the bluestones of Stonehenge originated. The study, which was massively covered by the media when our paper came out, had both visual and audio elements. We were able to detect a pattern of natural features being venerated, in a way that preceded the later monuments.*

But, more spectacularly, we discovered that the original areas of the Stonehenge bluestones on and around Carn Menyn comprised a soundscape of rocks that ring with metallic or musical tones when struck with a small hammerstone. Such 'lithophones' were greatly prized all over the ancient world, and we feel that the builders of Stonehenge thought likewise.

Paul Devereux demonstrating the acoustic properties of a Stonehenge lithophone for the Daily Mail ('Stonehenge was a prehistoric centre for rock music' Dec 9th 2013)

By this time Devereux was editing the more academically respectable journal, 'Time and Mind': *Towards the end of my tenure with The Ley Hunter, another journal called 3rd Stone came out, and it dealt with the same subject area very competently. I got friendly with the editor, Neil Mortimer, and he and I agreed that there needed to be something that stood between, that bridged academia and Earth Mysteries, something responsible and accountable. So we came up with 'Time & Mind', the Journal of Archaeology, Consciousness and Culture.*

I call it 'grown-up Earth Mysteries' because the articles in it, even if challenging at times, are properly researched and referenced, and not driven by a belief system.

The Ley Hunter, because of its history, couldn't have occupied the same territory that 'Time and Mind' now does: *TLH became associated with New Age Earth Mysteries. I still get called Paul Devereux the ley-hunter in some quarters, and in others I'm still reviled by some of the old New Agers. In my 'Shamanism and the Mystery Lines' (1992) I'd unpicked what the ley idea was – a mix of a sham and a misunderstanding. And yet some of the work that was done in ley-hunting was valid, and laid the foundation for better research later on.*

Despite his hard-nosed reputation, Devereux remains respectful of other more mystical approaches to the ancient sites, including eg Cheryl Straffon's use of ritual, described in the last chapter: *I've always thought Cheryl's writing was good, and sensible. But I am not into Neo-paganism myself. Some people need a religion, others don't. I've certainly been into spirituality ever since the sixties. I've had a number of dramatic spiritual and otherworldly experiences, but I just don't like religion. Religion starts where spirituality ends, in my view. And I can have magical and mystical experiences with nature without the need for any sort of 'ism'. But each to their own. People need to believe. A lot of it is an escape from humdrum daily reality. My argument is that you can still be intellectually and emotionally involved with real mysteries. There are amazing things happening in the Universe and in the human mind.*

And to add a political note, I think New Age mush allowed the rise of the right wing across the Western world now. To an extent my generation allowed it to happen. We should have been a bit tougher instead of drifting off. But ecological awareness did come out of that period, which is a good thing that has persisted.

Plato said 'go not beyond the beam of the balance'. That's important. It means basically, that you can engage in non-mainstream stuff but you still need to keep it real.

Strikingly, despite the rationalists in their midst, Neo-paganism in its manifold diversity was growing ever more confident, and one event more than any other demonstrates this.

Notes: 1) Straffon clearly had ambivalent feelings about TLH, and in a much later editorial in MM indicates that, as editress, she had deliberately avoided the rather dry, technical debates about leys that sometimes afflicted it.

2) In 1998, for example, Sullivan wrote a piece for the website stonesofwonder.com entitled 'Ley lines: dead and buried': *Seventy years after Alfred Watkins alerted the world to the existence of ley lines, his simple vision of prehistoric traders' trackways has evolved into a confusing and tangled web of delusions, falsehoods and superstition...I would say that there is no such thing as a ley...Watkins saw the remains of archaic spirit lines, medieval corpse ways and church road alignments and hundreds of chance alignments...*

38. The Solar Eclipse

The first meeting of CASPN (Cornwall Ancient Sites Protection Network - then Sacred Sites Protection Group) took place in October 1997, with representatives from the National Trust, Cornwall Wildlife Trust, the Bolitho Estate (landowners), O.B.O.D., the Pagan Moot and others all coming together (MM 35 winter-spring 1998). Andy Norfolk: *In 95/96 there were problems with some of the ancient sites in Cornwall getting damaged. So that's when I kicked off CASPN by writing to all the landowners and people who had a stake in the sites and their care. At about the same time I started CASPN I was contacted by someone who wanted to buy the Rollright Stones. As a result we set up ASLaN (Ancient Sacred Landscape Network), which was a bit more of a national thing. In the early days of ASLaN I worked with Claire Slainey on the ASLaN charter about how to behave at ancient sites. ASLaN links and PF links meant, later, that I also got involved in the Stonehenge planning enquiries.*

It was as members of CASPN (Cornish Ancient Sites Protection Network), that Cassandra Latham-Jones and Andy Norfolk worked together during preparation for the solar eclipse, which was scheduled for the 11th August, 1999.

Twelve months earlier Cheryl Straffon had written in MM:
> Word reaches us in West Cornwall that the forces are gathering in preparation for the Total Eclipse of the Sun in August 1999! Already there is much apprehension and worry about the anticipated half a million or so visitors, expected to converge on West Cornwall for 11.11 am on August 11th 1999 for this once in a lifetime event (the next one in Britain will not be until 2090 nearly 100 years into the future). Already it is being described by the County planners as 'anticipated mayhem', 'a recipe for disaster', 'like waiting for a meteorite to hit', 'a crisis in the making' and 'a massive strain on local resources'.

South-West Cornwall was the only place in the UK where 100% totality would be assured (ie where the sun would completely disappear).

Cassandra Latham-Jones speaking to Michael Beurk on BBC1, in Mount's Bay the day before the eclipse. She describes herself as a 'pellar' (a term she has since dropped) and is holding a bull-roarer that she demonstrates to the camera.

Andy Norfolk: *CASPN got concerned about the huge number of people that were expected to come down. I suggested that we had responsible people at each of the ancient sites where people were most likely to wind up, so there'd be something happening that they could look at or take*

part in, but there'd also be responsible people there to ensure they didn't start lighting fires against the stones and that sort of thing. As a result the media took an interest, and we did at least a couple of dozen radio and TV interviews.

One of the first events on the big day was held at 10 AM by, of all people, Ken Kesey and the Merry Pranksters. They had shipped their psychedelic bus 'Further', to Britain (in fact it was a near copy of the 1964 original), and descended on the Minack Theatre for a performance of 'Where's Merlin'. It was a show that they would take to London a few days later.[1)]

Ken Kesey (in vertical stripes) and the Merry Pranksters visiting the UK in 1999

The BBC, who the previous night had interviewed Cassandra Latham-Jones, were encamped with Patrick Moore and large expectant crowds near St Michael's Mount. Other film crews were ready and waiting elsewhere across the peninsula.

The CASPN volunteer-pool was not huge, but they'd been joined by others, including two of the most flamboyant personalities in contemporary Paganism: Uther Arthur Pendragon, the reincarnation of King Arthur, and the polyamorous American wizard Oberon Zell who bred, and owned, unicorns. Zell was also the founding editor of the influential 'Green Egg' magazine, and had originally contacted Latham-Jones by phone from the States.

Andy Norfolk: *We talked to people like King Arthur Uther Pendragon, so he and his people were at the Men an Tol. I was at Boscawen Un, others were at the Hurlers, and so we called on favours from people from all over Britain to keep an eye on the sites. It worked out well, and we didn't have any damage at any of them. Given the number of occasions people have built fires and sweat lodges all over the place, I think that was quite a success.*

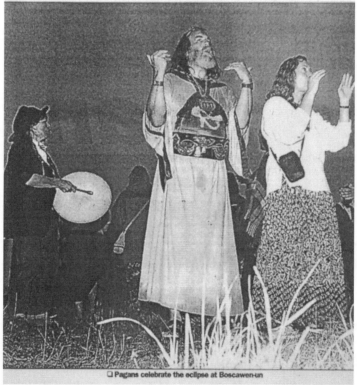

❏ Pagans celebrate the eclipse at Boscawen-un

Oberon Zell (centre) at Boscawen-Un: from an article in The Cornishman

Boscawen-Un was set up as a honey trap, so we had all the media there, and we had Oberon Zell over. We ended up with at least half a dozen film crews. I said 'please stay out of the circle', but one of them came in and his equipment immediately stopped working. Pure coincidence of course, couldn't be anything else! We'd planned a ritual. Zell was part of it, and as well as more than 100 people watching, there were about 30 other people who joined in, at various stages of being robed or not.

267

Not only did it end up being the largest public pagan ritual of its kind to have been held in Cornwall in centuries, but in its content and structure it was probably not that different from the Neolithic ceremonies of the monument's original builders.

Levannah Morgan, a witch based in Devon, contributed this account to MM in 2000:

Cassandra, Andy, Oberon Zell, myself and other friends walked the one and a half miles from St Buryan to Boscawen-Un early on eclipse morning by the ancient Trackways. We began our rite just before First Contact (the point where the Moon first starts to obscure the Sun)...

We all linked hands and I led the casting of the Circle. Everyone walked the Circle chanting 'We hallow this Circle in love, peace and trust'...Then Andy called the Quarters in Cornish, with loud shouts of "Hail and welcome" ringing around the stones. Oberon Zell then invoked the Moon Goddess using an invocation which he had created for an eclipse in America in 1979.

This was followed by me invoking the Sun God using Cornish and other Celtic names linked with Egyptian concepts of the progress of the Sun through the sky. Cassandra then led the raising of power, an intense freeform period of drumming, chanting, music and dancing which lasted about 45 minutes...

Five minutes before totality we stopped and everything became still and silent. Flocks of birds flew off to roost as the light dimmed; cows lowed and cocks crowed. Then we saw the Moon's shadow come racing towards us from the west, visible at first as a line of darkness along the bottom edge of the clouds, then racing along the ground towards us. We saw it reach our feet and suddenly we were in total darkness. There was a faint glow around the whole horizon as if we were standing in a 360 degree sunset. In the beautiful bright dark silence people hugged each other, shivered, communed with the Gods, the world and each other.

All too soon the light returned. Everyone was quiet, smiling and euphoric. The Deities, Quarters and Spirits were thanked, and the Circle closed "Merry meet, merry part and merry meet again" rang around the stones. At this point the Sun broke through the clouds and we saw most of the final phase of the eclipse...

Journalist, Colin Gregory, meanwhile, focussed on events a few miles north at the Mên an Tol (The Western Morning News):

High up on the Penwith hills, standing in the mystical Mên-an-Tol ancient monument, the sudden darkness of the total eclipse, the silence of people

and birds, and then the almost surreal orange glow that heralded the second dawn of the day was an unforgettable experience...

The holed stone provided a mystical and beautiful setting to watch the last great natural event of the 20th Century. Druids, including 'King' Arthur Pendragon, had been invited there for a ceremony to help protect the stones, and their presence added to the occasion. Arthur, with his sun crown and his green robe, together with Druid priests and priestesses, chanted and hit gongs to try and clear the clouds.

Everything went silent in anticipation at 10.50, but when totality came 21 minutes later it rolled over us at unbelievable speed. It was as if someone had turned back a dimmer switch, as darkness came. It was never completely black, and Ding Dong stood proud on the hill in the distance with people gathered on the spoil heaps around. It seemed just seconds, not over two minutes of darkness and then there was almost a flash of ochre as light began to return.

There was a strange aura, unlike any light I have seen before, and it did not come gradually. Instead, it sprang over the top of the hills above Mount's Bay, a glow of orange that was neither dawn nor dusk. There was almost a distant fire before normal daylight returned.

Everyone let out a howl of joy, the music began again, Arthur danced with his Druids and people looked around at each other in the daylight. It was as if everyone had emerged from the shadows, into a new age.

Whilst the larger, public events attracted the most media attention - including Ed Prynn in his druid robes in St Mabyn - all over Cornwall other more private celebrations were taking place. Visitors camping at Harmony pottery, for example, wore masks representing the planets, as events there were orchestrated by Geraldine Andrew.

Cheryl Straffon (C), Sheila Bright (S) and another friend, meanwhile, had spent several months planning their own much quieter ceremony in the far West (MM 41 Winter-spring 2000):

S: We cast a mobile protective circle around us at home, then walked within it, together but separate, to our local holy well to purify and bless, up the local holy hilltop for fresh wind through our aura and to the standing stone for hugs and grounding.

Western Morning News: campers prepare for the eclipse at Mên an Tol

C: As we moved through the landcape, we went from social gatherings of people on Cam Eanes to a very separate and private walk across the moors to Carn Kenidjack, chosen by us because of its legendary associations with the spirits of the dead and the otherworld...

S: There we did the most powerful invocation I have ever done of the Dark Goddess of death, endings, separation, cutting and letting go. So clear, so focussed, so final, almost vibrating with power. Then we each named out loud our offerings to Her, those things we wished to irrevocably let go of - and waited for second contact and the awesome shimmering darkness to complete our magical act.

C: At the moment of Total Eclipse when a great wave of blackness swept across the Land I connected in a deeper and more profound way with the spirit of the universe that I call the Goddess than I had ever before, and just gave it all back to Her....We returned from whence we had come across the moors as the final contact of the moon and sun unfolded, and I felt very

vulnerable and shaky as though I had become a baby again. The whole experience was for me very profound and moving and the spiritual and emotional work I did stayed with me afterwards and changed me and my life in very many ways.

The eclipse of 1999 still seems to haunt the present. Gemma Gary: *I think the fact that it was overcast that day was a good thing. The conditions encouraged us to look around us, at the landscape, to see familiar surroundings take on an otherworldly and surreal appearance. In that way it was particularly transformative.*

Cassandra Latham-Jones: *The cloud-cover diffused the light and it looked like the end of the world, or maybe the beginning, it was that spooky. And you could watch the moon's shadow move across the clouds really clearly, and I'll never forget it.*

Gemma Gary: *The eclipse certainly seemed to bring with it a profound shift for me. Geraldine's eclipse camp at Harmony was the last of her events I attended, and my focus moved away from open rituals and pagan meetings to a more private and intimate approach. I dug myself into a very personal path of operative magic and a quiet spirituality nestled in the landscape: dusk walks along the narrow lanes, sea-cliffs and thorn-bordered fields surrounding the village provided all the ritual I needed.*

Steve Patterson: *Eclipses are traditionally an inauspicious, dark time, and it was in accordance with that. Maybe it marked the end of a particular stage of paganism in Britain. May be it marked the moment when it became digitised and dissociated itself from the landscape. In the 90's, the internet gets switched on, and as the pagan world embraces the digital world, the old structures break up: the whole coven structure and whole ways of networking break up.*

And it's a very different world from that point onwards. But the internet only provides a simulacra of magical ideas, because actually magic is experiential and otherworldly.[2]

Meyn Mamvro went 'online' in 1999, or at least it had a website of its own (MM40 Autumn 1999), and it wasn't long until most other pagan writers and organisations followed suit.

271

Digital technology can certainly be seen to have affected the Penwith Pagan Moot in the years since 1999. Sarah Vivian: *The moot rituals got bigger and bigger during the noughties, but then they tailed away again and would have done so sooner had we not had a brilliant team of ritual planners and such good places to go. We did rituals on Sennen Beach, on Chapel Carn Brea, Crean Woods, Sancreed House, Sancreed Village Hall, Merry Maidens and Boscawen Un. We had that boldness to do rituals in public that people wanted to be part of.*

But in recent years the numbers have dwindled down to 20 or so. There seems to be a general societal move away from meeting face-to-face in real groups and instead relying on Facebook and other social media. Many groups I knew of when I first moved here have gone, not just in Pagan spheres but across the board – for example St Just once had three choirs and now only one remains. It's a change in the way people think and feel. It worries me a lot.[3]

The counter-cultural qualities that energised Paganism, and made it edgy and radical in the 70's, 80's and 90's, have also faded in recent years. Steve Patterson: *There was a lot of energy in the 80's when it was still a radical underground scene. As it came out in the open, some of the old 'magic' began to dissipate. It's like fairy gold, once you take that into daylight. It was the same with the moot thing. It was great that people were able to come together, but some of the 'magic' definitely began to dissipate.*

August 12th 1999. Oberon Zell meets up with Ken Kesey on the day following the solar eclipse and presents him with the figurine 'Millenium Gaia'

Sarah Vivian: *Originally Pagans felt the need to meet in semi-secret with like-minded people, but now acceptance is so widespread, especially here in SW Cornwall, that like-minded people are everywhere you go, and therefore people no longer feel the need to group together.*

In my street alone there are four households of directly and specifically Pagan people, a further six sort of vaguely Pagan-ish, or Druid-ish, and there are many more that are okay with it. Neighbours, even the outwardly conventional ones, have seen me packing cauldrons or swords or other ritual stuff into my car and just said things like "Oh another ritual, have fun" or "Say a spell for me too"...

Back in 1999, however, some residual antagonism towards pagans remained. Having learnt to speak Cornish, Andy Norfolk, like Craig Weatherhill a few years before, was made into a language bard of the Cornish Gorseth. As he recalls: *I got an interesting letter from the Grand Bard at the time. It said 'They'd talked about me and they probably would make me a bard but I had to make it clear that the Gorseth has nothing at all to do with anything pagan'. At the time various bards still turned up to get changed for the ceremony wearing T-shirts saying 'Pagan and Proud'!*

That same year local councillors tried to prevent Geraldine Andrew from continuing to use Tehidy Woods for her 'pagan rites'. She was disappointed and upset by this, but took up teaching on 'Wicca' at Truro College instead: *The councillors admitted that they couldn't stop me from doing it on public land so I eventually got an apology from them, but decided the feeling's not right now, so withdrew. Instead I thought 'how else can I get the message out?' So I did several ten week adult education courses instead.*[4]

1) Earlier in the summer a more secular but equally memorable response to the eclipse had been erected on a hill overlooking Mount's Bay. 'Elliptic Ecliptic', an installation by American artist James Turrell, remained in situ in Tremenheere Gardens for several months. It was a 'skyspace' - a room with a ceiling open to the sky - and in some ways it was like a post-modern version of some of the other sacred spaces discussed in this book. Jonathan Jones in The Guardian reported on it thus: *Inside the aluminium shed, there's an oval wooden bench with golden light flowing out of it... The light creates the illusion that the sky has warped into the dome of a renaissance palace. You peer at the clouds painted on the ceiling and hope they might have gods and goddesses perched on them. (The Guardian 8th July 'Immortal Longings')*

2) A spate of vandalism, including homemade 'napalm' being used on the Mên an Tol by a mysterious organisation calling itself 'The Friends of the Stone' prompted similar speculation in MM in 2002.

3) Interestingly, social networks and proactive pagan Facebook groups encouraged greater numbers of people to describe themselves as Pagan in the 2011 census, with numbers doubling relative to 2001.

4) Never herself having been initiated into a Wiccan coven, at the time Andrew used the term 'Wicca' in its broadest sense: *I took the women's angle: the Wheel of the Year, the sacredness of all life and Gaia. I was in a college scenario that was completely dead, but I was able to talk about my own experience.*

39. The first and the last

'we walk...towards the wall of Death, where our Earth spirit-forms will speak up and so ensure that one is accepted and allowed to pass into the world of everlasting life' Cecil Williamson quoted by Levannah Morgan in The Cauldron 155 (2015)

It is not known how Cecil Williamson experienced the eclipse, but at some point during summer 1999 he suffered a debilitating stroke and was moved to a nursing home. Then, only weeks after Doreen Valiente's death (on September 1st) and days before the new millennium, he died at the age of 90 (on December 9th).

Williamson remains an influential, if enigmatic figure. Paul Broadhurst: *Cecil lived in North Devon and didn't come down (to Boscastle) very much. But I did see him in the pub on occasions, and he was an amusing character in many respects. Balding, podgy, little guy with two terriers: you wouldn't think he was the king of witchcraft! But when you started talking to him it was different. He had lot of hidden depth. When I sent him a flyer for 'Secret Shrines' he immediately rang me up and we had this very long chat on the phone. I said 'you must have got to know some fascinating people over the years'. He said 'Oh no. People think you're interesting and they'll chat to you about witchcraft, but when they realise its all true they clam up and vanish'. He was not a dilettante. He scared a lot of people off.*

The day he turned up at the 'Secret Shrines' book launch he was very impressive. He wore a long robe. He wasn't shy and retiring at all. He wasn't the dumpy little guy in the pub! He'd suddenly transformed into a kind of Celtic bishop. He had a big staff with a rough Celtic cross at the top of it.

Myths about Williamson abound, despite the recent publication of Steve Patterson's biography. Paul Broadhurst: *He was a practising occultist. His laboratory, at his house in Witheridge (Devon), which we (Paul Broadhurst and Graham King) dismantled after his death, was absolutely full of ongoing projects. He was a solitary practitioner and he had*

various small shrines in his house. Certainly when you met Cecil it was obvious that he used to mess around with the 'dark stuff'.

Williamson, who lived alone, had become increasingly solitary in his old age, but letters sent to Levannah Morgan in the year before he died confirm his continuing dedication to an unseen spirit world. He is clearly aware of how eccentric his beliefs might seem to others, however: *'It is nice to meet with someone who will not regard me as a cranky old fool for having, making use of, talking...with Spirit Forces. For we live in a world where THEY are all around us and ever present ready to help and protect us from Evil...you and I are indeed fortunate to be aware of their existence and are ready and happy to take steps to foster and to promote our contact with their presence and to...make use of the advice they give us from time to time... I live alone and work alone in my house late at night either indoors or out. One has to, for it is their way. To be active while mankind sleeps and nature is ever wakefull and awake'*....Quoted by Levannah Morgan in The Cauldron 155 (2015).[1]

Williamson had witnessed the rise of Neo-paganism at first hand, yet his indifference towards Wicca had created something of a rift between himself and the mainstream as it developed in the 70's and 80's. He had, however, consistently championed the craft of the cunning-folk and the wayside witch, in a way that anticipated more recent developments.

Cecil Williamson's crystal ball on display at the MOWM 2016.

Ronald Hutton has been a long-term supporter of the Museum of Witchcraft (and indeed spoke at the inaugural meeting of the Friends of The Museum of Witchcraft in December 1997 (MM 35, 1998)). Steve Patterson is sure that Hutton's book 'Pagan Religions of the British Isles' (1991), played a big part in changing Williamson's fortunes: *During the eighties all the radical Neo-pagans were still hanging on to the myth of the 'burning times' and the prehistoric fertility religion - the old Murrayite idea. Then during mid 90's Ronald Hutton pulled the rug from under Wicca, and this is when you get a readjustment and a looking again at the old crafts: the craft traditions that grew out of the 18th and 19th centuries, and the non-Wiccan traditions.*

Gemma Gary also highlights the importance of Hutton's later book 'The Triumph of the Moon' (1999): *Many people refuted his findings and dug themselves deeper into Murrayite theory, whilst the resulting 'authenticity paranoia' saw others abandon Wicca, and other coven-based traditions, in search of the 'cunning-craft' in the belief that this would make them appear more legitimate.*

Being of the generation that entered adulthood in the 1990's, ours was perhaps the first to enter into Wicca and traditional witchcraft fully aware of their modern origins, yet at the same time able to discern the earlier strata of influences which form their component parts. Now when we enter into Craft initiation, we do so without fantasies of the 'burning times' or the agonies of an ancient line of forebears. Instead, we knowingly take on the mantle of traditions developed more recently: we can know and cherish it for what it truly is; two or three generations of occult and neopagan experimentation and innovation.

The 'third strand' that derives from Robert Cochrane (Jones & Valiente, 1990) helped inform Jo O'Cleirigh's influential group - which by then was called 'Cuil na Sidhe' - and thereby other emerging practitioners in Cornwall, like Gary herself: *I took to these ways instantly, recognising much in them from my intuitive exploration of Cornish Craft and my interest in the 'Cochrane tradition'....The group (Cuil na Sidhe) also possessed a candle-lantern made by a founding member of Cochrane's covine...*Wiccan Pagan Times

Despite heated debates as to the legitimacy of 'modern' traditional witchcraft, Cornish or otherwise,[2] it is as if Williamson's time has at last come. Steve Patterson: *Cecil was unknown and disregarded outside*

277

the museum. But now people talk about him in relation to traditional craft. Cecil has come very much back into the fold.

Spirituality is private and subjective, and, taboos relating to Paganism and witchcraft still have much power. As I found writing this book, some were cautious about speaking to me. (For example, Sarah Vivian was reluctant to show me all the records of the Penwith pagan moot, for fear that she would 'out pagans against their wishes'). Going public has, therefore, been difficult but necessary. Cheryl Straffon: *It's amazing how Paganism has grown, to an incredible extent, and I guess it wouldn't have happened had it remained a private secret initiates-only sort of faith. And now it's – relatively-speaking - huge and that's only come about because of the publicity and the people who have written about it. It's quite extraordinary. If you were growing up in the 60's and 70's you'd have never have guessed that it would have blossomed in this kind of way. I think it is good, too, that it's not so rigid now. People can make their own choices and can pick and mix around it. It's a faith or belief, that started out with some rigid rules, but it's thrown those shackles off now, and it's grown organically.*

Cassandra Latham-Jones standing at the foot of the maypole at Harmony Pottery, Beltane 1996.

Cassandra Latham-Jones remains hugely inspired by West Cornwall and its proximity to the the ocean: *I will never lose my love for this landscape because it's such a liminal space. The ancient Celts, if you look at their teaching and writings, viewed the in-between spaces as special: where things were neither one thing or the other; where there was a threshold or an edge. The first and the last; the beginning and the end; the one and the all. Land's End. Finisterre. These were places that were haunted by spirits. This is why at Halloween they say the veil is thin. It's a time when the dark starts to overcome the light.*

Jo O'Cleirigh emphasises his attachment to the spirits of the Lamorna Valley in particular: *As Pagans we feel very connected to the spirits of the Earth - especially so where we work...Our circle is partly overlooked by an ancient Holly, whose spirit seems always to guard us... My hope is that Pagans will use their faith and magical workings and lifestyle to heal our Mother Earth from the terrible abuse we are still inflicting upon her body.* The Cauldron 143 (2012)

The Earth Mysteries movement in the UK gave many who were inspired by the Cornish landscape a route into pagan-thinking if not Paganism itself. Alan Bleakley: *Here in West Cornwall we live on a giant Neolithic graveyard. There is an odd combination of immense beauty on the surface, then underneath that is all of this stuff with this incredible power. This is the <u>real</u> earth energy.*

The movement had relied much on 'The Ley Hunter' for its sense of identity, which it lost when the magazine folded at the end of the millennium. Yet the man that originally revived the magazine in 1969, Paul Screeton, is of no doubt regarding the role it played in helping to change the views of the generation that read it: *In the 70's leys offered a very British - even English - alternative to Eastern religions. Pseudo-druidry and paganism were becoming popular then. Even the Aetherius Society and other saucerians were in the frame as options to non-Christians. This counter-cultural milieu certainly enlivened society and the faith debate. Young people found new politics, new music and new philosophies.*

Cheryl Straffon, who continues to publish both 'Meyn Mamvro' and 'Goddess Alive!' has seen a number of comparable magazines come and go during her long tenure as editor.[3] She was another of the generation encouraged by The Ley Hunter, and inspired by the landscapes and folklore of Cornwall, and she recognises the enormous change that has

occurred during her lifetime. It seems the battle for a more spiritually creative and open-minded society has been won, partly as a result of the efforts of many discussed in this book: *There is a different generation around now who, are much more open to the spirituality of the landscape. I was brought up in an age that was homophobic and anti-anything that might not be Christian. I've seen the world change 360 degrees. There's been an extraordinary shift in my lifetime...*

Notes 1) In the same 'Cauldron' article Levannah Morgan comments *'Cecil was a spirit worker with absolutely extraordinary powers and skills; the best I have ever met and am ever likely to meet'.* Williamson also inspired Morgan's recent book 'A Witches Mirror' (2013).

2) Semmens, for example, is not convinced that there is anything truly distinctive about 19th Century Cornish traditional witchcraft (Semmens, 2010). Gemma Gary challenges this, however: *Some Cornish charms do appear unique to the region, and there is much to be found in the Cornwall's folklore, fairy faith, and the rituals of operative magic associated with some of its ancient monuments and holy wells that all add up to form something of distinction (pers comm.).*

Gary's views on traditional witchcraft also include the following: *I think the arguments about legitimacy are ultimately a dead end. Whether it's Wicca, modern day 'cunning-craft', or 'traditional witchcraft', it's all reconstruction, recreation and reinvention. Wiccans have reinvented pagan magical spirituality, modern 'wise-woman' and 'cunning-men' partially re-create 19th century and earlier methods of magic, and 'traditional' groups draw upon folkloric witch beliefs to create practices for the modern day. In this sense all should be allies, there should be no reason to be at enmity with those who pursue a path which differs to one's own....Ironically, I don't think the 'old-time' witches were much bothered about historical legitimacy and authenticity, they just got on with it. Efficacy, fulfilment and the production of results are the only real 'badge of authenticity' required of a personal path. (pers comm.)*

3) eg Alex Langstone, who moved to Cornwall in 1994 after publishing his first book 'Bega and the Sacred Ring', produced two magazines: ASH (Albion's Sacred Heritage) which ran from 88-93, and The Lighthouse from 93-2000.

And you who seek to know Me, know that your seeking and yearning will avail you not, unless you know the Mystery: for if that which you seek, you find not within yourself, you will never find it without.

Ha why, neb a venga gothas ve, guthvetho na ra goz aspeangow ha whansow goz avaylia, menas why uffia an Mystery, rag po nag era why cavas an peath era why wheelas bera goz hunnen, henna na re why e gavas tewe aveaz noneil.

For behold, I have been with you from the beginning. and I am that which is attained at the end of desire. I await you now.

Otta! Me a vee gena why an dallathvas, ha tho ve an pearl: a veuth comerus ort an dewath a hirrath. Ha thera ve goz corms lebmen.

Exerpt from Craig Weatherhill and Neil Kennedy's translation of Starkhawk's 'Charge of the Goddess' (originally written by Doreen Valiente) MM 46 (Autumn 2001)

References

Adler, Margot (1979) Drawing Down the Moon *Beacon Press*

Bleakley, Alan (1984) Fruits of the Moon Tree *Gateway Books*

Bleakley, Alan (1989) Earth's Embrace *Gateway Books*

Bord, Janet & Bord, Colin (1972) Mysterious Britain *Garnstone Press*

Borlase, William (1754) Observations on the Antiquities Historical and Monumental... *Jackson*

Bottrell, William (1870) Traditions and Hearthside Stories of West Cornwall *William Bottrell*

Bourne, Lois (1998) Dancing with Witches *Robert Hale*

Broadhurst, Paul (1988) Secret Shrines: In Search of the Old Holy Wells of Cornwall *Pendragon*

Broadhurst, Paul (1992) Tintagel and the Arthurian Mythos *Pendragon*

Broadhurst, Paul & Miller Hamish (2000) The Dance of the Dragon *Mythos*

Colquhoun, Ithell (1957) The Living Stones *Peter Owen*

Colquhoun, Ithell (1961) Goose of Hermogenes *Peter Owen*

Colquhoun, Ithell (1973) Grimoire of the Entangled Thicket

Colquhoun, Ithell (1975) Sword of Wisdom: MacGregor Mathers and the Golden Dawn *GP Putnams Sons*

Colquhoun, Ithell (1976) Surrealism – Ithell Colquhoun: Paintings, Drawings Collages 1936-1976 *Newlyn Orion Gallery*

Colquhoun, Ithell (2011) Two fragments on Ataturk *Starfire Volume II, No. 4*

Cooke, Ian McNeil (1993) Mother and Son: The Cornish Fogou *Men An Tol Studio*

Cooke, Ian McNeil (1987) Mermaid to Merrymaid: Journey to the Stones *Men An Tol Studio*

Cross, Tom Painting the Warmth of the Sun (1984) *Alison Hodge*

Davies, Owen (1999) Witchcraft Magic and Culture 1736-1951 *Manchester University Press*

Deane, Tony & Shaw, Tony (1974) The Folklore of Cornwall *BT Batsford*

Devereux, Paul (1990) Places of Power: Measuring the Secret Energy of Ancient Sites *Blandford*

Devereux, Paul (1992) Shamanism and the Mystery *Lines Quantum*

Drury, Nevill (2004) The New Age: Searching for the Spiritual Self *Thames and Hudson*

Du Maurier, Daphne (1966) Vanishing Cornwall *Penguin*

Feraro, Shai (2013) 'God Giving Birth' - Connecting British Wicca with Radical Feminism and Goddess Spirituality *Pomegranate Vol 15, No 1-2*

Farrar, Stuart (1971) What Witches Do *Coward, McCann & Geoghegan*

Farrar, Janet & Farrar, Stuart (1980) Eight Sabbats for Witches and Rites for Birth, Marriage and Death *Robert Hale*

Frazer, Sir James (1890) The Golden Bough: A study in Comparative Religion *Macmillan*

Gary, Gemma (2008), 'Traditional Witchcraft - A Cornish Book of Ways' *Troy Books*

Gimbutas, Marija (1974) Gods and Goddesses of Old Europe *Thames and Hudson*

Gooding, Mel (2002) Song of the Earth *Thames and Hudson*

Hale, Amy (2004) The Land Near the Dark Cornish Sea *Journal for the Academic Study of Magic*

Hale, Amy (2012) The Magical Life of Ithell Colquhoun (in Pathways in Modern Western Magic ed. Neville Drury) *Concrescent*

Harrison, Charles (1981) English Art and Modernism 1900-1939 *Viking*

Howard, Michael (2009) Modern Wicca *Llewelyn Publications*

Hunt, Robert (1865) Popular Romances of the West of England *John Hotten*

Huson, Paul (1970) Mastering Witchcraft *Putnam's*

Hutton, Ronald (1991) The Pagan Religions of the Ancient British Isles *Blackwell Publishing*

Hutton, Ronald (1999) Triumph of the Moon: A History of Modern Pagan Witchcraft *Oxford*

Hutton, Ronald (2013) Pagan Britain *Yale*

Huxley, Aldous (1954) Doors of Perception *Chatto & Windus*

Jones, Kelvin (1998) Seven Cornish Witches *Oakmagic Publications*

Jones, Kelvin (2015) Cornish Witchcraft: the History and Craft of Cornish Witches *Cunning Crime Books*

Jones, Evan John & Valiente, Doreen (1990) Witchcraft: A tradition Renewed *Robert Hale*

Latham-Jones, Cassandra (2011) Village Witch *Troy Books*

Leger-Gordon, Ruth (1965) Witchcraft and Folklore of Dartmoor *Robert Hale*
Lippard, Lucy (1983) Overlay: Contemporary Art and the Art of Prehistory *The New Press*

Lippard, Lucy (1997) The Lure of the Local: Senses of Place in a Multicentred Society *The New Press*

Lovelock, J.E. (1979) Gaia: A New Look at Life on Earth *Oxford University Press*

Lethbridge, T C (1962) Witches: Investigating and Ancient Religion *Routledge & Kegan Paul*

Madge, S.J. (1950) Chapel, Kieve and Gorge of St. Nectan, Trevillet Millcombe *Liddell*

Mellor, David Alan (2012) The Bruce Lacey Experience *Camden Arts Centre*

Michell, John (1967) Flying Saucer Vision *Sidgwick & Jackson*

Michell, John (1969) The View Over Atlantis *Garnstone*

Michell, John (1974) The Old Stones of Lands End *Garnstone*

Michell, John (1977) Short Life at the Land's End *Compton Press*

Michell, John & Rickard, Robert (1982) Living Wonders *Thames and Hudson*

Michell, John (2010) Michellany: A John Michell Reader *Michellany Editions*

Miller & Broadhurst (1989) The Sun and The Serpent *Pendragon Press*

Morgan, Levannah (2013) A Witch's Mirror *Capall Bann*

Nelson, Elizabeth (1989) The British Counter-Culture 1966-1973*Palgrave Macmillan*

Newman, Paul (2007) The Tregerthen Horror *Lulu*

Parker, Rozsika & Pollock, Griselda (1987) Framing Feminism: Art and the Women's Movement 1970-1985 *Pandora Press*

Patterson, Steve (2014) Cecil Williamson's Book of Witchcraft *Troy Books*

Redgrove, Peter (1987) The Black Goddess and the Sixth Sense *Bloomsbury*

Radford, Roy & Radford Ursula (1998) West Country Witchcraft *Peninsula Press*

Ratcliffe, Eric (2007) Ithell Colquhoun *Mandrake of Oxford*

Rhiannon Ryall (1989) West Country Wicca: A Journal of the Old Religion *Pheonix Publishing*

Sagar, Keith (2003) The Life of DH Lawrence *Chaucer Press*

Screeton Paul (2010) From Atlantis to Avalon

Semmens, Jason (2008) The Cornish Witch-finder *Old Cornwall Societies*

Semmens, Jason (2010) Bucca Redivivus *Cornish Studies: Eighteen*

Shiels, Tony Doc (1990) Monstrum: A Wizards Tale *Fortean Tomes*

Shillitoe, Richard (2010) Ithell Colquhoun: Magician Born of Nature *Lulu*

Shuttle, Penelope & Redgrove, Peter (1979) The Wise Wound

Sjoo, Monica & Mor, Barbara (1987) The Great Cosmic Mother *Harper & Row*

Sjoo, Monica (1992) New Age and Armageddon: The Goddess or the Gurus *Women's Press*

Smith, Jill (2000) The Callanish Dance *Capall Bann*

Smith, Jill (2003) Mother of the Isles *Meyn Mamvro Publications*

Starhawk (1979) The Spiral Dance: A rebirth of the Ancient Religion of the Great Goddess *Harper and Row*

Stone, Merlin (1976) When God was a Woman *Mariner Books*

Straffon, Cheryl (1993) Pagan Cornwall: Land of the Goddess *Meyn Mamvro publications*

Straffon, Cheryl (1997) The Earth Goddess: Celtic & Pagan Legacy of the Landscape *Blandford*

Straffon, Cheryl (2007) Daughters of the Earth *John Hunt*

Straffon, Cheryl (2013) Between the Realms: Cornish Myth and Magic *Troy Books*

Tudor-Pole, Wellesley (1951) Michael: Prince of Heaven *Watkins*

Twinn, Nigel (2010) Hamish Miller: A Life Divined *Penwith Press*

Underwood, Guy (1969) Patterns of the Past *Museum Press*

Valiente, Doreen (1978) Witchcraft for Tomorrow *Hale*

Valiente, Doreen (1989) Rebirth of Witchcraft

Weatherhill, Craig (1980) Belerion *Alison Hodge*

White, Rupert (2013) Folk in Cornwall: Music and Musicians of the 60's revival *Antenna*

White, Rupert (2015) Monstermind: The Magical Life and Art of Tony Doc Shiels *Antenna*

Williamson, Tom & Bellamy, Liz (1981) Ley Lines in Question *Littlehampton Books*